T0029595

The Artist's
STEP-BY-STEP GUIDE TO
DRAWING
HOW TO CREATE BEAUTIFUL IMAGES

The Artist's
STEP-BY-STEP GUIDE TO
DRAWING
HOW TO CREATE BEAUTIFUL IMAGES

SIRIUS

Dedication
To my dear family and friends for their wonderful and unending support.

Acknowledgements

My grateful thanks to Arcturus Publishing; editors Ella Fern and Diana Vowles; health specialists Janet Wrathall and Dr John Roberts, and all those who allowed me to use their photographs or supplied 'props', as follows:

Chapter 2: Jug of organic and socially responsible flowers (Organic Blooms, Bristol).

Chapter 3: Garden terrace (Heidi Hanson on Pixabay).

Chapter 4: Family car (Derek Coleman).

Chapter 5: View of a hill (the late Ann Bowker, Mad about Mountains).

Chapter 6: Kathleen and Joe Armstrong with prize-winning, pedigree Ayrshire cows (Plaskettlands Farm, Mawbray); Children playing, Charles Edouard and Alex Gibb (Annette Gibbons OBE); Garden bird (Kevin Philips on Pixabay); Wild animal (Zdenek Machacek on Unsplash); Domestic cat, Rocket Dog (David Jeffries, Ministry of Doing); Labrador (Tom and Nicki, ToNic-Pics on Pixabay).

SIRIUS

This edition published in 2024 by Sirius Publishing, a division of
Arcturus Publishing Limited,
26/27 Bickels Yard, 151–153 Bermondsey Street,
London SE1 3HA

Copyright © Arcturus Holdings Limited

All rights reserved. No part of this publication may be reproduced, stored in a retrieval system, or transmitted, in any form or by any means, electronic, mechanical, photocopying, recording or otherwise, without prior written permission in accordance with the provisions of the Copyright Act 1956 (as amended). Any person or persons who do any unauthorised act in relation to this publication may be liable to criminal prosecution and civil claims for damages.

ISBN: 978-1-3988-3676-1
AD008611UK

Printed in China

Contents

Introduction

As you are reading this, you're probably curious about how you can learn to draw or improve your existing drawing skills. This book, then, is perfect for you! It will guide you from first steps to creating beautiful works of art, step by step. Don't worry if your previous attempts have not lived up to expectations – all you have to remember is that drawing is simply about making marks on paper. The skill is to make the desired mark in the correct place, and this book will show you how. Whether you would like to produce simple pictures or very detailed drawings, each example is broken down into manageable steps so you can see how to accomplish the finished piece. You will discover that most drawings use exactly the same fundamental techniques – those of drawing lines, shapes, and different shades – just in different combinations. Once you have mastered the fundamentals, you will discover how to apply them to create a variety of work.

You may be surprised to know there is no right or wrong way to draw. I am self-taught and I realized that drawing is as individual as we are, in the same way that we all move, talk and write differently. Whatever your style, you can use the techniques to achieve your desired results. All that is required is an open mind, a willingness to practise, and the ability to see the world a little differently.

This book focuses on pencil drawing using readily available and affordable materials, allowing you to explore more detailed examples in this medium. Naturally, detailed drawings cannot be rushed and take longer to produce than sketches, although I'm sure many people have started out thinking they can complete an ambitious subject in no time at all, myself included! I'm certain, though, that no one would get into the driving seat of a car or aeroplane for the first time and expect instant mastery. It's the same with drawing; detailed portraits of people and pets are much more intricate and technically challenging than, say, a drawing of a simple box or ball.

Some skills, therefore, must be practised before you can move to the more advanced levels later in the book, hence the first examples are easy, and each step and technique is explained. As you work through the exercises, you will see your skills develop, along with your ability to draw more ambitious and exquisite pieces with confidence. As with most things, the best foundations produce the best results, practice makes perfect and, with your new-found skills, you will be able to draw almost anything!

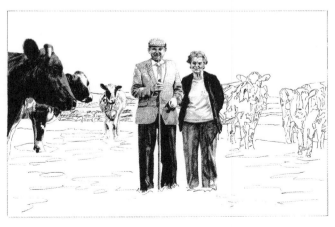

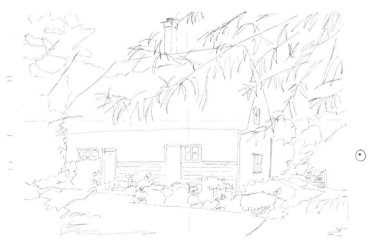

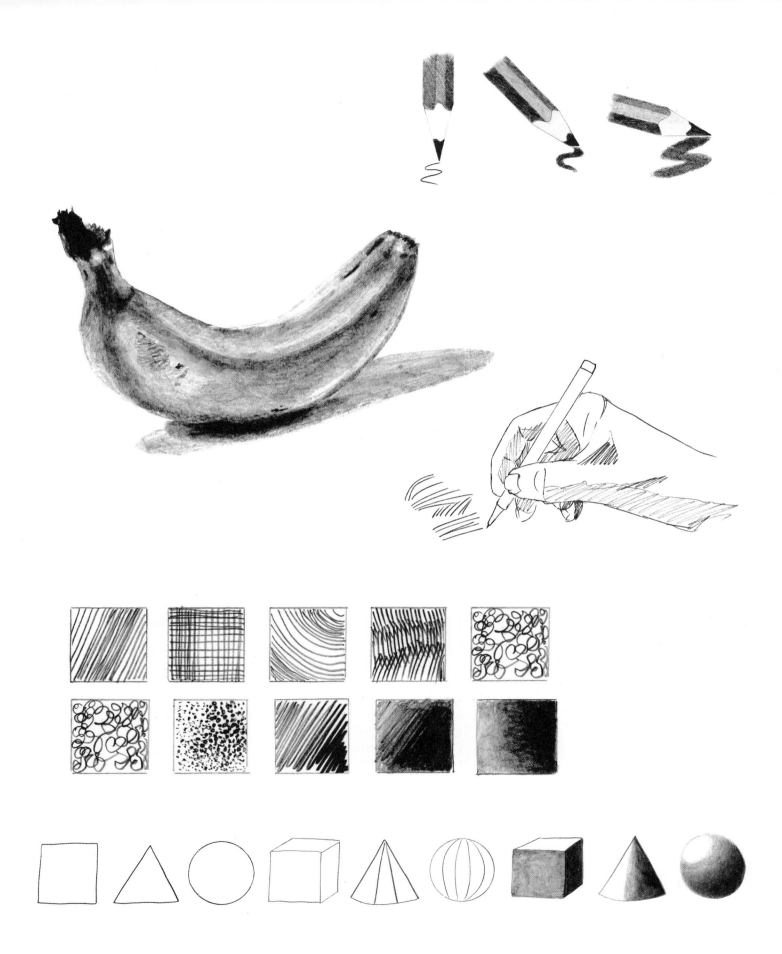

Chapter 1

Materials, Techniques and First Exercises

This chapter begins by looking at the materials you'll need for the projects in this book and how to start on the process of drawing. Whether you're a beginner or seeking to improve your skills, the exercises guide you from the first steps to mastering more advanced techniques in easy stages, step by step. We'll explore the basic elements of drawing, including lines, shapes and shading, how to combine them to create volume, perspective and textures, and how to use light and shade to bring your drawings to life. Finally, we'll bring these elements together in some step-by-step exercises focusing on objects of different shapes and textures.

Drawing materials

The first step is to assemble some drawing materials. The items listed here are relatively inexpensive and easy to obtain, and include those I've used to create the drawings in this book. Naturally, you will develop your own favourites – I like to use an HB pencil, but I heartily encourage you to try as many different materials as possible.

Most reputable art shops stock a range of drawing supplies and it's a good idea to try samples before you buy if possible. Obviously, you won't be able to try items online so you will need to be guided by reviews.

9H

8H

7H

6H

5H

4H

3H

2H

H

F

HB

B

2B

3B

4B

5B

6B

7B

8B

9B

Pencils

Regular graphite pencils, as illustrated below, are used throughout this book, and I recommend you buy any reputable brand. They are normally graded from Hard (H) to soft (B, or 'Black'). The leads are made from graphite, a form of carbon, mixed with a clay filler. The harder leads, or 'H' range, give the palest tones and finest lines and have a higher clay content than the softer 'B' range, which produce the darkest tones when shading. The mid-range HB pencil ('Hard and Black') is very versatile, while the 'F' grade pencil, which is slightly harder than an HB, sharpens to a 'Fine' or 'Firm' point and was originally used for writing shorthand.

The two graphite pencils illustrated here show (a) a wood-encased pencil lead and (b) a pencil with an extendable lead. Some mechanical pencils have refillable leads, and you can also buy solid graphite sticks that have no casing.

(a) *Wood-encased graphite pencil.*

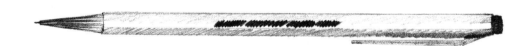

(b) *Graphite pencil with a lead that extends when you grip the pencil body and twist the point.*

Pencils can be bought individually or in sets and you'll discover that the softer pencil leads (for example 9B) are much crumblier and break more easily than the harder, 'scratchier', leads such as 6H. It's a good idea to start with a small selection, such as 3B, B, HB, H, 3H and 5H, until you know which grades you prefer.

Range of light and dark tones from pencil grades 9B to 9H.

Pencil sharpeners

You will need to sharpen your pencil to maintain a suitable length and shape of the point and for this you can use a pencil sharpener, a craft knife or a sandpaper block. There are no hard and fast rules for which method of sharpening is best; I tend to use all three methods, depending on the effect I want to create.

(a) *An everyday pencil sharpener with a sharp blade is perfectly acceptable.*

(b) *If you prefer a craft knife, carefully shave away the wood casing and graphite core to create your required pencil point.*

(c) *A sandpaper block is easy to make by stapling a piece of medium or fine sandpaper to a small piece of wood. This example is 7 cm long x 3 cm wide x 1 cm high (2¾ x 1¼ x ½ in). To sharpen your pencil point, rub the lead over the rough surface. It's ideal for quickly creating a fine pencil point for drawing fine lines as well as a broad, blunt edge for areas of shading.*

TIP It's best to use several different sharpeners, because no single sharpener will create the whole range of pencil points. After sharpening, remove any loose graphite dust by lightly wiping the lead on a piece of scrap paper, and always test your pencil point before returning to your drawing. You can save graphite dust in a jar to use another time for drawing.

Erasers

You will need an eraser to remove any unwanted marks from your work – many examples in this book require you to lighten areas or erase superfluous lines. A white plastic or latex-free eraser (a) is most effective for all-round use with graphite pencils, and can be kept clean by wiping it on a piece of scrap paper. You can maintain the eraser's sharp edges by trimming with a craft knife, and also create smaller slivers (b) with precise edges for erasing very small or fine areas of graphite. Other erasers include a putty eraser which can be moulded to shape and used for lifting off graphite from the page, and eraser pens which are fun to use but more expensive to buy.

 (a) *Plastic eraser* **(b)** *Sliver for precise erasing*

Paintbrush

Avoid using your hand to wipe away eraser crumbs as this can smudge your work, while blowing them away may leave unwanted moisture on the page. Instead, use an ordinary, soft-bristled paintbrush to gently clear away eraser pieces, dust, or other debris that may have fallen onto your paper.

Ruler

You may have been advised never to use a ruler, but I find one invaluable. Use it for measuring the size and scaling of your work, drawing faint guidelines and boundaries, and helping to create straight lines of perspective. A clear plastic 30 cm (12 in) ruler is cheap to buy and easy to keep clean by washing with plain soap and water.

Blender

Blenders come in many varieties and are used to smudge together adjacent areas of light and dark pencil work, as well as smoothing the lines of individual strokes. The blender shown here has a soft, colourless acrylic tip (which has darkened slightly over time with use). You can also use a cotton bud or piece of tissue, though these are not so accurate; smudging with your fingertip is not recommended as it will leave a greasy mark on your page. Using a blender will alter the surface of your work, so is best left until you have almost finished your drawing.

Paper

Cartridge paper is most commonly used for drawing – it's a good idea to try different brands until you find one you prefer. Some art stores will send paper samples on request. Always use acid-free paper to ensure longevity, since acid paper will turn yellow and become brittle over time. Buy a branded paper with a weight of 130 gsm (80 lb) or above (gsm is grams per square metre). Better-quality papers weigh more than cheaper papers.

The surface texture of paper is known as the 'tooth'. Papers with less tooth are smoother, such as Bristol board, and are ideal for drawing fine, crisp lines, especially in pen or ink. Very rough papers with more tooth are heavier and include watercolour papers, which are great for producing very textured effects, particularly with charcoal and pastel. Some surface texture is a benefit, as this allows the graphite to adhere to the paper. Slightly textured cartridge papers are ideal for pencil drawing as they result in lightly textured pencil lines.

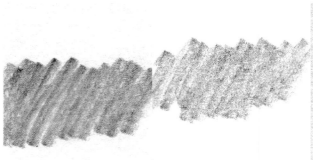

Shown here are graphite strokes of the same HB pencil on three different papers. Left to right: 190 gsm (90 lb) light-textured cartridge; 220 gsm (100 lb) smooth white Bristol Board; 300 gsm (140 lb) watercolour paper.

The standard cartridge paper colour can vary from bright white to a warmer off-white; I find that a slightly off-white paper is more versatile and better complements most mount and frame colours. My favourite surface is a 190 gsm (90 lb) natural white paper, and most of the examples in this book are produced on this.

Compared to spiral-bound pads, paper pads with gummed pages are easier to manage and remove pages from without tearing. Look for ones with a firm backing board, which will provide better support when drawing.

TIP For your best works, use the highest-quality paper you can afford. Keep a supply of other paper for rough working, scrap, and resting upon while you're drawing so you don't smudge your work.

Buying artists' supplies: Do's and Don'ts

Do: Research before you buy; shop locally if you can; ask other artists and experts for advice; try items before you buy if possible; look for sale or clearance items and consider buying environmentally-friendly supplies.

Don't: Shop without a list or a budget limit; forget what supplies you already have; get carried away with excitement; or buy novelty items for the sake of it!

Now that you have assembled your drawing materials, let's make some marks on paper.

First steps and pencil strokes

In this section I'll guide you through making different marks on paper, from simple pencil lines and shapes to more complex shading. Choose a comfortable position for drawing, which could be standing or sitting at an easel or sitting at a desk. I prefer to sit at a level table or desk with my drawing paper resting on a couple of spare sheets of cartridge paper and a firm backing board that is raised at the back by a few centimetres.

If you are new to drawing or haven't practised for a while, start by making a few random pencil strokes on scrap paper to warm up and become familiar with the materials. Any mark is fine – this is not an exercise in striving for perfection. Remember that you probably draw all the time without realizing it – you make the same straight and curvy lines and shapes when you write, it's just that when you draw, the marks are different sizes.

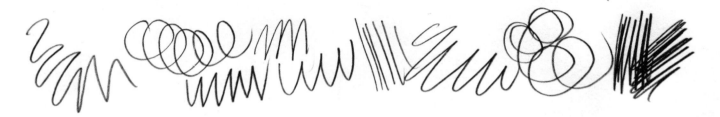

The ultimate aim is for you to be able to make any mark you choose, of the correct dimensions, shape, shade, and orientation, in the desired place on the page. To achieve this, you need to be familiar with the drawing materials and the marks they create, and have good hand-eye co-ordination and observation skills. The more you practise and develop your skills, the easier it will be to accomplish any mark-making you wish, even without thinking!

Now, have a go at drawing some straight and curved lines that form the basis of most drawings. You may need to rotate the page to draw some of the strokes and, if you like, you can add some faint guidelines to help you draw in rows. Some lines are harder to draw than you might think, so do practise these as often as you can. You'll discover that if you can draw lines of any kind competently, this will improve your drawing skills immensely.

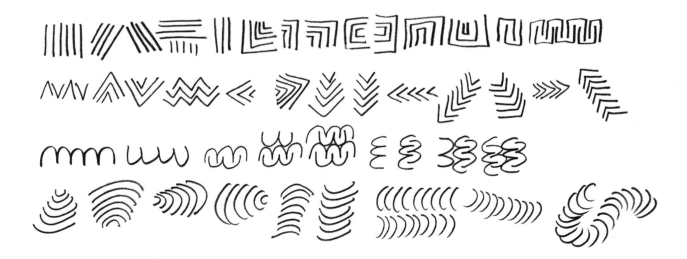

Holding the pencil

Did you know that you can create different effects by altering the way you hold your pencil? See if you can achieve the following effects: (a) fine lines with a fine point and upright pencil, (b) wider lines with an angled pencil and blunter point, and (c) very broad strokes with the flat side of the pencil lead – but be aware that, at this angle, too much pressure on the page may break the pencil lead.

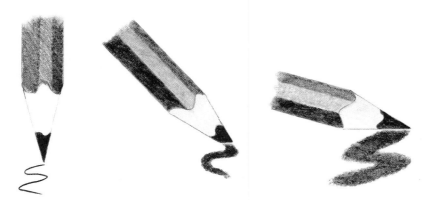

Pencil points, left to right:
(a) *fine*
(b) *blunt*
(c) *flat side*

Loose or firm grip?

You will find that you can make freer, less precise, marks more easily and quickly with a loose grip on the pencil, and this grip also exerts less pressure on the page. This technique is useful when sketching out your ideas and rough drafts.

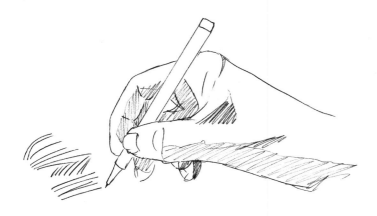

A firm grip, as in holding a writing pen, will give you more control over making finer, more precise marks when refining your work, and enable you to make darker marks that require a blunter pencil point and greater pressure on the page.

Here are some more effects for you to create, using different pencil holds.

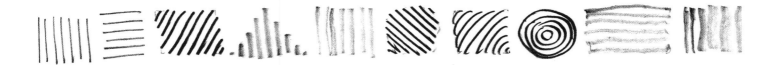

Shapes

Now that you've practised drawing lines, the next step is to develop your control of the pencil by joining lines together to create assorted regular and irregular shapes. This may seem like a simple exercise, but mastering the recognition and drawing of shapes is one of the foundations of successful drawing and forms the basis of most of the exercises here. Drawing the correct shapes, so that everything is in proportion, is key to producing your best work.

 Have a go at accomplishing these various shapes. Notice how you can group some together to form new designs.

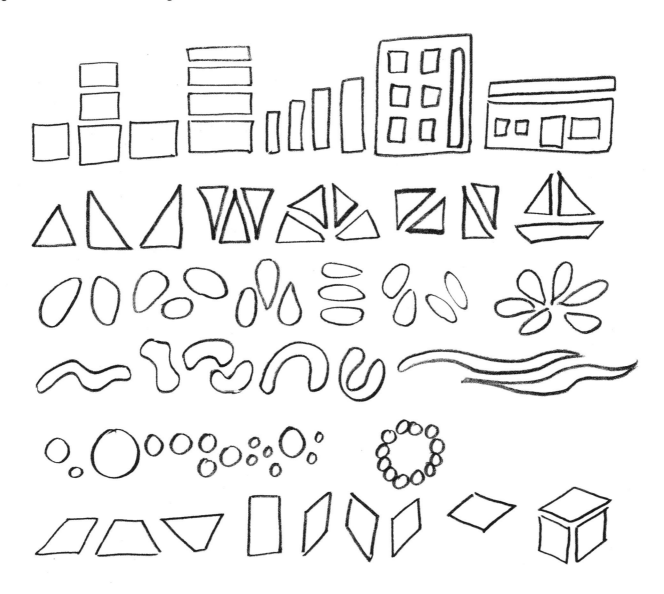

Rounded shapes such as circles and ellipses can be more challenging but they are another important element of drawing, so you need to become proficient at executing them. Very few round objects appear to us as always perfect circles but instead as various elliptical shapes that change according to our viewpoint.

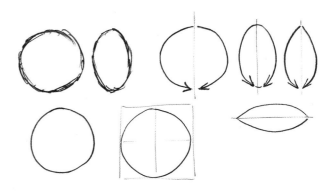

Here, I'll show you a few different ways to produce them. Remember that these circles and ellipses are symmetrical; some of the examples here include a faint vertical or horizontal guideline to show the axis of symmetry that can be erased once you have completed your shape.

Practise drawing these circular and elliptical shapes until you can create them with ease. Clockwise from top left: draw overlapping curved strokes until you achieve the desired shape; draw the shapes with both rounded and pointed ends as mirrored halves, each side of a central vertical guideline; draw a horizontal, pointed ellipse around a horizontal guideline; outline a square divided into quarters then use the points where the horizontal and vertical lines intersect the square as a guide to draw your circle; draw freehand in a single stroke. Of course, these are not perfect shapes. On the rare occasions when you might need to draw a perfect circle, you can draw around a circular object or use a compass.

Next, try creating this wine glass, which includes some of the lines and shapes you have just practised.

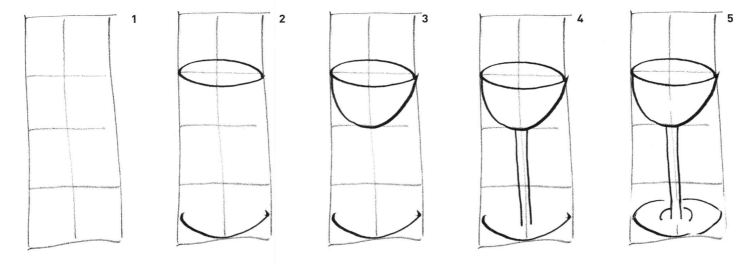

Step 1
Draw a rectangular box and divide it in half vertically, and into four equal sections from top to bottom.

Step 2
On the first horizontal line from the top, draw an ellipse shape the full width of the box, then draw a half-ellipse in the bottom section.

Step 3
Between the first and second lines, draw half an upturned circle the full width of the box (this is the wine glass bulb).

Step 4
Then, either side of the vertical line, from line two to just above the bottom line, draw two vertical strokes. This is the glass stem.

Step 5
Next, just below the third line, draw the second half of the ellipse in two pieces (the left and right sides of the glass base). Finally, just above the bottom line and either side of the glass stem, draw two small, curved sections (where the glass stem meets the base).

Shading

After practising the lines and outlines of empty shapes, the next step is to master shading. This is where you'll use the pencil to create areas of light and dark, to convert colours to black and white, and to create volume, texture and perspective. As a result, you will achieve greater realism.

Areas of light and dark are called shades, tones, values, and tonal values, and I use these terms interchangeably because they all mean the same. They are achieved with graphite pencil in shades on a scale that ranges from 'white' (that is, no shading) to black, with a number of grey shades in between.

Recognizing and using tones is a key element of art, and one of the most important skills you can develop is the consistent use of a range of distinct tones. So, we'll now practise creating tones.

Creating light and dark

There are many different methods to create areas of light and dark, but here we'll focus on rough shading and blending as these are the techniques used in this book. However, it's also helpful to be aware of different methods, such as hatching and stippling, illustrated here. Notice how the more closely spaced and denser lines appear to create the darker tones.

Different ways to create light and dark areas. Top row, left to right: hatching, cross-hatching, contour hatching, dash hatching, scribbles. Bottom row, left to right: stippling, rough shading, shading, blending/ blended shading. The difference between rough shading and shading is that the pencil strokes are very obvious in the rough shading with gaps between the strokes, whereas in shading and blended shading the aim is to hide any strokes, eliminating gaps between them.

Rough shading

The skill is to draw these lines quickly but control their width, direction and tone. Use an HB pencil with a blunt point and varying pencil pressure on the page to create the different values in strings of zigzags. Practise as many times as you like until you feel confident you can create six to eight different tones.

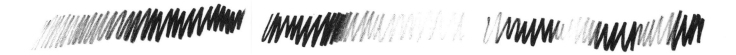

Range of tones created with an HB pencil.

Repeat this exercise, this time using different pencil grades to create the zigzags.

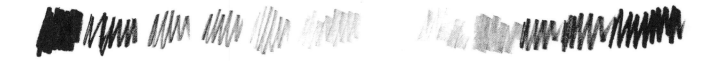

Range of tones created with 3B, B, HB, H, 3H and 5H pencils.

Now have a go at creating these geometric shapes using rough shading.

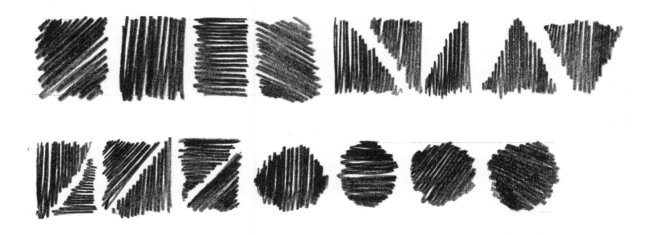

Blended shading

Blending is another way to shade areas of tone, but now the aim is to obscure individual strokes so that you can cover an area evenly without any gaps. This is an advanced technique but a key one to master, because it will enable you to produce realistic drawings with tonal textures that fade seamlessly between light and dark, for example skin and fur textures.

Blended shading requires a finer touch, a blunt pencil point, and circular, partially overlapping strokes in a random circular motion, so that the pencil glides smoothly and softly across the page. As before, different tones are created by using either a single pencil and varying the pressure on the page, or by several different pencil grades. For small areas use small circles and, for larger areas, use bigger, elongated oval strokes.

1

2

3

Step 1

Use the sandpaper block or a piece of scrap paper to create a soft, blunt, pencil point, then draw a few diagonal pencil strokes on scrap paper to test that the point is as you want. Remove any loose graphite dust.

Step 2

Practise by making a string of small circular marks on the page, just to become familiar with the circular motion. When blending, the small circles can be as little as 2 mm ($\frac{1}{16}$ in) in diameter.

Step 3

Continue to practise the circular shading motion to create an area of tone from a continuous and very condensed string of strokes. The top image shows the shading, while the bottom image is a greatly enlarged and expanded view of the actual pencil path.

In the next exercise, use the circular shading technique and an HB pencil with a very blunt point to draw continuous gradients of blended shades that fade between dark and light by simply increasing and decreasing the pencil pressure. This exercise is more difficult, so draw a rectangular outline as a guide if this helps.

TIP If you feel that the pencil lead has become glazed or shiny and the graphite is no longer adhering as well to the paper, try rotating the pencil in your hand to use a different 'edge' of the lead that grips the paper better. Alternatively, rub the pencil lead on the sandpaper block, but don't forget to remove any loose graphite dust by lightly wiping the point on a piece of scrap paper, otherwise you may create unwanted darker patches in your shading.

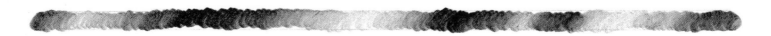

Gradients of blended shades drawn within a rectangular outline 5 mm (¼ in] tall.

Tonal strip

This is not an activity at the gym, but a further technique to help you develop your drawing skills! The aim is to draw blocks of seven different and consistent tones and create a tonal strip from 'white' to 'black' to act as a reference aid for your work. You can then use the strip by holding it up to your subject, closing one eye, and working out which tone on your strip is closest to the value of your subject. In this way, you can gauge which value to draw on your page.

Decide if you would like to use a single HB pencil or several different grades such as 3B, B, HB, H, 3H and 5H to create a tonal strip from rough shading. The resulting tonal strips from either pencil selection should be the same. Use a piece of heavyweight, lightly textured cartridge paper, approximately 16 x 7 cm (6¼ x 2¾ in).

Step 1

Use a clean, dust-free sheet of paper and faintly outline a row of eight small squares, approximately 1.5 cm (½ in) square, which I am numbering 1 to 8 from left to right.

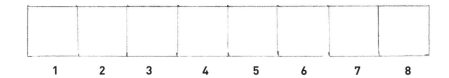

Step 2

Leave square 1 blank, which we'll call 'white'. Fill square 8 with the darkest tone you can manage (black) using either a blunt-point HB and the firmest pressure on the page, or a 3B pencil. Don't worry if you draw over the lines – it's more important to create distinct values than to keep within the box.

Step 3

Fill square 2 with the palest tone you can draw.

Step 4

Fill the remaining squares with intermediate tones, gradually darkening towards the right.

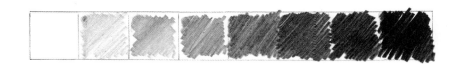

Repeat the exercise but, this time, use blended shading to create the same tonal values. This takes patience and skill to control the pencil, but the more you practise the easier it will become. Take care to avoid shading over any dust or graphite particles as this can add darker streaks to your work.

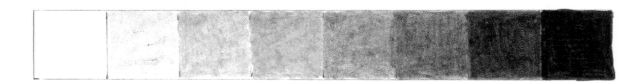

Common mistakes

 Unwanted darker streaks are caused by shading over dust, graphite and eraser fragments. They can be avoided by gently sweeping away any particles from your work with a soft brush.

Not drawing sufficiently dark tones is common at first. To overcome any reluctance to create very dark tones, experiment on scrap paper so that you become familiar with creating different tones and see how dark you can really draw and how much pressure you can apply to the page without tearing the paper or breaking the pencil lead.

> **TIP** To create the darkest, most beautiful black and velvety tones, use a very blunt, shortish, pencil point and hard pressure, almost to the point where you think the pencil point might break. If you are shading larger areas, it's a good idea to overdraw the area in different directions to conceal individual strokes, rotating the page to do this.

Advanced blending

Now, let's take the blended shading techniques you've practised to the next level. This more challenging exercise requires you to shade and blend different tones and control the tonal changes over an area. Merging, or 'smudging', different values in this way is an advanced skill which you use to create greater realism in a drawing.

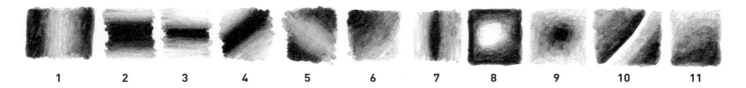

1. Shade from left to right, fading from dark to light then back to dark.
2 and 3. Start with horizontal dark shading across the centre and fade to pale tones above and below.
4. Repeat steps 2 and 3, but this time, shade diagonally.
5. Start at the top right corner with a dark tone and shade diagonally downwards, fading to a pale tone across the middle and then deepening to a dark tone towards the bottom left corner.
6. Start at one corner and fade from a very dark to a very light tone, diagonally, from corner to corner.
7. Shade vertically from left to right, working from light to dark to light again, creating a tall and narrow, elliptical shape in the middle.
8. Start with a dark tone around the edges and fade to light, leaving the centre area white.
9. The reverse of 8 – start with a very dark centre and fade towards the edges.
10. Divide the square into two diagonally. Shade both halves from bottom right to top left, fading from dark to light.
11. Shade diagonally from bottom right to top left, fading from dark to light.

A few examples of how you might use these techniques include the pupil in a cat's eye (No 7); a faraway star in the night sky or a sparkling bubble on the water's surface (No 8); and a crisp fold in a fabric that has both bright highlights and deep shadows (No 10). It is the alternating contrast between the adjoining very dark and white tones that helps create the three-dimensional realism.

White bits

In many exercises, you'll see that some areas have 'white' bits or no tone. Learning how to create these areas will make it much easier for you to incorporate features such as white whiskers or glinting highlights on darker backgrounds in your work. Notice how the different methods create varying sharp or fuzzy 'boundary' effects between adjoining areas of light and dark tones.

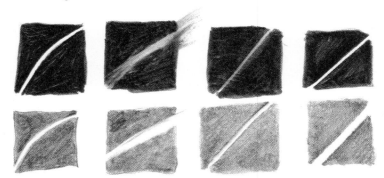

Try drawing these four pairs of techniques for creating white bits on both black and grey backgrounds. Left to right: Outline a long, thin feature and draw around it, leaving the thin, middle strip blank; use an eraser sliver with a sharp edge to erase a strip of graphite (and try to avoid smudging, as in the top example); indent the paper first with a rounded object such as a paper clip, then shade over the indent; finally, use the edge of a piece of paper as a mask to shade each edge of the white strip in turn.

Converting colours to pencil greyscales

When looking at a scene in front of you, you may wonder how to draw all the different colours in shades of black and white on your page. The best thing to do is to look for the very dark and light areas in the scene and outline these first. This will give you the range of tones in your drawing and you can then decide how many in-between shades to include. Closing one eye will help you to identify and compare colours because the different tones become more obvious than the colour hues. It's then easier to work out the relative light and dark shades in a scene.

The monochrome strip below shows different colours when they're converted to black and white. The strip includes the three primary colours (red, yellow, blue), three secondary colours (orange, green and violet), and six tertiary colours (red-violet, yellow-orange, yellow-green, blue-green, blue-violet and red-violet).

You can see that three groups contain normally readily identifiable individual colours like (a) the orange, yellow-orange, and yellow-green; (b) the blue-green, blue, and blue-violet; and (c) the red-violet, green, and violet, but they are almost indistinguishable from each other when converted to monochrome. Note that the colour brown does not appear but is a shade of dark red-orange.

Once you have found your converted 'colour' on the monochrome strip, find the matching shade on the strip of pencil tones, and this is the tone you need to draw.

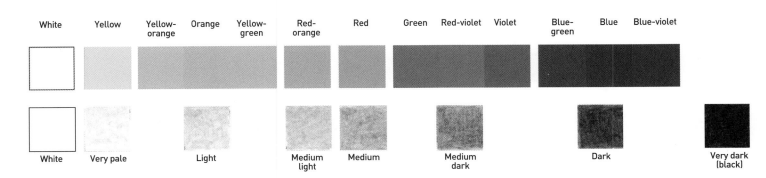

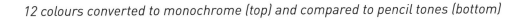

12 colours converted to monochrome (top) and compared to pencil tones (bottom)

Volume

Now, you need to bring together the techniques of drawing lines and areas of shading that you've practised so far to create the illusion of volume on a two-dimensional (2-D) page, so that objects appear to have height, width and depth.

Method 1: Add lines to create volume

Start as shown in Row 1 and very lightly draw a row of three shapes – a square, triangle and circle. Then, as shown in Row 2, add various straight and curved lines to create volume. Notice that the circle shape remains the same, unlike the square, which requires you to draw lines outside the original shape, and the triangle now needs a curved base.

Method 2: Add shading to create volume

As shown in Row 3, lightly draw another row of outlines of the shapes in Row 2 but this time, fill each shape with blended tones. In order to create volume, you'll notice that within the square shape each area has an even tone whereas the curved surfaces of both the cone and sphere have a range of tones that fade from light to dark.

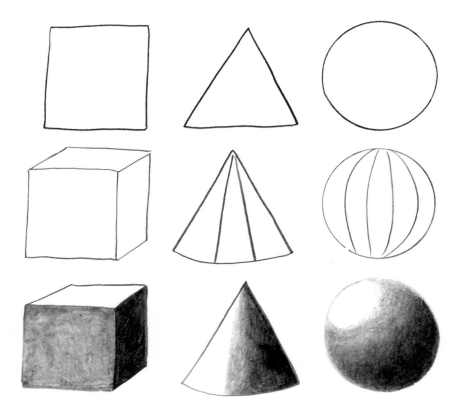

Adding lines works well for the square (to create a cube), but not so well for the triangle (cone) and circle (globe), which require curved lines. Adding shading, however, produces the best results for creating volume and a three-dimensional appearance.

Perspective

You can see how easy it is to create the impression of volume for a single object by lines and shading, but it's technically more challenging to create a three-dimensional effect on a two-dimensional page with scenes containing many elements, such as a still life, a room or a landscape. Here, we need perspective to help create the illusion of depth and distance in our picture, so that our eyes perceive a more three-dimensional and realistic scene overall.

Perspective is the process by which we convey the correct impression of objects' volume (height, width and depth) and their positions in relation to each other. Mastering the use of it is another key element to producing scenes that look authentic and pleasing to the eye, rather than oddly distorted views with objects out of place. There are two main ways we can create perspective: linear and aerial perspective.

Linear perspective

This type of perspective creates the illusion of depth by objects being drawn progressively smaller the further they are away from the observer. With greater distance, the objects will also appear less defined and contain less detail. There are three types of linear perspective, imaginatively called one-, two- and three-point perspective, which refer to the number of vanishing points on the horizon respectively. A vanishing point (VP) is where two or more parallel lines, such as those defining a railway track, a straight road, or a very long corridor, meet at infinity, or the horizon.

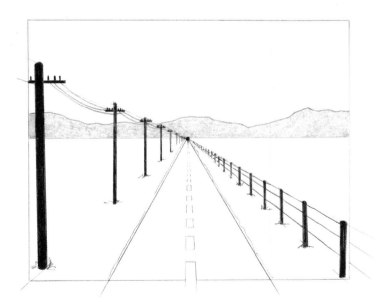

One-point perspective creates the illusion of distance where things appear to vanish out of sight at a single point on the horizon. We know that a stretch of road or railway track remains a uniform width along its length, but the effect of perspective shows the lines converging at the VP. Thus, we know that the closer these lines are together, the further they are away from us.

One-point perspective shows the single vanishing point (VP) as a black dot on the eye-level horizon into which all the lines of perspective, such as the road, pole and fence lines, appear to 'vanish'.

To create this effect, draw the lines of perspective radiating out from the single VP to define the road edges, as well as the top and bottom of the telegraph poles and fence posts. Draw vertical poles and fence posts between the lines of perspective, remembering these lines are verticals parallel to each other, and shortening them as they get closer to the VP. Add further details such as fence wires as desired. Some of the perspective lines (which are effectively guidelines) are extended outside the box to show you how they were used.

Two-point perspective has two VPs on the horizon and is used to depict objects at an angle to the observer, such as the corner of a building on a street where two sides can be seen at the same time. In this example, you'll draw vertical lines that are all parallel but there are no horizontal lines. Instead, the normal horizontal lines of the roof and windows are shown to recede along the lines of perspective.

This scene shows the observer standing at the corner of an imaginary building with the perspective lines converging at the VPs on either side.

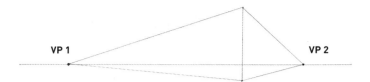

Step 1

Draw a horizon line, mark a VP near each end of this line, then draw a vertical line just to the right of centre (this is the corner of the building). Next, draw faint lines from the top and bottom of this vertical line to the VPs on each side.

Step 2

Between the lines of perspective, draw two more vertical lines either side of the first vertical line and parallel to it. These are the walls of the building.

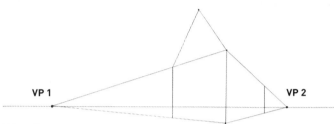

Step 3

Mark a central point in the space above the top of the left-hand wall – this point becomes the peak of the roof gable end. Next, draw two lines from this point, one to each of the top corners of this wall.

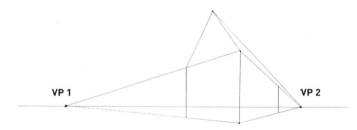

Step 4

From the roof peak, draw a faint line of perspective to VP2.

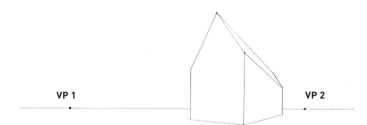

Step 5

Draw a line from the top of the far right-hand wall, parallel to the existing roof line at the other end of the roof, to intersect the line of perspective. This gives you the roof shape in perspective. Erase unwanted perspective lines.

Step 6

Using the same technique of drawing perspective lines to guide you, add additional features such as a door, windows, and other buildings. Finally, shade the scene using dark and medium tones. Notice how you can use different-sized windows and doors to alter the scale of the buildings – for example, a large door can create the appearance of a small house whereas a small door can make the building look like a large barn.

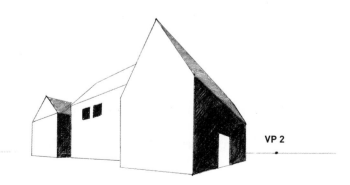

Three-point perspective utilizes three vanishing points (VPs) to depict the illusion of depth, and all the lines vanish to one of these VPs. Notice how the three VPs form a triangular shape – two are on the horizon and the third is either above or below the horizon, depending on whether you are looking upwards or downwards to your subject.

See how easy it is to create this perspective by completing the next two examples of a tall object, using a ruler to draw the lines if you need to.

Example 1: Looking up at a tall building from a neighbouring tower block.

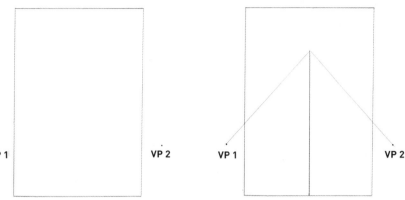

Step 1
Use faint lines to draw a rectangle and then mark the three VPs around the rectangle as shown (VP1, VP2, VP3).

Step 2
Add a central vertical line that runs from the base of the rectangle to about three-quarters of the way up. Then, from the top of the vertical line, draw faint lines to VP1 and VP2.

Step 3
On the perspective lines you've just drawn, at approximately 1 cm (½ in) distance either side of the top of the central vertical line, make small, faint marks to indicate the width of the building. Then, use VP3 as a guide to draw the sides of the building from these marks down to the bottom of the rectangle.

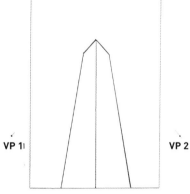

Step 4
Embolden lines as required and remove unwanted guidelines. You can now see the overall shape of the tall building.

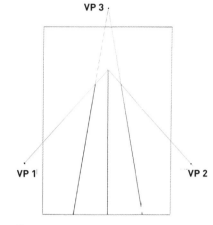

Steps 5 and 6
As before, use the VPs and lines of perspective as a guide to add details such as windows and other buildings. Pay attention to scale – for example, the windows get smaller and closer together as they recede. To complete the exercise, shade the features in light, medium and dark tones.

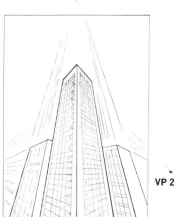

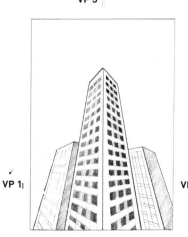

Example 2: Looking down onto a tall object.

In this next exercise, see if you can apply the same techniques described in Example 1 to complete this drawing of more tall buildings, shown in a different perspective. The overlapping shapes also make it easier to judge the relative distances of objects and how they relate to each other in that space.

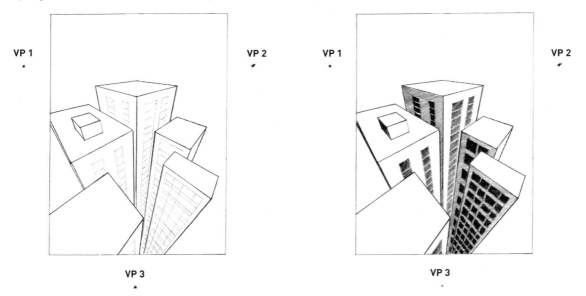

Once you've completed these two exercises, experiment by drawing more examples with the three VPs in different locations, noticing how you create different shapes each time.

In linear perspective, **foreshortening** describes how an object appears compressed and shorter than it actually is. If you're unsure if an object is foreshortened, or don't know how to portray this in your drawing, simply locate the viewpoint(s) and apply the lines of perspective to reproduce the features appropriately.

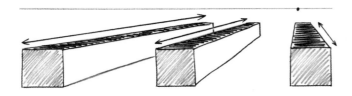

The right-hand object appears foreshortened (shorter or more compressed than the other two), when viewed end-on and close-up, especially when observed from near to ground level. If viewed from overhead, however, all three objects would be seen as the same length, so you can see how identical objects appear differently depending on the viewer's perspective.

Aerial perspective

This type of perspective uses tonal changes to create depth. Have a go at drawing the following example to show the foreground objects in darker tones, using progressively lighter tones for increasingly distant objects.

Without a vanishing point, you must rely on the use of paler tones, smaller objects, less detail, and overlapping items to convey the illusion of depth and how different objects relate to each other in that space.

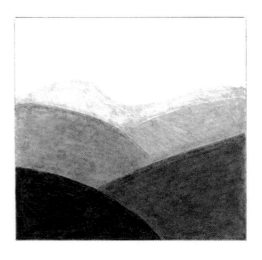

Light and shadows

You've seen how to use various light and dark shades to create the illusion of depth and volume, but you also need to understand how to create shadows to give an authentic representation of a scene according to different lighting conditions.

When the light is blocked by an object, shadows appear – that is, the shape of that object is cast onto the surrounding surface(s) on the opposite side to the light source. The size of a shadow will change depending how close the object is to the light source.

Light comes from the sun as natural daylight and other sources such as lanterns, electric light bulbs and firelight. Light travels in a straight line and illuminates our surroundings and, of course, we only see things if there's light – we don't see much if it's dark!

The illustration depicts the shadows of various objects at varying distances from the light source, the sun.

To draw shadows, use the vanishing point directly beneath the light source to work out the shadow width, and lines or 'rays' from the light source itself to establish the shadow length. The examples show shadows cast by objects of different shapes, sizes and proximity to the light source. The light source is on one side of the object and the shadow on the opposite side.

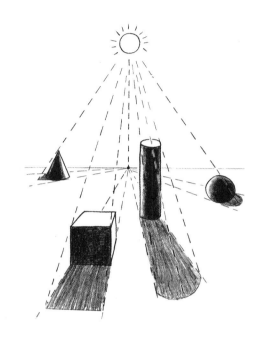

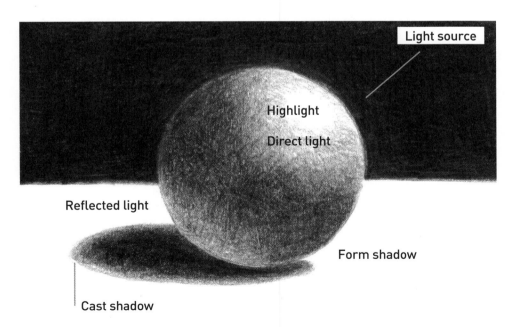

Light source

Highlight

Direct light

Reflected light

Form shadow

Cast shadow

In addition to the light that falls directly on an object (direct light) and the shadow that is cast onto a surrounding surface, the other basic components of a shadow include form shadows (actually on the object), highlights (the brightest area) and reflected light which is bounced off another surface onto the object.

Shadows and very dark-coloured objects can heighten the illusion of depth in a picture, as well as adding shape, texture and contrast. Multiple and overlapping objects will create more complex shadow effects that interact with each other.

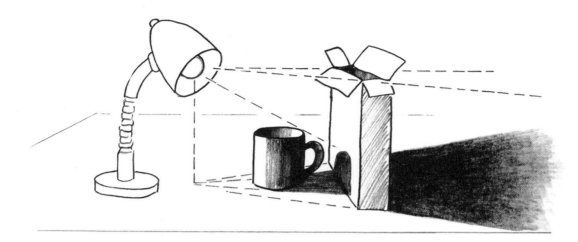

The dotted guidelines from the desk lamp (light source) illustrate how to create these more complex 'cast' and 'form' shadows of the mug and cereal box.

Surfaces and texture

What we actually see depends on the amount of light that reaches our eyes.

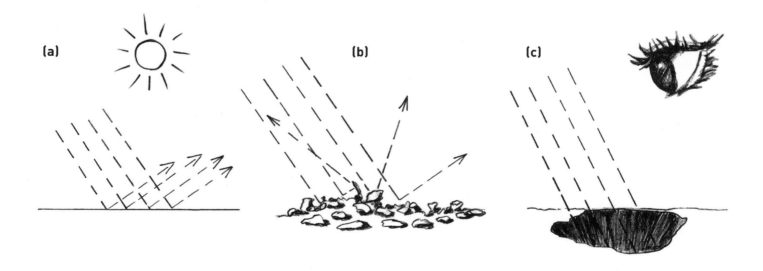

Left to right: We see (a) very bright/white tones when almost all the light bounces off a smooth, shiny (reflective) surface; (b) a mixture of light, dark and grey tones when light is bounced randomly off an uneven surface; and (c) black tones when the light is not bounced off but absorbed by the surface.

The amount of bounced light that reaches our eyes varies according to the nature of that surface. When you look around, you'll probably see a complex scene of different surfaces in myriad light and dark shades, which is the effect of light bouncing off all these different surfaces. At one extreme, almost all light will bounce straight off a perfectly smooth, shiny surface like a mirror and dazzle you whereas, at the other extreme, a non-reflective surface will absorb the light so that it appears very dark. Everything in between will appear as a mix of light and dark, representing an infinite variety of smooth and rough surface textures that randomly scatter light. Your brain interprets all these scattered light patterns as images. The essential skill is to recognize what you see – not what you think you see – and translate this into the desired shades of black, white and grey on the page.

To begin with, you can simply ask yourself 'What am I looking at? What are the main shapes and their sizes? What are the surface textures? Are they shiny or matte (that is, reflective or not), smooth or uneven?' Surface textures will fall into one of these four categories or a combination of two of them, for example, 'shiny and smooth'. A few examples of each are given here.

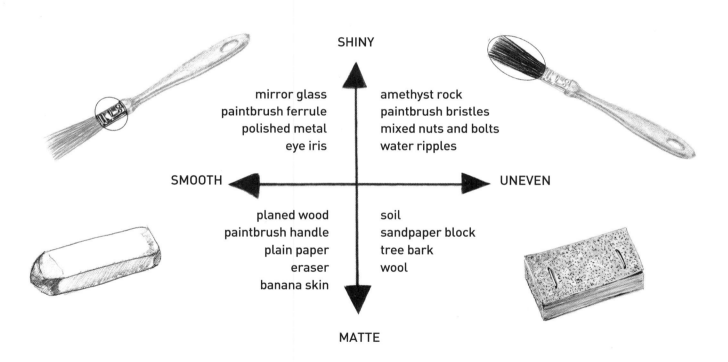

SHINY

mirror glass amethyst rock
paintbrush ferrule paintbrush bristles
polished metal mixed nuts and bolts
eye iris water ripples

SMOOTH UNEVEN

planed wood soil
paintbrush handle sandpaper block
plain paper tree bark
eraser wool
banana skin

MATTE

On the following pages, you can try to draw some small, everyday objects of increasing complexity that bring together everything we've covered so far, including lines, shapes, shading, perspective, light, shadow and texture. I'll guide you step by step so that you can see how easy it is to create drawings which include all these components. In each exercise, I have included photographs of the examples to help you understand how the drawings are constructed.

EXERCISE
Pencil

Let's start with an easy subject that has straight lines, smooth, mostly matte surfaces and regular shapes, with just a few areas of mostly uniform tones. You can see that this close-up image of a wooden pencil is in perspective because the pencil barrel appears to get smaller as it recedes into the background. For this example, use HB and 3H pencils, varied pressures, and blended shading.

Did you know that a pencil is hexagonal in shape because it's easier to manufacture, easier to grip, doesn't roll away, and uses less wood than a circular pencil shaft?

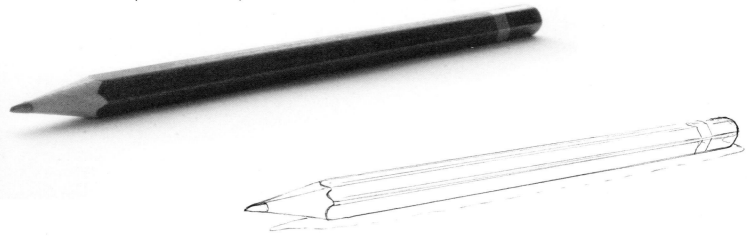

Step 1
Use an HB pencil and straight lines to outline the main shapes of the pencil, including the three visible long rectangles of the hexagonal (six-sided) barrel, the triangle tip, and the narrow band around the end. Don't be afraid to use a ruler – it can take quite a bit of practice to draw long, straight lines freehand. Notice that the pencil is illuminated from behind and that the top surface appears pale in the light compared to the underside, which is in shadow. Use faint lines to outline that area of shadow.

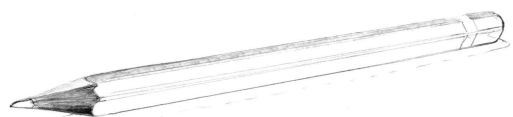

Step 2
Then, with a 3H pencil, use pale tones to fill the top surface of the pencil barrel. With an eraser, gently lighten the outlines at either end of the pencil so that they don't show in the final drawing. Starting at the pencil point, draw a short line of slightly darker tone a little way along the far edge of the pencil barrel. Use an HB pencil, minimal pressure, and short, straight strokes to fill in the sharpened area of wood of the pencil point, making the marks slightly darker on the underside. Notice how the combination of these dark and light lines gives the impression of a wood texture.

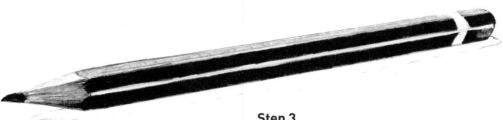

Step 3

Use the HB pencil with a very sharp point to fill the graphite tip. Then, use a very blunt point to fill the two remaining barrel sides with very dark, even tones, leaving blank the highlighted barrel edge and the band at the end of the pencil.

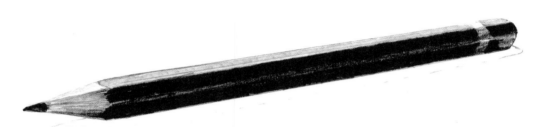

Step 4

Fill the highlighted barrel edge and band with HB pencil in medium tones, blending the edges where they meet the darker tones and using lighter tones for the shapes at the pencil end.

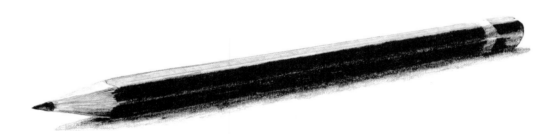

Step 5

Still using the HB with a blunt point, fill in the shadow shapes underneath the pencil in very dark tones, fading to lighter tones at their edges. Make any final necessary adjustments – I erased part of the graphite tip to create a sharper pencil point, created a narrower highlighted edge along the barrel, and erased any remaining unwanted outlines.

EXERCISE
Books

These three books with a matte surface texture rest on a plain white surface illuminated from the right-hand side. The quirky arrangement and viewing angle have been chosen specially to give the books an interesting perspective and shadow effects, and to challenge your observation and drawing skills. Drawn with HB and H grade pencils, the lines are mostly straight, the shapes are regular, and the tones are mostly dark and medium, with a few lighter ones.

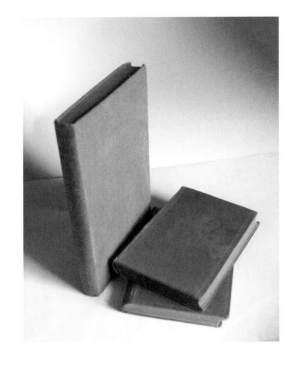

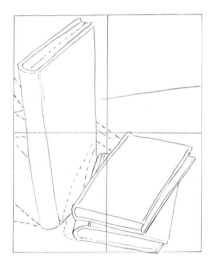

Step 1

Decide how big you'd like to make your drawing and use the H pencil to draw a faint boundary rectangle this size, then divide it into quarters – this will help you estimate the relative proportions of the books. If you're unsure how to start estimating sizes and drawing the shapes in proportion, you can use a ruler or techniques such as the 'rule of thumb' to mark out the rough dimensions. Outline the main shapes of the three books, noting the distortions caused by the viewing perspective. Add faint dotted lines to outline the main areas of shadow.

RULE OF THUMB

To gauge the size of an object, for example its height, hold your pencil at arm's length with the top of the pencil aligned with the top of the object, close one eye, then slide your thumb down the pencil barrel until it is aligned with the bottom of the object. Transfer this length measurement onto your page by making small marks to denote both the pencil top and thumb positions. Repeat this technique to gauge other dimensions such as width and diagonals.

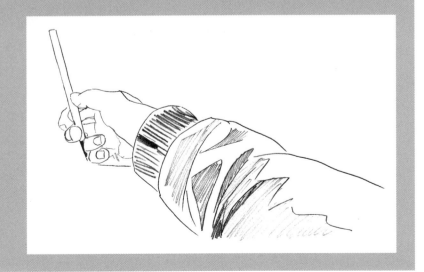

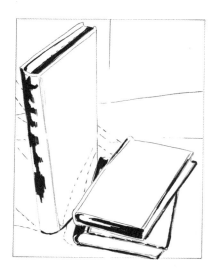

Step 2

Erase any unwanted marks and refine any lines and shapes you think necessary. Then use a blunt HB pencil point to shade the darkest tones in strokes that are in the same direction as the book spines and cover edges.

Step 3

Still using the HB pencil but with lighter pressure on the page, fill in the medium tones in strokes that follow the lines of the vertical book spine, selected page ends and flat book cover, making any adjustments to other areas of tone if needed. Use rough and/or blended shading to create any gradients of dark to medium tones.

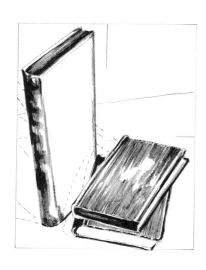

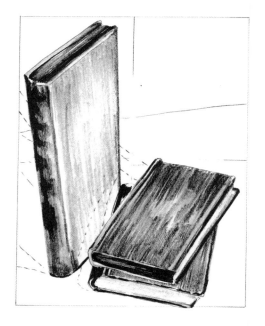

Step 4

Use an H pencil, or an HB and even less pressure, to shade the areas of pale tones, blending with the medium tones on areas such as the cover and page edges. For the larger areas of pale tones on the cover of the vertical book, use a very light touch and several layers of overlapping strokes to create the subtle tonal variations. Use strokes of random lengths to avoid visible 'edges' to the shaded areas where your strokes overlap. Draw a few very fine, darker straight lines to describe the book pages.

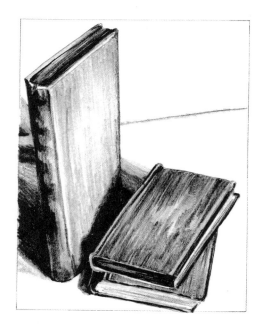

Step 5

Finally, use an HB pencil and blended dark and medium tones to add the areas of dark and medium-toned cast and form shadows.

EXERCISE
Nut and bolt

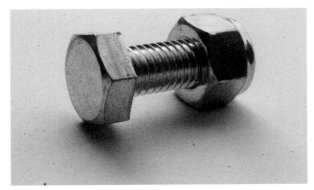

This example of a metal nut and bolt on a plain matte surface is illuminated by natural daylight from behind, and will challenge your ability to draw curved lines and shapes with smooth and uneven shiny surfaces. Notice that it has the same overall hexagonal shape and orientation as the pencil exercise but with two blunt ends and an exposed, striped core in the centre. It's surprising how everyday objects such as this are often overlooked as they can make interesting and unusual studies. Draw this example in HB and H pencils, and notice that some of the shapes have cleaner, sharper edges than others.

Start by making a rough sketch to practise drawing the main shapes, the overall proportions and the angles of the different faces on the nut. Making a rough sketch before you get started on your drawing is a good habit to get into, especially if it is an unfamiliar subject.

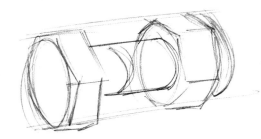

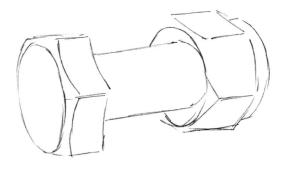

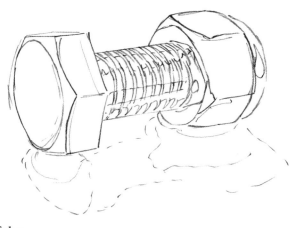

Step 1
As in previous exercises, use an HB pencil to draw faint outlines of the various shapes and shadows, illustrated here in two stages so you can see how the basic shapes have been constructed. If needed, employ the rule of thumb to check that you have the correct proportions.

Step 2

Use an HB pencil with a blunt point to fill in the larger areas of very dark tones that have softer edges, then sharpen your pencil point and take particular care to fill the various precise shapes around the thread of the nut, leaving strips of white (no tone) to denote highlights. If you look closely, you will see a pattern where some of the shapes are repeated along the length of the thread, and this can help you when shading the values. See how quickly you can create a dramatic effect with just two tones.

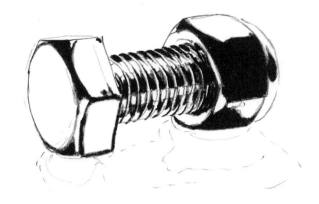

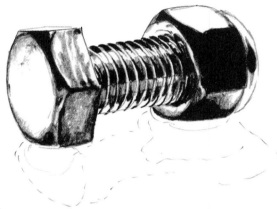

Step 3

Now, fill in the areas of medium tones, refine any lines or shapes as necessary and erase any unwanted marks. It can be difficult sometimes to judge the various tones of objects, so use your tonal strip to guide you and identify which value you need to draw.

Step 4

Add the pale tones with an H grade pencil, leaving the remaining areas white.

Step 5

Finally, after erasing any guidelines so they don't show in the finished piece, add the shadow areas as gradients of blended tones from dark to light, using both HB and H pencils. Ensure the darkest shadows are where both ends of the nut and bolt touch the surface. The palest shadows are those cast by the bolt thread which is above the surface, and the edges of the shadow furthest away from the object. If you like, draw a rough horizontal line just above the nut and bolt to indicate the edge of the surface in the background.

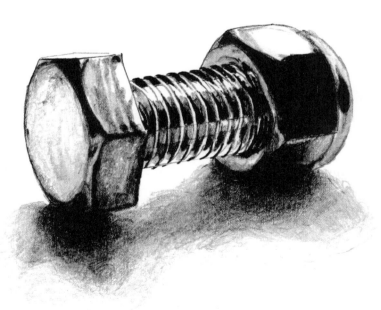

EXERCISE
Banana

This time, we'll draw an organic object with more muted tones and shade all the blended tones in one go from left to right across the picture. This is a similar technique to one you practised earlier where you created a continuous gradient in a strip (see page 20). The banana is illuminated from above by an electric light bulb and has a smooth, matte surface with mostly dark and light values. There are a few medium tones at either end, along the banana skin ridges and in the shadow underneath. If need be, close one eye and/or use your tonal strip to check which values to draw. This exercise requires fine control of the pencil and good hand-eye co-ordination.

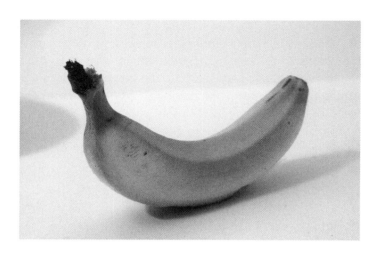

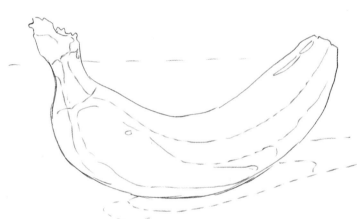

Step 1
Outline the main shapes and different areas of tone and shadow in sufficient detail so that it's easy for you to draw continuously across the various shades without stopping too often.

Step 2
Lightly erase any guidelines so they won't show through your drawing. Using blended shading and an HB pencil with a blunt point, start with the very dark shades on the left-hand side and then use medium tones along a couple of the banana skin ridges. Work from left to right, creating the various tones by simply varying the pencil pressure on the page.

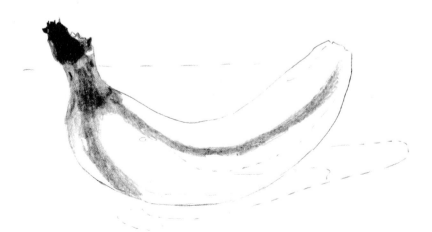

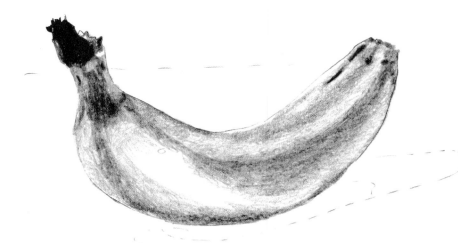

Step 3
Continue to fill in the medium and light shades along the length of the banana.

Step 4
Complete the shading of the banana, adding darker skin blemishes and adjusting any areas of tone as necessary, for example darkening any ridges.

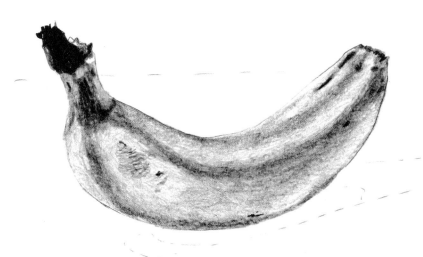

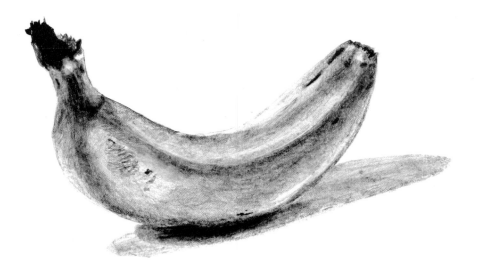

Step 5
Add the shadows underneath the banana and make any final refinements. If you like, use the blender tool to lightly smooth over all the areas of your finished piece.

EXERCISE
Buttons

This deceptively simple exercise requires you to draw the various curved lines and shapes of two buttons, one covered in tweed fabric and the other faux leather. The light source is behind the buttons. Use HB and 3H pencils to describe the patterns of light and shade in these uneven matte-surface textures. If you're wondering where to start with the tweed button, perhaps feeling overwhelmed by the complex texture, think 'shapes' instead, and begin by simply outlining the most obvious ones you see.

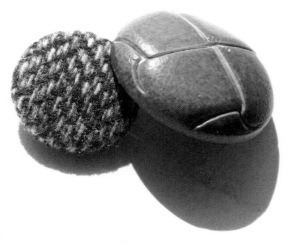

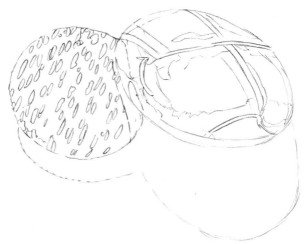

Step 1

Outline the main shapes of both buttons in HB – the key is to achieve the correct proportions with all the elements in the right place – and decide if you would like to outline the darkest or lightest shades first. Although both buttons appear to have regular patterns, you will perceive and interpret them as different objects depending which tone you focus on. I started outlining the darkest values on the tweed button first, which appear as right-angled zigzags, but realized it was easier to outline the palest tones first as these diagonally orientated, elongated shapes of the visible warp threads would act as a better guide to filling in the darker tones later. By comparison, it was easier to outline both dark and light shapes on the faux leather button.

Step 2

Use an HB pencil to carefully add the areas of darkest tones on both buttons. Adding these tones to the tweed button is rather fiddly, but worth the effort! Use your powers of observation to identify the individual dark shapes you are shading – you'll notice that many are triangular (see detail below). You'll probably think at some stage that your drawing will look nothing like it's supposed to, but just keep going because it will come to life as soon as you add other tones.

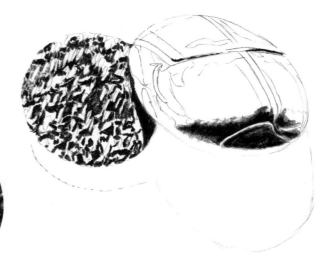

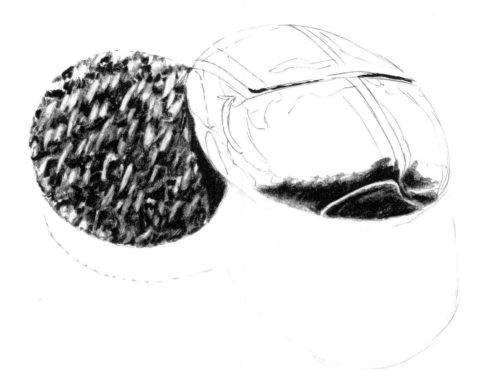

Step 3

Now add the medium tones in HB to just the tweed button, blending with the dark tones where appropriate. Make refinements to any lines or shapes, and erase any areas to create the correct white shapes, if needed. Remember to use a piece of scrap paper to rest upon, to avoid smudging your work as you draw.

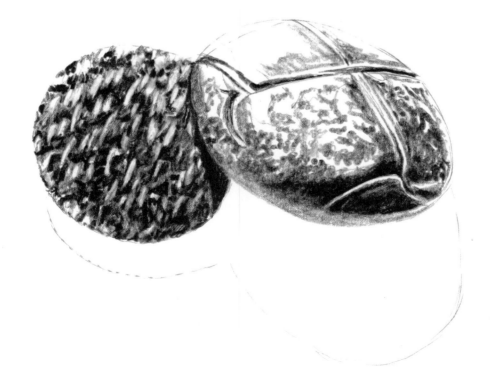

Step 4

Before you begin shading the faux leather button, lighten any outlines around the top of it if you think there is a risk they will be visible in the finished work. Then add the medium tones using both the HB and 3H pencils to create the mottled and blended graduated areas.

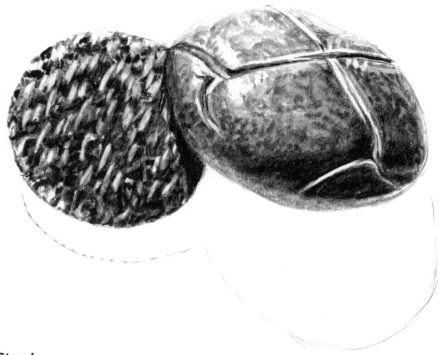

Step 5

Use the 3H pencil to add the palest tones, particularly to the faux leather button, leaving all the brightest areas white. Use your eraser to remove unwanted tones in those areas where you need to define any highlights better.

Step 6

Lastly, add the cast shadows of both buttons and the form shadow on the tweed button, remembering to use very dark tones adjoining the buttons then fading to medium tones towards the edges. Note that the tweed button has a more ragged edge to its shadow to show the uneven surface texture of the tweed.

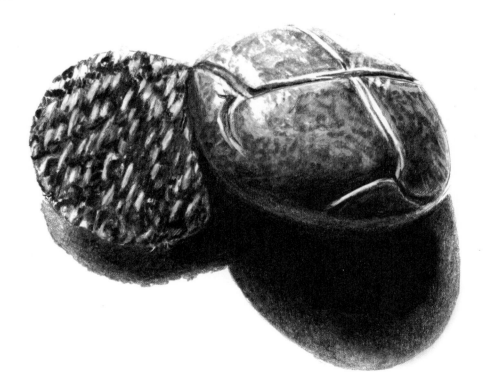

KEY TECHNIQUE: SHADING LARGER AREAS

When you're shading larger areas of even, consistent tone, try to complete each discrete area without stopping partway through because it's usually difficult to draw in exactly the same way when you return to it.

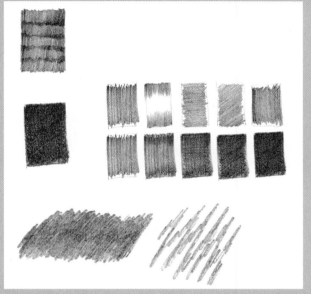

Top row Avoid shading in rows unless this is an effect you would like to achieve, for example, rows of roof tiles and stripy fur.

Middle rows Better results for creating areas of even and consistent tones are achieved by building up individual layers of parallel strokes in different directions. The upper row shows the five layers of strokes used in sequence to create the area of evenly shaded tone and the lower row shows the cumulative effect.

Bottom row Use bigger blended and random strokes to create even coverage. For illustration, an expanded view of the strokes is shown on the right.

TIP When the shading direction, or 'grain', is at right angles to a straight edge, for best results, draw strokes that start at and flick away from that edge.

Summary

After completing all the exercises, you will be quite accomplished at recognizing and drawing various lines, shapes, and shades.

Before we move on to the next stage of drawing more complex scenes containing multiple objects, relax and enjoy drawing some of these elements in a different style.

Experiment and have fun drawing patterns of assorted lines, shapes and shades that you've practised so far. Drawings like these are also called mandalas and can be used as an aid to meditation. In some cultures, the shapes are said to have spiritual attributes and also represent positive elements of the universe and the circle of life.

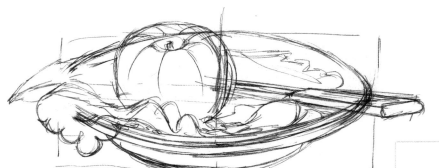

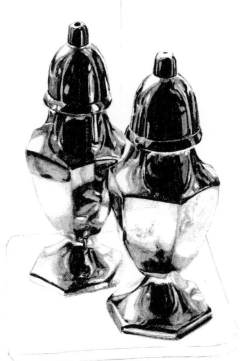

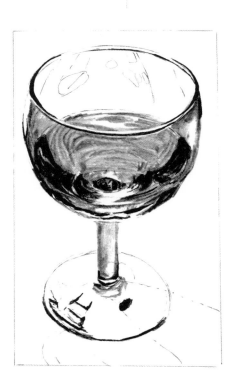

Still Life

In this chapter, you'll need to be a bit more adventurous as we move on from the mostly singular and simpler subjects in Chapter 1 to tackle more challenging exercises. You'll be drawing some different surface textures, but they're still based on the same shiny/matte and smooth/uneven categories, and you'll still be using exactly the same techniques you've already practised. It's just that the lines, shapes, shades and perspectives will appear to be more complex, and the examples will take a little longer to complete.

The term 'still life' describes a work of art that features mostly inanimate objects. Still-life subjects can be natural or man-made, and popular choices include flowers, food, kitchenware and musical instruments. Lighting tends to play an important part in a still-life composition, so the arrangement and balance of objects is carefully considered to highlight their shape or form.

Loaf of bread

Bread is a popular still-life subject and can symbolize many things, including abundance and prosperity. The terms 'earning a crust', 'earning one's bread' and 'having enough dough' are synonymous with money and derive from the 19th century, when bread was the traditional and everyday necessity of life. Bread can also represent sharing, as in breaking apart loaves to feed many mouths.

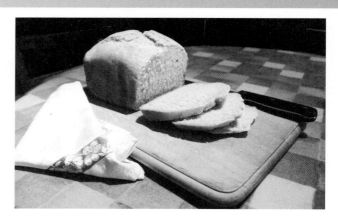

So, have a go at drawing a still life of a roughly shaded loaf of bread. You can either make your own arrangement or reproduce this drawing of a loaf and knife on a breadboard, drawn in HB and H pencils in two-point perspective. The scene is lit from above by an electric light bulb and contains straight and curved lines, a mix of shapes and mostly uneven, matte surface textures. You can choose how large to draw your loaf. This example is 15 x 25 cm (6 x 10 in) and it contains two dark tones, two medium tones and one pale tone.

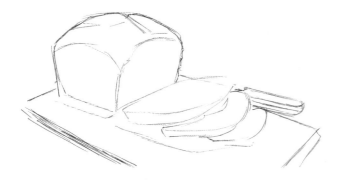

First, draw a rough sketch of the various shapes, using the rule of thumb and/or a rectangular border, if needed, to help you gauge the correct proportions and perspective. Although this loaf will not be a detailed drawing, you do still need proportioned outlines – though it's surprising just how few accurate outlines are needed to distinguish all the features.

Step 1

When you are happy with your sketch, you can make a start on the drawing proper. You can either start afresh on a new piece of paper, using your sketch as a guide, or work directly onto the sketch, erasing any rough lines. Refine the details of your line drawing, adding the irregular edges and surface textures of the loaf and slices, as well as details of the knife and breadboard edge. If you like, use a ruler to draw the straight lines of the board and knife.

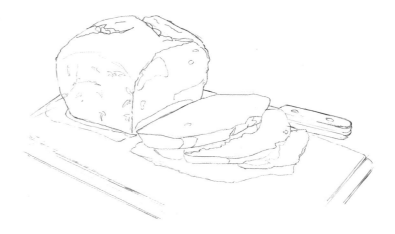

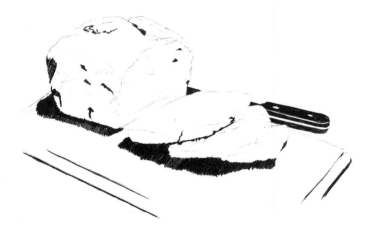

Step 2

Now that you have the overall shapes, lighten the outlines so they won't show in the final work, but leave sufficient detail for you to work from. Use an HB pencil and practise shading the parallel diagonal strokes on a piece of scrap paper first to become familiar with the tones needed, as these bold lines can be difficult to erase. The darkest tones are on the knife and the edges of the loaf, slices, and breadboard. See page 43 for tips on how to shade perpendicular to edges.

Step 3

Still using your HB pencil and the same diagonal strokes, add the medium tones to the sides of the breadboard, the loaf, and slices, using overshading to create the more prominent bread textures, particularly on the side of the loaf. As you draw, make any refinements you think are necessary; I edited the textures on the cut end of the loaf.

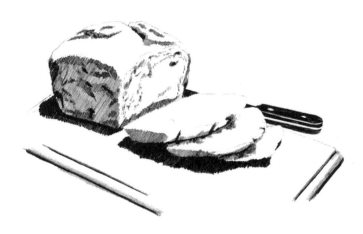

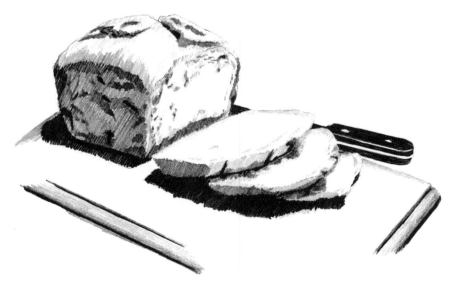

Step 4

Now, add the palest tones to the edges of the breadboard, loaf, and slices, blending tones and overshading again where needed, for example along the edges of the breadboard. Leave the remaining areas white.

OVERSHADING

Sometimes, you may wish to create subtle shading effects with two tones. Rather than laboriously drawing both areas of tones individually, you can create different effects by first drawing the darker tone and then simply overshading with the paler tone.

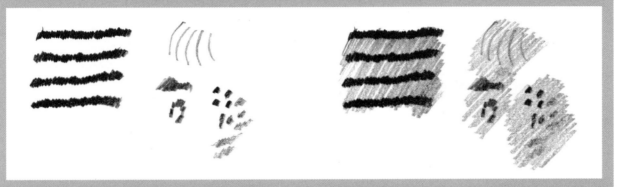

Use existing marks (left) to create new textures (right) by overshading, as your first marks will nearly always show through. This technique is useful for drawing features with two tones, such as rows of roof tiles and the textured surface of bread.

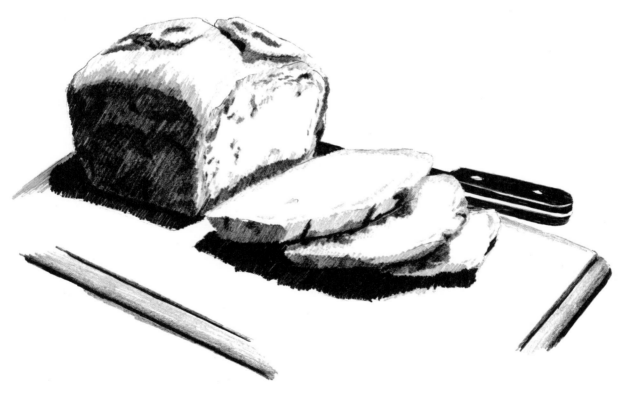

Step 5
Make any final adjustments to your drawing, such as darkening or lightening any tones. I used overshading again to darken the side of the loaf.

Salt and pepper pots

Salt and pepper are two of the world's most important food flavour enhancers and the salt and pepper pots you see here are rather ornate examples of the table condiment dispensers commonly found in many Western cultures. These pots are made from polished metal, which gives their surface a smooth and shiny appearance, and the resulting light reflections help describe their shapes. The pots are standing on a smooth, matte, cork surface and the arrangement is in one-point perspective, illuminated from behind by natural daylight. Notice how the reflective surface gives rise to the sharp contrasts between adjacent areas of light and dark tones, particularly on the left-hand pot.

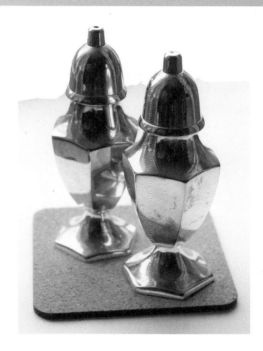

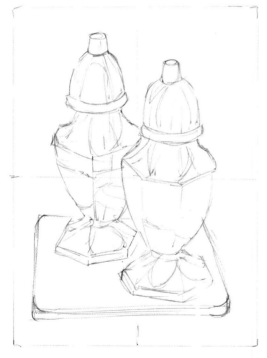

It's a good idea to start by making a rough outline of the arrangement first to become familiar with the correct shapes, proportions and relative positions. Draw a rectangle outline divided into quarters if this helps. Otherwise, if you feel confident, skip to Step 1. The completed size of this drawing is approximately 15 x 10 cm (6 x 4 in).

HOW TO ARRANGE OBJECTS IN A STILL LIFE

Generally, objects are arranged so that they're pleasing to the eye, and this can mean simply experimenting by adding or taking away objects until the arrangement looks 'right'. It helps if some of the objects overlap, and each is clearly identifiable. If items are connected in some way, such as colour, shape or subject, it's helpful to emphasize these connections in the arrangement, for example, by placing them together.

Step 1

Decide how much detail you require so that you can later identify and draw all the different tones – the example shown is quite detailed, but you can choose a simplified approach. Whether you are working from your first outline sketch or from scratch, draw and refine the objects' outlines and the shapes of the main areas of dark and light tones, erasing any unwanted lines, until you are happy with the result.

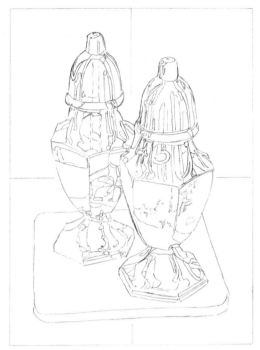

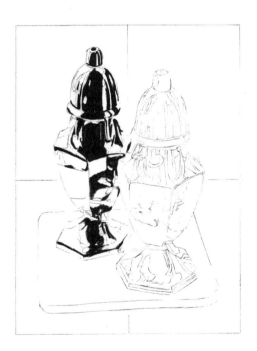

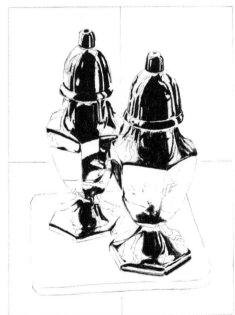

Step 2

Lighten the outlines so they won't show in the final work, then choose from 3B, B, and/or HB pencils to add the darkest tones to the first pot. Note which areas are adjacent to areas of highlights ('white' areas) and so require a sharp outline and fine pencil point, such as the stripes around the tops of the pots. Notice also those areas which fade to medium tones and require a blunter pencil point and graduated tones, such as the pot bases. Remember that you can rotate your pencil to use the sharp or blunt edges of the pencil point to achieve the different effects.

Step 3

Continue to use the same techniques for the second pot (see detail above).

Step 4

Still following your initial outlines, add the areas of
medium tones in HB pencil, blending where appropriate
and, if required, using your tonal strip to gauge how dark or
light to draw.

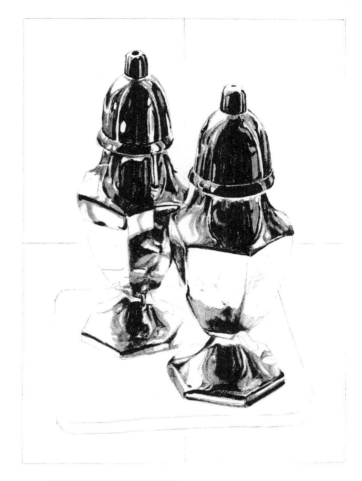

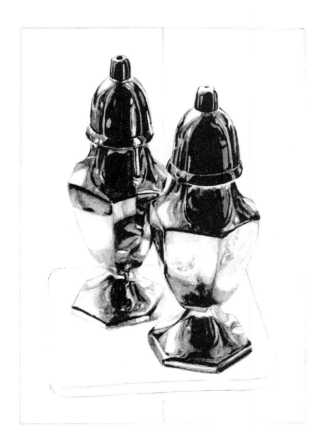

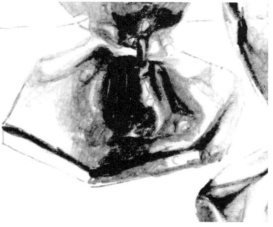

Step 5

Add the pale tones using a 3H pencil and soft, blended
tones. The detail above shows areas of light, medium and
dark tone on the left-hand pot base.

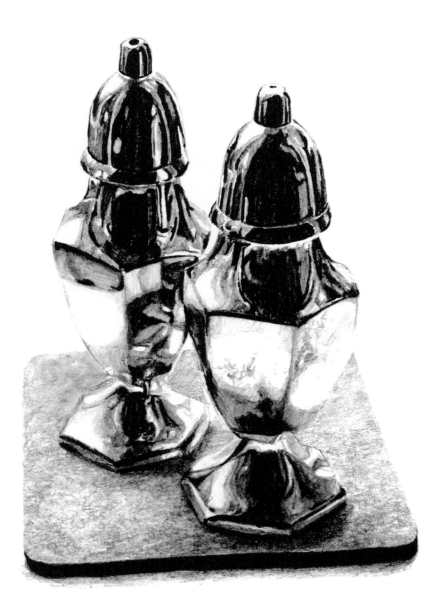

Step 6

Complete the coaster surface in H pencil using a blunt point, a light touch, and blended paler tones. Add the strip of very dark-toned shadow along the coaster edge in the foreground with an HB pencil. Review your work, make any changes and final tweaks, and erase unwanted guidelines. In this example, the coaster was extended to the rear to provide a darker backdrop to the pale sides of the pots, and an eraser sliver was used to emphasize some of the highlights. Although the side of the left pot is white, the viewer is able to understand that it is not part of the background of the same colour.

Wine glass

This glass stands on a smooth, matte, speckled surface and is great practice for drawing curved lines, rounded shapes, and the smooth and reflective surfaces of glass and liquid. It's drawn in H, HB and 3B pencils in a mix of dark, medium, and light tones. Notice how the contrast between the very dark and light tones creates a dramatic and realistic three-dimensional effect.

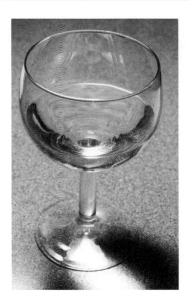

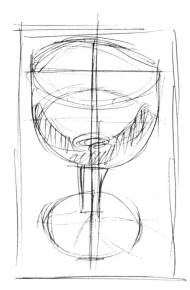

First, make a rough sketch to get a feel for the angle of the glass and the various curved shapes. Ellipses (see page 17) are formed at the rim of the glass and at its base, as well as by the liquid in the central bowl.

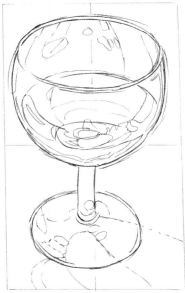

Step 1

Lightly outline your desired drawing area with a rectangle, divide this into quarters and use these as a guide to outline the main shapes and areas of tone of the wine glass.

Step 2

Make any adjustments to lines that you feel are necessary and erase unwanted marks, for example, those bordering areas of white paper or light tones. Use an eraser to lighten any lines so they don't show in the final drawing, and when you are happy with your outlines, use an HB pencil to fill in the areas of dark tone on the wine glass. See page 23 for drawing the white highlights in the dark-toned areas. If you like, leave the areas of shadow on the matte surface until last. If need be, rest your hand on a piece of scrap paper to avoid smudging your work.

Step 3

Use an H pencil and the blending techniques you practised on page 22 to fill in areas of medium and light tones of the wine glass up to the water level, including any tonal gradients. Where appropriate, draw your strokes to follow the lines of any features such as the curve of the water level. Decide how much detail you would like to include and remember that at this stage, the idea is to achieve a good likeness, not absolute perfection, so it doesn't matter if a few lines are not quite right.

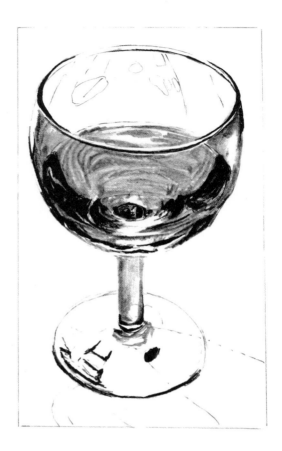

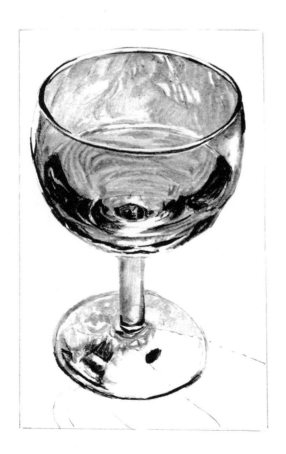

Step 4

Using the H pencil, continue to use blended diagonal strokes to fill in the remaining areas of the wine glass bowl, and then add general blending for the glass base.

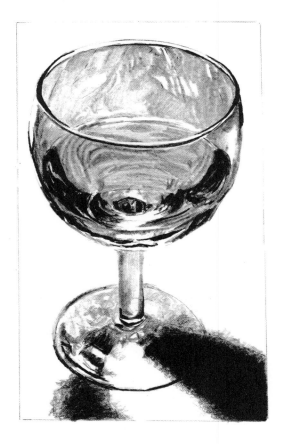

Step 5
Use a 3B pencil or an HB and firm pressure to fill in the two strips of very dark shadow on the surface underneath the wine glass base, using lighter pressure to fade to paler tones at the edges.

Step 6
Complete the shading of the surface the glass is standing on, using H and 3B pencils with a blunted point to draw the mottled tones that fade from light to dark as you move from the bottom to the top of the picture. To create the speckled effect, either use varying pressure of the pencil point on the page, or first create a base layer of paler tones then overdraw the speckles in slightly darker tones. Finally, make any adjustments to your drawing that you feel are needed. I darkened a couple of lines in the bottom of the wine glass bowl and used an eraser to gently lighten some of the areas on the far side of the bowl.

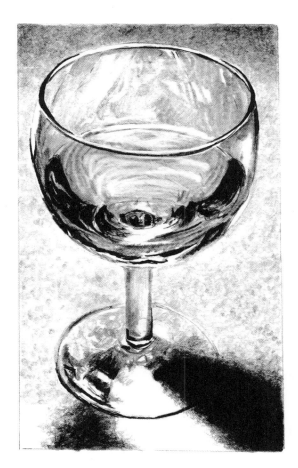

Apple in a bowl

This example of an apple, knife and napkin in a bowl uses several of the techniques you have practised so far and combines different shapes and textures. The arrangement is illuminated by an overhead electric lamp and placed on a raised platform so it can be viewed at almost eye level to reveal part of the bowl underside.

 The first stage is to lay out the complete drawing, and the first four steps have been darkened so that the layout lines show clearly. Then you will fill in the HB tones with blended shading. More steps are included in this exercise to show you in detail the particular way in which this drawing is rendered.

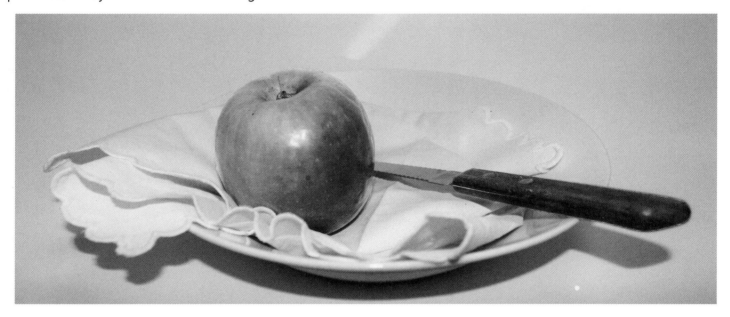

Start by making a quick sketch of the positions and proportions of the objects. Sketch a rectangle around the edge of the still-life arrangement, then divide this rectangle into quarters. Add a horizontal line just above the midline and use this as the mid-point to sketch the symmetrical oval shape of the top of the bowl. Next, add a narrow rim along the bottom edge of the bowl, then the bowl base. Roughly outline the shapes of the apple, knife and napkin in the bowl, erasing a section of the bowl where the napkin folds over the bowl rim.

 Use the rectangle quarters and rule of thumb to help you place your outlines correctly. For the apple, add a stalk and a few curved strokes to describe its rounded shape. Don't worry too much about the perspective of the knife at the moment as this can be adjusted later.

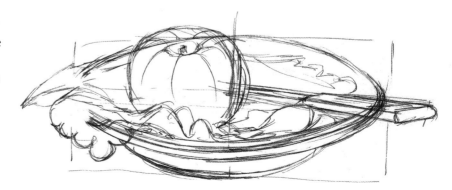

Step 1

When you are satisfied with your layout, start your line drawing on a new piece of paper as I have done here, or work on your sketch, using an eraser to remove unwanted lines and lighten any others so that just the essential details remain. Use light strokes to refine your drawing and draw two lines fairly close together to create a narrow border along the napkin edge.

Next, decide the final position of your vanishing point for the knife and mark this on the left side of the page. I took two attempts before I was happy with the position of the vanishing point and ended up lowering it and redrawing the knife at a different angle. Use the vanishing point to draw the knife handle and blade in perspective (see page 25), using a ruler for the straight lines if needed.

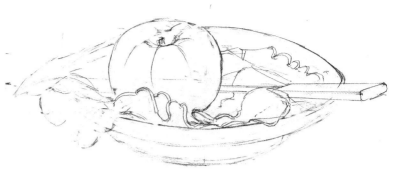

Step 2

Continue to work on your outline drawing until you are happy with the result. For example, adjust the napkin shape a little more by refining the double lines along the scalloped edge, and add further details such as the two studs on the knife handle. Erase any unwanted lines.

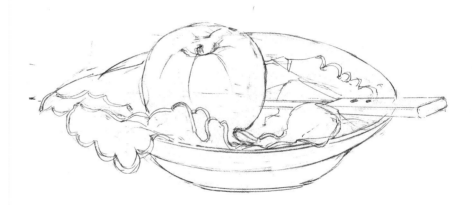

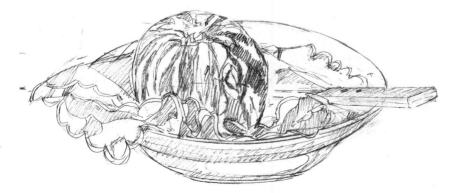

Step 3

Use the HB pencil to outline the main areas of dark, medium and light tones on the various objects. You can leave the far side of the bowl blank because there is little tonal variation here. You could also use a harder pencil lead, such as a 2H, to create the light strokes if you wish, but take care not to press so hard that you indent the paper surface.

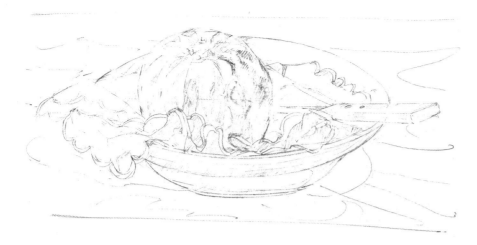

Step 4
Use an eraser to lighten the layout lines so that they don't show through on the final drawing, especially in areas of paler tones. Then add a few simple lines to denote areas of light and shade on the table surface.

Step 5
Use an HB pencil with a blunt point to draw horizontal strokes to shade in the background table surface.

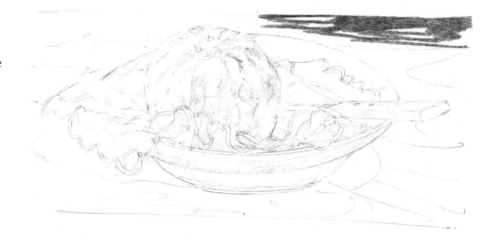

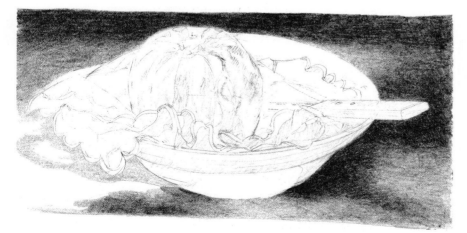

Step 6
Slowly blend and build up the shading of the table surface to create areas of even tone. See the box opposite for tips on how to shade around objects in even tones.

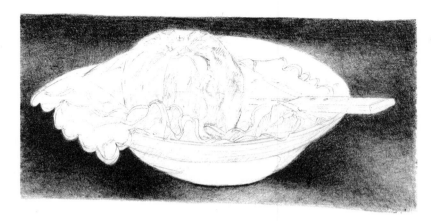

Step 7
Complete the background shading. Continue to use swirl strokes with either an HB pencil with a blunted point and varied pressure, or a combination of HB and 3H pencils to create the different tones of the light and shadowed areas of the table surface. I decided to use a dark background to create a contrast with the white bowl and napkin for a more dramatic effect.

Step 8
Once you have completed the background area, begin to add soft, light, blended tones to the edges of the napkin.

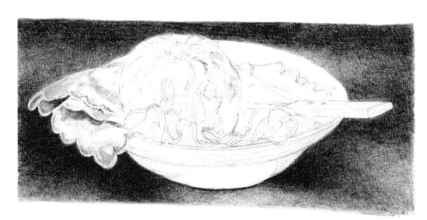

TIP To avoid smudging your work, rest your drawing hand on a piece of clean scrap paper.

BACKGROUND SHADING TECHNIQUE

Use a smooth, blunt pencil point and soft, horizontal strokes to draw the surface tones, fading the strokes at each end so that there is no abrupt edge to the end of each line. Use a light touch on the pencil point and pale tones to swirl along the edge of the rounded object.

Add more soft, horizontal strokes to the background surface as before, leaving gaps between some of the strokes.

Add more horizontal and swirl strokes to fill in the gaps between the lines and use increased pressure on the pencil point to create darker tones.

Use a mixture of long and short soft zigzag lines and swirl strokes to extend the shaded area outwards and away from the edge of the rounded object.

Finally, turn the page through 90 degrees to add strokes in a different direction, using more layers of darker swirl strokes to gradually complete the coverage of the area in an even tone.

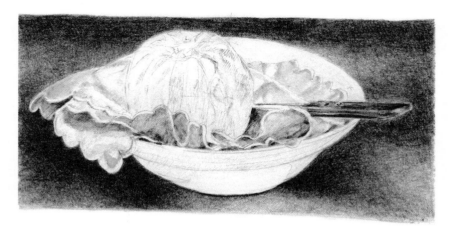

Step 9

Observe the areas of light and shadow on the napkin and then add the appropriate light, medium and dark tones to the napkin folds using swirl strokes, remembering to leave white strips along the napkin edges (see detail below left). Complete the shading of the napkin.

Use straight light and dark strokes to complete the wood and metal textures of the knife handle and blade (see detail below right). Only two lines are needed for the knife blade.

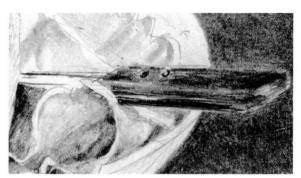

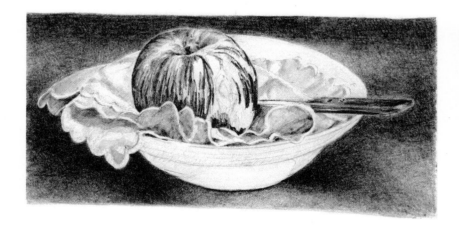

Step 10

Begin to shade the apple. Use short, dark strokes for the little vertical stalk and deep shadows. Use blended tones for the areas around the top of the apple on the side furthest away from you. For the apple skin texture, use curved dark and medium-dark strokes to define the apple shape, leaving gaps between some of the strokes.

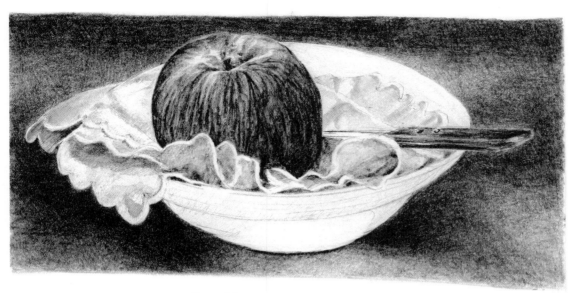

Step 11
Continue to shade the whole apple, leaving an area of highlight on the top left-hand side. Next, use a harder pencil (I used a 5H) to gently overshade all over the apple, then use the side of the HB pencil point to add darker-toned shadows on the right-hand side and base.

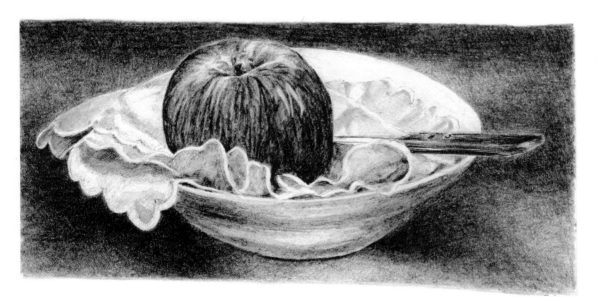

Step 12
Use an HB pencil with a blunt point, varied pressure, and soft, curved strokes in light, medium and dark tones to add the ceramic textures to the base of the bowl.
 Finally, check your work and add any extra touches you feel are needed.

Flowers

Flowers are a popular choice for a still-life arrangement, though the infinite variety of shapes, sizes, and tones can make them challenging to draw.

This arrangement in a ceramic jug is illuminated by natural sunlight and contains roses, tulips and foliage. It consists of mostly curved lines and shapes and the surface textures include smooth and shiny (jug) and smooth and matte (petals and foliage). The original drawing is 14 x 17 cm (5½ x 6¾ in).

It is a fairly detailed drawing, so it is explained in several steps. As always, you are free to choose your preferred grade of drawing pencils, though I recommend a 3H and/or a 5H for the soft petals because their pale tones require a delicate touch. You will need to add all the different tones at the same time as you work across this drawing, rather than adding each dark, medium and light tone in turn.

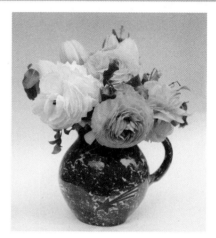

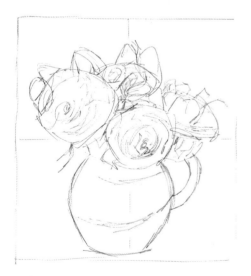

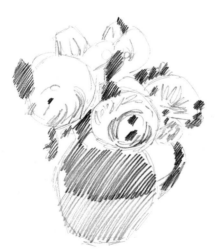

By way of preparation for your drawing you may wish to make a rough outline sketch to become familiar with the subject and to gauge the relative sizes and proportions of the various elements. Making a rough tonal sketch to identify the main shades and areas of shadows and highlights would also be useful. This is where your tonal strip (see page 21) can help you translate the colours of the flowers and foliage into the main dark and medium tones for your drawing.

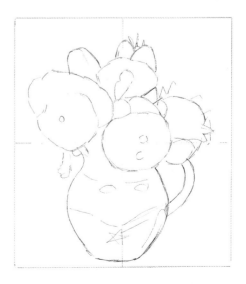

Step 1

As accurately as you can, draw the outlines of the main shapes of the flowers and jug to ensure you have the correct layout and proportions. Use the rule of thumb and/or a rectangle divided into quarters to help you do this if needed. You will see that most of the lines are curved, and the shapes are circular and oval. Bear in mind that this drawing contains a lot of medium and pale tones, so your guidelines will need to be quite faint so that they won't show through in the final work.

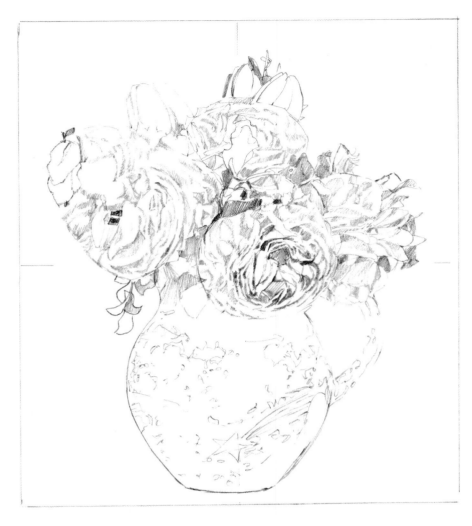

Step 2

Once you are happy with your main outlines, add the remaining shapes of the arrangement in much greater detail, either as lines or areas of pale tone, as shown in the extract. You may find it easier to focus on the shapes and areas of tones rather than try to draw every outline of the individual petals and leaves.

It's also helpful to identify areas of very dark tone and to add these areas at this stage as this will help you to navigate around the drawing later. Judge for yourself how much detail you'll need in order to be able to shade all the different tones later. If you get stuck, simply remember to draw what you see, not what you think you see. The more time you spend at this stage, carefully outlining the shapes, the better your final drawing will be.

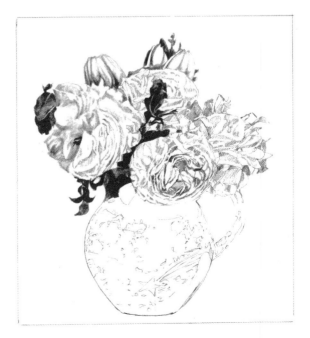

Step 3

Begin to fill in all the dark, medium and light tones of the flowers and foliage, gradually working your way around the drawing. I am right-handed, so I started at the top left with the tulips, dark-toned foliage, and the left-hand side of the largest rose. To protect your work, rest your drawing hand on a piece of scrap paper as this will avoid any unwanted smudging. Use an HB or 3B for the darkest tones and an H and 3H for the palest.

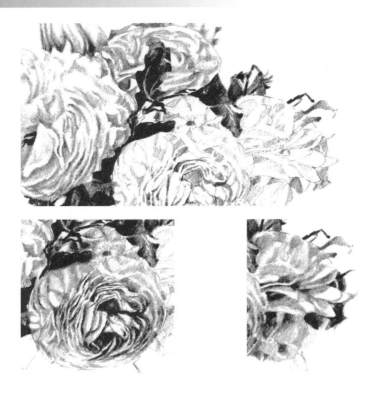

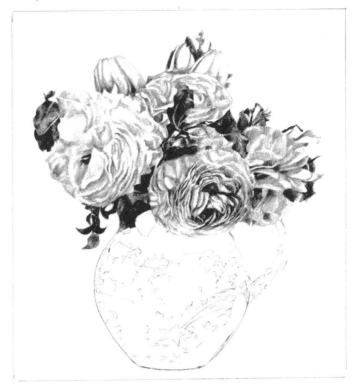

Step 4
Continue to fill in all the tones of the arrangement, completing each flower in turn. Above, three images show the process of adding tone to the flowers.

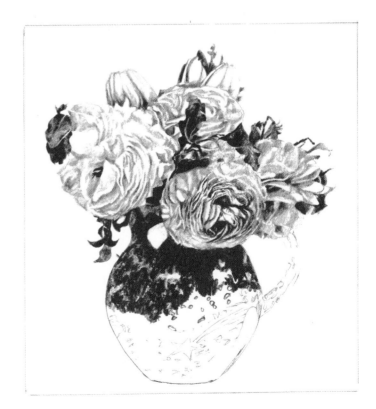

Step 5
Use HB and 3B pencils to fill in the medium and dark tones at the top of the jug.

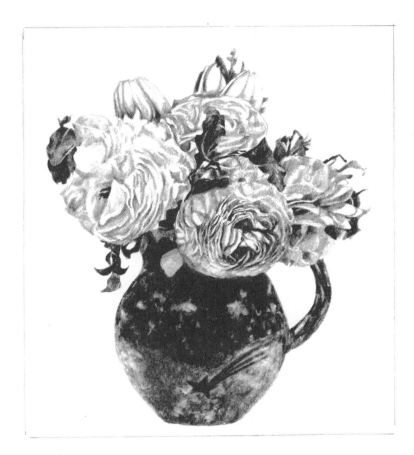

Step 6
Shade the lower part of the jug with medium and medium-dark tones.

OUTLINE TONAL AREAS

When shading areas that contain flecks of a lighter tone amid a darker-toned background, it's often easier to outline or shade the paler-toned areas first using a 3H or 5H pencil, then draw around these blending to the darker tone, rather than draw all the dark tones first and erase the lighter-toned areas later. See also page 23 with regard to creating the 'white bits' or, in this case, 'medium' bits.

Step 7

Review your work and edit any areas of tone as required. Here, darker tones were added to the undersides of the three roses at the bottom of the arrangement.

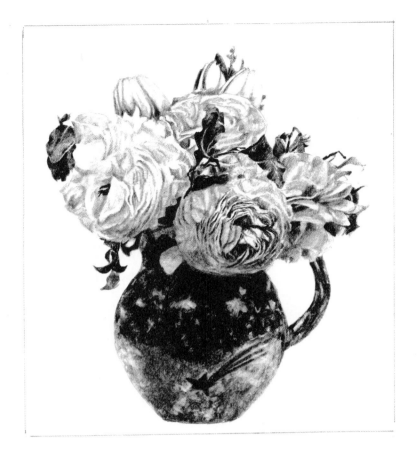

Step 8

Add shadows at the base of the jug and continue to review your work – for example, adding highlights to the upper parts of all four roses using a sliver of eraser.

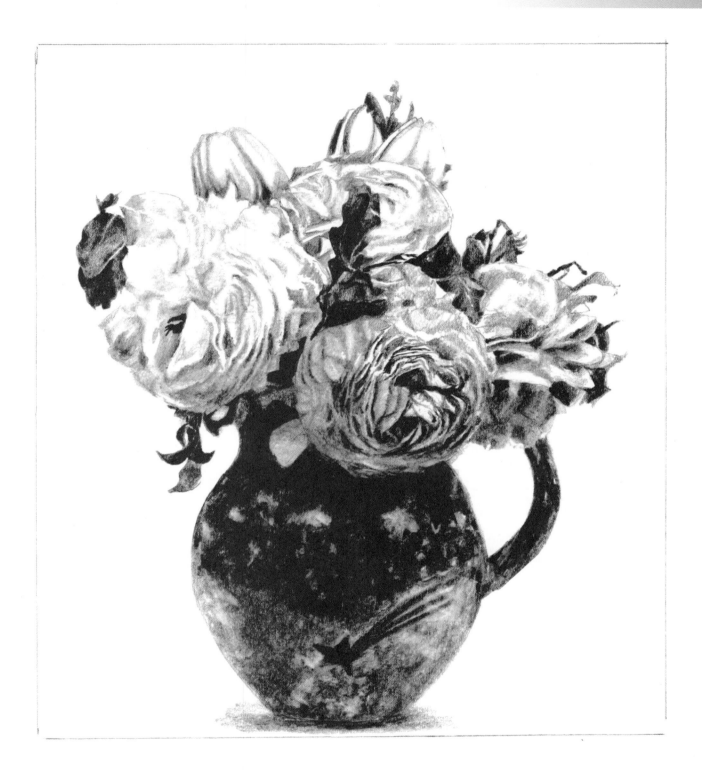

Step 9
Make any final adjustments to your drawing. I added much darker
tones to the strips of shadowed areas of all four roses, enhancing the
three-dimensional effect, and to the handle and upper part of the jug.

Drawing at Home

This chapter will guide you through drawing a variety of subjects you may find at home, still employing the same techniques for drawing lines, shapes, and shades as before except that there is increasing complexity. Now you will also need to consider multiple elements, different lighting conditions and perspectives, and how to convert what you see in these more detailed scenes into monochrome shades on your page.

To help you select a scene to draw, a simple technique is to hold your hands up to your eyes to frame a particular viewpoint. By doing this, you can quickly see which views could potentially make a good subject. When you select simple items to draw, try imaginative viewing angles that can add interest to your composition.

Chest of drawers

This box-shaped chest of drawers has mostly straight lines except for the curves at the top and bottom corners, on the handles and on the wood-turned feet. It is viewed in two-point perspective and lit by natural daylight through an opening on the left, with dark cast shadows underneath. The assorted rectangular items on top include books and some photographs in wood and metal frames. There is also an oval wood-framed mirror hanging on the wall above. Most of the surfaces are smooth and matte (the front of the chest of drawers, the items on top of it, the walls and the floor), while two areas are smooth and shiny – the mirror glass, and the side of the chest of drawers.

The aims of this particular exercise are to use a limited range of tones in rough, graduated shading to create a reasonable representation rather than a precise likeness; then to review your work and, if necessary, apply corrections to achieve the desired tones.

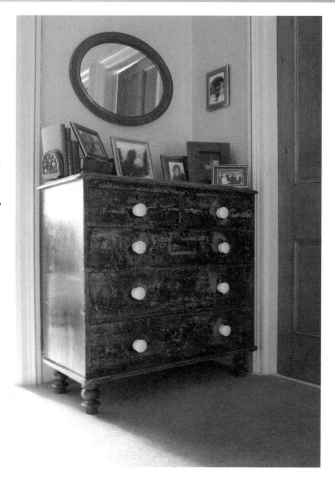

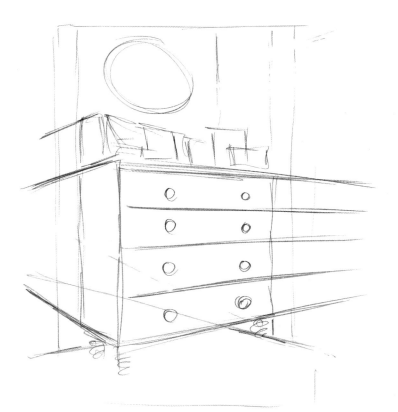

First, draw a rough sketch to familiarize yourself with the subject, gauging the dimensions of all the elements and identifying the lines of perspective by looking for those linear features that are normally horizontal. In this example, the linear features are the floor level and the tops and bottoms of the drawers and side panel. Then, draw the lines of perspective, shown here as extending out from both sides of the chest of drawers. As described in the section on perspective (see page 25), these lines will enable you to draw all the elements correctly.

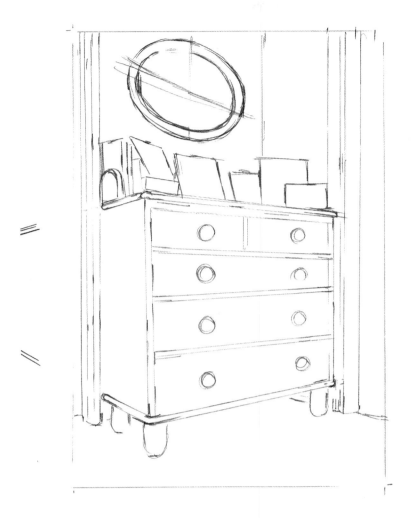

Step 1

Decide how large you would like to draw your chest of drawers, then outline these dimensions as a rectangle on your page in faint lines. Next, establish the correct proportions of the main elements and outline these shapes as accurately as you can. On each side of the page and outside the rectangle, mark the positions of the two vanishing points, based on your previously identified lines of perspective. If required, use a ruler to draw any straight lines such as the overall shape of the dresser and the wall verticals. When drawing the oval mirror, you may find it helpful to draw it in two halves, using a midline to create your symmetrical ellipse shape. Establishing the correct proportions throughout the drawing is key if you are looking for realism.

The actual colours of the items in this chest of drawers scene are brown, shades of pale orange, pale yellow-green, and red-orange. Using the monochrome and tonal strips on page 23 as a guide, these colours translate into the following tones for use in this exercise: dark, light, and the three medium tones.

Step 2

Refine the outlines so that you have sufficient detail to add all the tones, then erase any unwanted marks to leave clean guidelines for shading. Don't forget that you can be selective about the elements to draw in a scene, including or excluding items as you please.

Step 3

Add the dark tones around the wall mirror, parts of the picture frames, drawer edges and keyholes, and dresser feet. The darker-toned, imperfect lines around the drawers emphasize the uniqueness and hand-made qualities of this dresser. Decide if you need to make any adjustments – for example, I refined the shapes of the white drawer knobs.

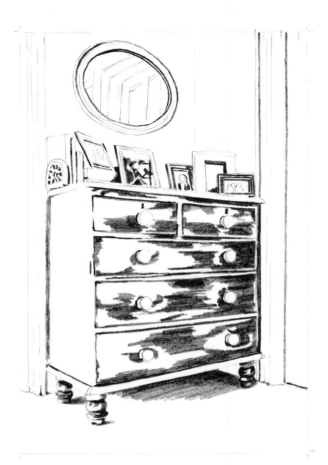

Step 4

Now add the various medium-dark tones in HB pencil to describe the oval wall mirror's moulded frame, the shadows under the dresser, and various patches on the drawer fronts and divider frames using strokes that follow the woodgrain, which is horizontal on the drawer fronts and vertical on the dresser corners. The variations in tone on the drawer front reflect years of use which have worn away patches of the darker varnish to reveal paler wood tones beneath. When shading at right angles to the drawer edges, refer back to the tip on page 43 for guidance.

Step 5

Continue to use an HB pencil to shade the medium and medium-light blended tones of the drawer fronts, the shadows on the carpet, and reflections in the mirror.

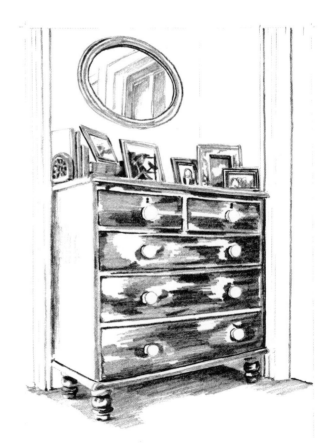

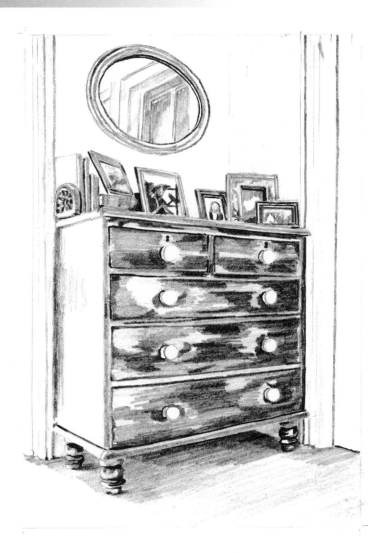

Step 6
Use a 3H pencil to add the very pale tones of the walls and foreground carpet, referring to the guide for shading larger areas on page 43 if needed.

QUICK METHOD TO REVIEW YOUR WORK

Hold your work up in front of a mirror and you'll be surprised how much easier it is to check your shading and spot any errors from this viewpoint. Another way is to take a photograph of your work and view it on screen.

Step 7 (facing page)
Now, review your progress and make any adjustments you feel are necessary. Remember, it's inevitable that things won't always go to plan with your work, and you may need to re-do some aspects of your drawing – but don't worry, this is a natural part of the drawing process, and it actually helps you to learn. The beauty of pencil is that it's not permanent and mistakes can be easily erased and remedied! Reviewing your work as you draw is a good habit to adopt.

In this instance, my own review revealed that the tones of the oval mirror, drawer fronts, and carpet shadows were not as dark as I would like. So, the way to remedy this was to check that all these areas were first shaded with a 3H pencil, then overshaded and darkened with an HB pencil. I used strokes in the opposite direction to those already there – for example, I added vertical strokes to the horizontally shaded drawer fronts. I emphasized the lines of perspective along the drawer divider strips using a ruler, and you may wish to do this too.

The review also showed me that the door on the right-hand side had been overlooked, so I shaded this in medium tones with strokes following the direction of the vertical wood grain.

You will notice that the combination of darker foreground carpet and paler background walls also gives the appearance of aerial perspective, enhancing the effect of depth in the drawing.

Finally, remove any unwanted marks and the drawing is finished.

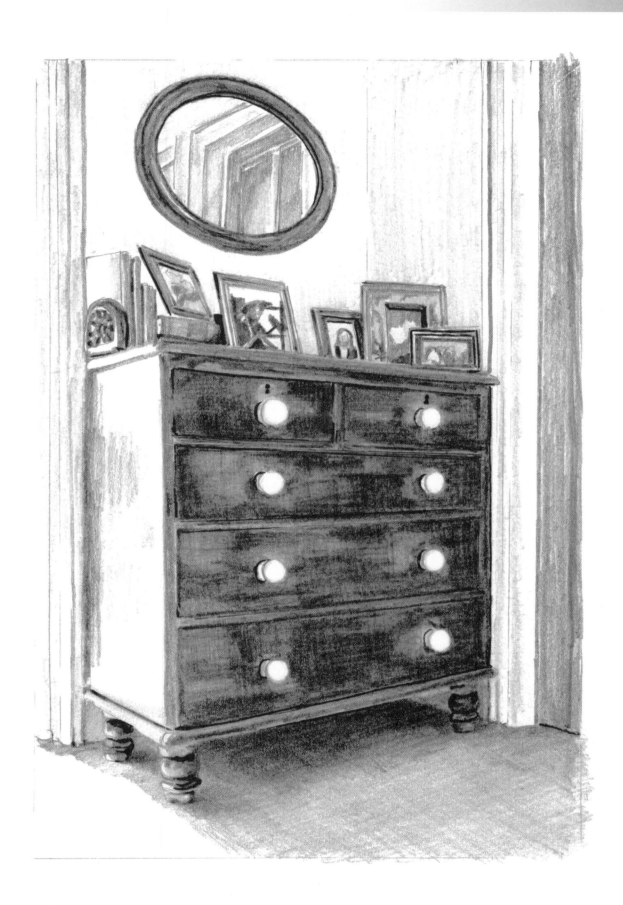

Armchair

This more detailed drawing requires you to complete each element in turn in a mix of tones, rather than draw tone-by-tone across the picture. The chair is viewed from below eye level looking towards a front corner, thus creating a two-point linear perspective. The scene is illuminated from the left-hand side by natural daylight and is drawn using HB, H, 3H, and 5H pencils.

The chair has a solid wood frame and, for additional interest, two cushions and four soft toys of mixed surface textures and shapes. As well as the shiny and matte smooth surface of the chair frame, the more complex textures include the velvety chair fabric, cotton cushion covers, the fleece-covered teddy bear and mole, and the knitted kangaroo and cat (matte, uneven textures). There are straight and curved lines, a few rectangle shapes in the chair frame, and many irregular shapes in the soft toys, cushions, and the chair seat and back.

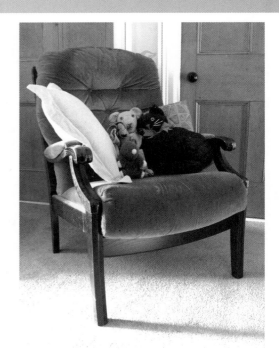

First draw a rough sketch to assess the relative size and proportions of all the main elements including the lines, shapes and areas of tone. Use the (normally horizontal) lines of the chair frame to determine the lines of perspective, shown here as extending from each side of the chair, and mark these on the edge of your page. Although both vanishing points (VPs) are off the page, you can still use the marks to estimate the VPs and perspective. If you'd like to be very precise about finding and marking a VP, then temporarily affix another sheet of paper to extend the width of your drawing page, plot the VP on this extra piece of paper, and use it to set out your drawing in the correct perspective.

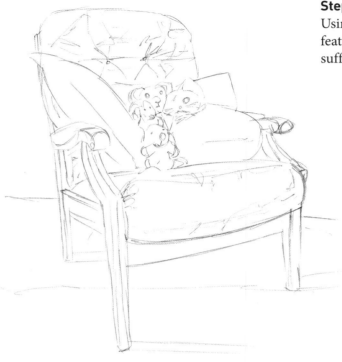

Step 1
Using faint lines, carefully outline the main shapes and features in their correct size and perspective so there is sufficient detail for you to fill in the tones next.

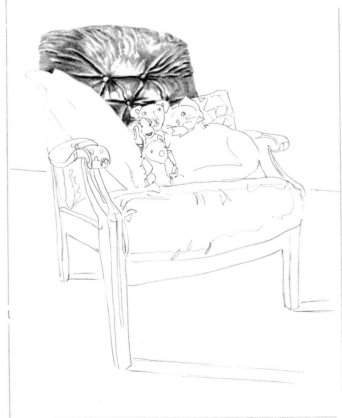

Step 2
Lighten any guidelines and refine details, if required, then use an HB pencil and blended shading to add the soft tones on the chair back. Create instant three-dimensional effects with the fabric folds by leaving white strips (highlights) adjacent to the very dark-toned strips (deep shadows). Next, add strips of graduated tones from light to dark in between. Leave some areas blank to be filled in with a 5H pencil later.

Step 3

Fill in the dark, medium and light tones of the chair frame on the left side using HB and H pencils, leaving blank strips to denote highlights between the seat cushion and frame, and down both legs. Shade in the direction of the grain, then use 5H for shading the seat cushion edge. Create the puckered appearance of the seat back where it joins the frame under the chair arm by shading a scalloped edge in a very dark tone. When shading the arm itself, simply look for and shade the shapes of each tonal area rather than working out the exact construction details. Take care when shading at right angles to the leg edges and where the medium and light tones meet along the seat frame.

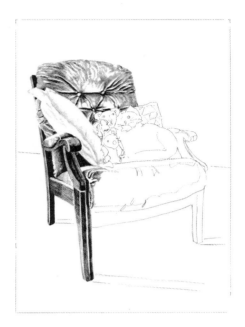

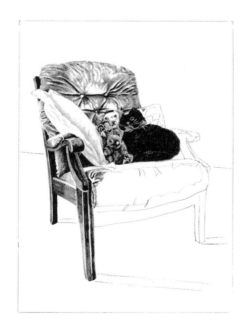

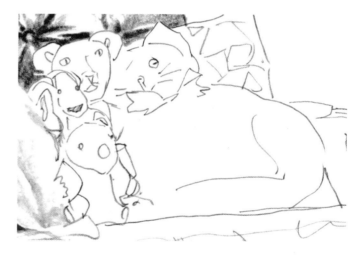

Step 4

Now complete the soft toys using the following pencils: teddy 3H; mole HB and H; kangaroo and cat HB. Blend where appropriate to achieve the various soft- and hard-edge effects. For the cat's whiskers, see the guidelines about drawing 'white bits' on page 23. Notice how you need only a few simple shaded shapes to draw the teddy's head and face. The details on the right show the toys before shading (top) and after shading (bottom).

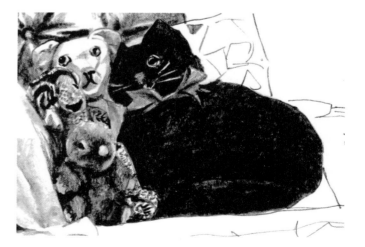

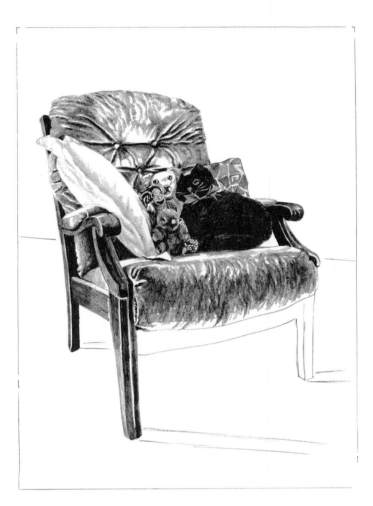

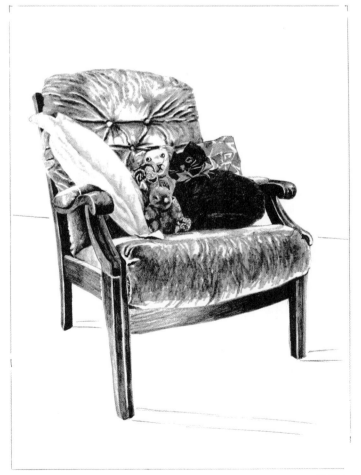

Step 5
Shade in the chair seat and right-hand arm rest in the same way you shaded the seat back and left arm rest. Leave the lower edge of the seat cushion at the front blank. Use an H pencil to fill the darker pattern elements of the scatter cushion behind the cat, then overshade in 5H.

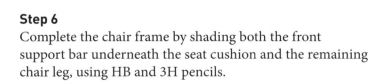

Step 6
Complete the chair frame by shading both the front support bar underneath the seat cushion and the remaining chair leg, using HB and 3H pencils.

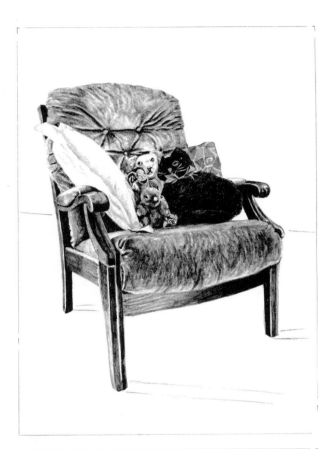

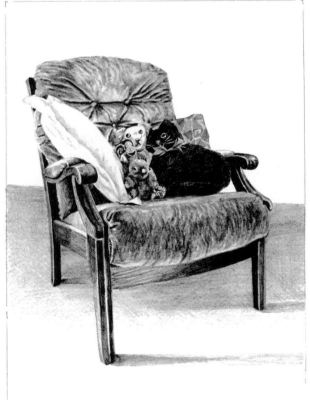

Step 7
Overshade the chair seat cushion with a 5H pencil, blending to create softened edges between the dark- and light-toned areas.

Step 8
Add the chair leg shadows in soft HB pencil so they fade from medium to light tones towards the shadow edges and along their length as they extend away from the chair. Check that the shadows are parallel.

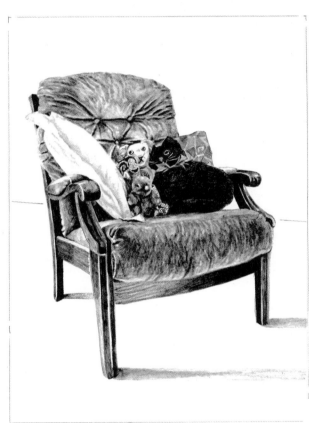

Step 9
Add the carpet, using layers of even shading. First, use an H pencil and horizontal strokes to shade the carpet behind the chair in medium tones, fading to paler tones in the foreground using a 5H pencil. Then, overshade three more layers using strokes in different directions. As the initial strokes were horizontal, use vertical strokes next, and then diagonal strokes for the subsequent layers. Finally, overshade the carpet using the flat of an HB pencil lead (see page 43 for shading large areas).

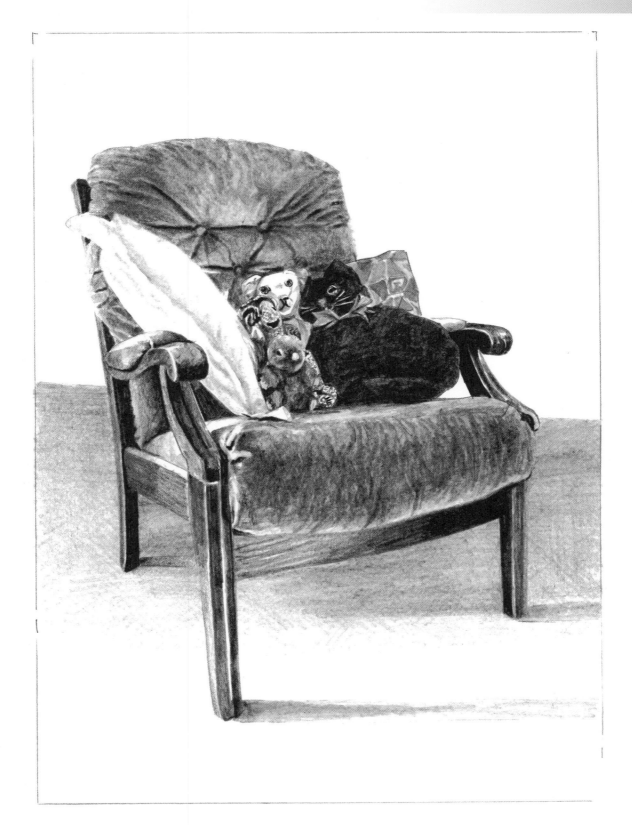

Step 10
Complete the armchair by overshading the seat back in 5H pencil and make any final adjustments you think are necessary.

Kitchen scene

In this exercise you will draw a 20th-century country cottage kitchen with a window view overlooking the garden. By now, you will be familiar with drawing different shapes in multiple tones, so here is a pleasing mix to test your drawing skills. Refer to previous exercises if you need to refresh your memory about any of the techniques.

First, roughly sketch the kitchen scene to become familiar with the main elements, using the rule of thumb to gauge proportions. Next, identify the two vanishing points (VPs) which will help you to draw an authentic scene.

Kitchen perspective – finding the vanishing points

In your rough sketch, draw dotted lines from the main elements in the scene that have horizontal lines in reality (ceiling, floor, windowsill, appliance and kitchen unit worktops). The vanishing points are where the dotted lines intersect. The first VP (VP1) is located within the bottom right windowpane, shown here as a black dot within the circled area.

The first VP is easier to find because you can see that the cooker top is wider in the foreground and appears to get narrower as it recedes into the background. Also, the lines of the tops of the walls on either side appear to be diagonal. Don't worry too much if all the diagonal dotted lines don't meet exactly as this is a rough sketch. Just choose the point where most lines intersect, name this as your vanishing point, and use it as your guide to draw your scene in perspective.

The second VP is more difficult to find because, at first glance, the items appear to be distorted in only one direction, that is, towards VP1. However, if you look more closely at the ceiling above the window, it appears to slope downwards to the left, as does the window frame. Although the lines of the front and back of the sink and cooker sides appear to be more horizontal, the floor line slopes upwards to the left where it meets the sink unit. If you draw more dotted lines of perspective from these items, you can see that they do not converge on the page, indicating that VP2 is some distance away. In this instance, you will have to imagine the position of VP2 based on the perspective lines and outline your scene accordingly.

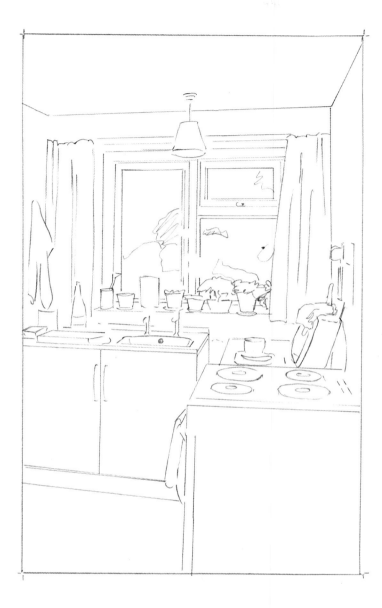

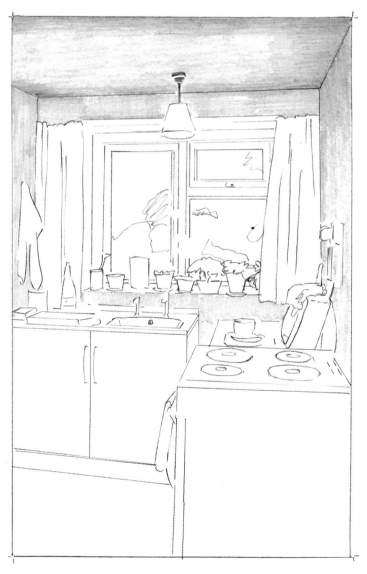

Step 1
Use the information from your rough sketch to help you carefully outline the main shapes and lines in perspective.

Step 2
Use 3H and 5H pencils to shade the ceiling and walls in pale, even tones.

Step 3

Darken the small section of wall above the window, as well as lines where the walls meet the ceiling. Adding greater contrast with the tones like this helps to create more depth in the scene.

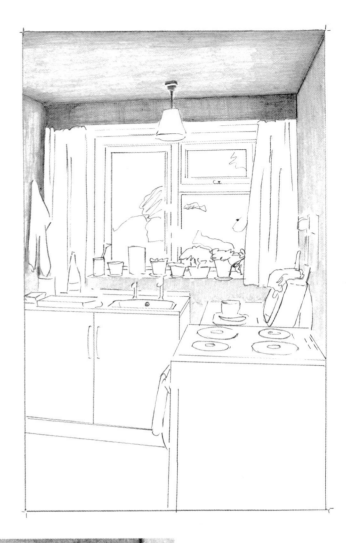

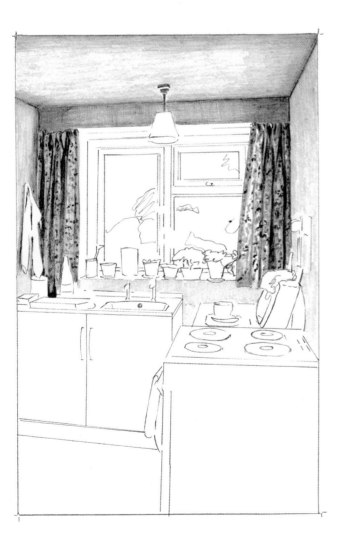

Step 4

Add the floral-patterned curtains in 5H and HB and use near-vertical strips of blended dark and light tones to create the effect of softly folded fabric.

Step 5

Use 3H and 5H pencils to complete the window frame, adding thin strips of HB on a few edges for the dark window seals. Leave strips of white to describe the highlighted edges of the window frame. Create the illusion of the out-of-focus garden plants seen through the window by using 5H, H and HB in soft tones and assorted irregular shapes. Use HB and graduated tones to draw the circular pots, potted plants, roll of kitchen towel, and glass jar with a brush on the windowsill, using a few strings of elliptical shapes to suggest the leafy stems of the houseplants. Leave the windowsill surface blank to denote the highly reflective surface.

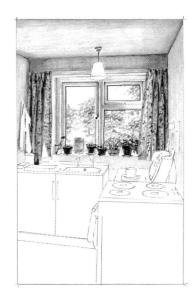

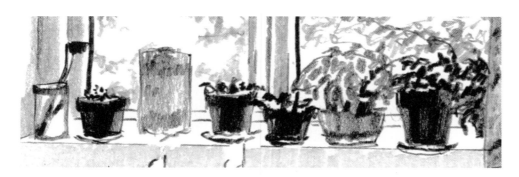

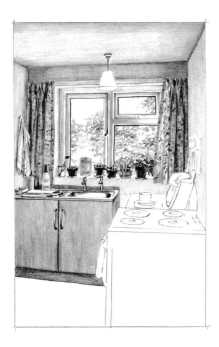

Step 6

Add the kitchen sink unit, bottle, plastic jug, and tea towel in HB tones, leaving the sink's highlighted areas and clipboard paper white. As with the curtains, use vertical stripes of different blended tones to help describe the tea towel fabric folds, as well as a few wavy lines along the bottom edge.

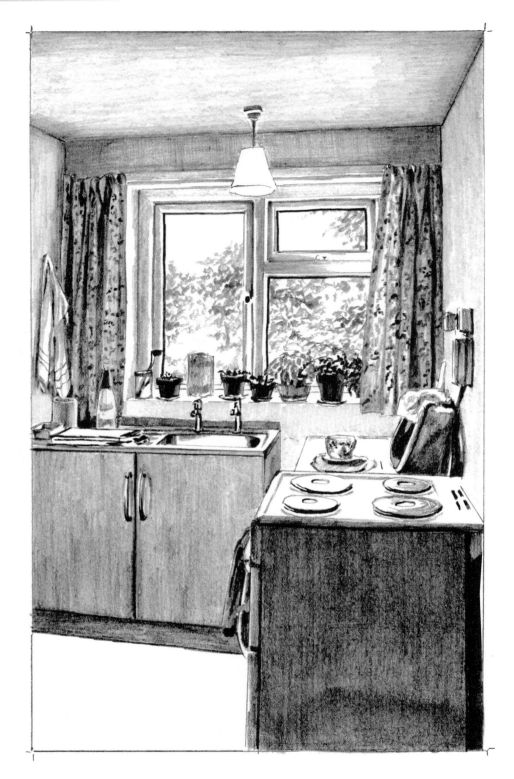

Step 7
Draw the cooker with the tea towel on the front rail, the wall socket and adjacent worktop with cup and saucer, and plastic washing-up bowl in shades of HB, leaving the highlighted areas blank. Use vertical strokes to shade in the cooker side panel.

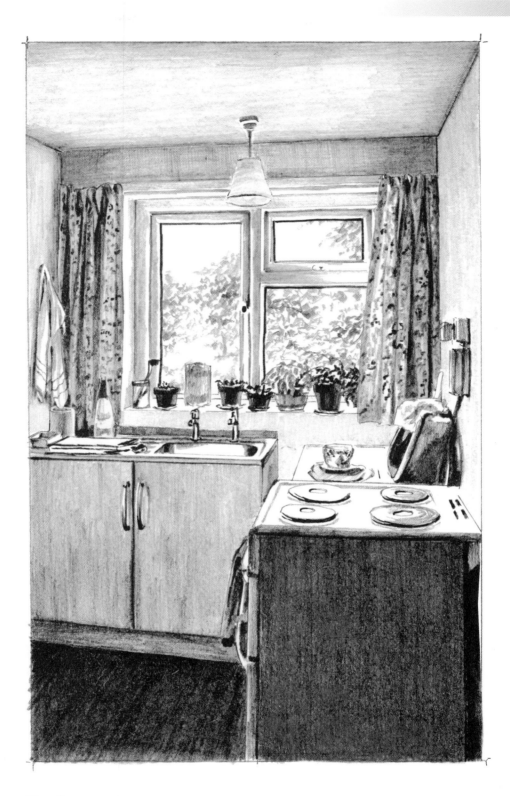

Step 8

Still using the HB pencil, complete the floor in very dark strokes in the direction of the line of perspective. Use H to add the pale tones of the ceiling lampshade, leaving the visible tip of the light bulb blank. Finally, review your work and adjust as appropriate. At this stage, I darkened the areas of shadow on the sides of the cooker panel and bowl to give more even tones.

View through a doorway

Now, you'll draw the view through the doorway of a 17th-century sandstone barn that looks out onto a small grass paddock bounded by a wooden fence, a stable block and trees. The scene is viewed in one-point perspective and from below eye level, so the unusual angles of the stable doors add extra interest. You'll complete each element of the drawing in turn, starting from the background and working towards the foreground.

The pencils used are 3H and HB for the main wood, stone and vegetation textures. The main tones used in the drawing are very dark, dark, medium dark, medium and medium light.

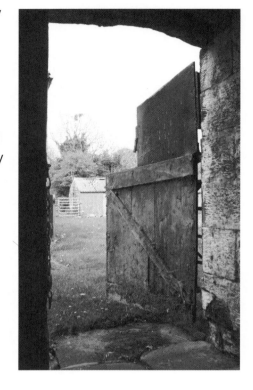

By referring to the finished drawing, first draft the main shapes of the scene, then use the lines of the masonry courses to help you work out the lines of perspective and the single vanishing point (VP) on the left side of the picture, illustrated here as the circled dot.

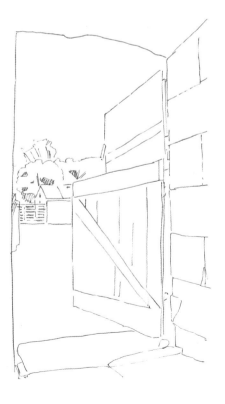

Step 1
Outline the main features carefully in faint tones, including the stone wall on the right-hand side of the doorway, the flagstone floor, the wooden stable doors, and the distant fence, stable and trees.

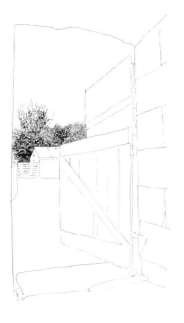

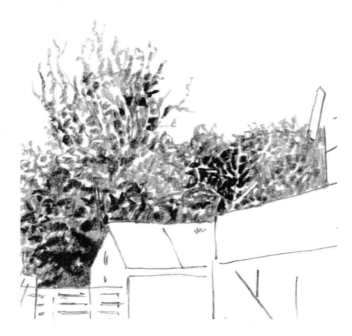

Step 2
Draw the background trees in HB pencil, rotating the pencil point to switch between blunt and sharp points as you alternate between adding sharply defined dark tree branches and the soft-toned areas of leaves. Try drawing the shapes between branches (the negative space) rather than the branches themselves.

Step 3
Using the HB blunt pencil point, draw the dark-toned negative spaces around the fence rails then, in slightly paler tones, add the concrete wall render and lines of the stable block corrugated roof. In darker tones, add two rectangular openings in the end wall of the stables.

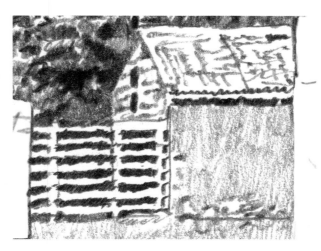

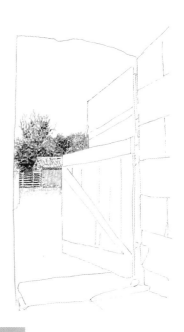

NEGATIVE SPACE

Sometimes, it's easier to draw the negative space, or the space around the object, rather than the object itself. In this farm fence and tree example, the negative space is between the bars of the fence and branches, respectively. The opposite (positive) space is therefore the white area of the fence rails and branches.

Step 4

Using rows of short vertical strokes to simulate grass, complete the paddock area, using increasingly dark tones as you move towards the foreground. Immediately, you'll see that this light-to-dark tonal gradient creates a linear aerial perspective and thus greater depth in the drawing.

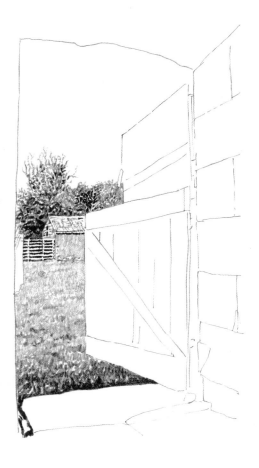

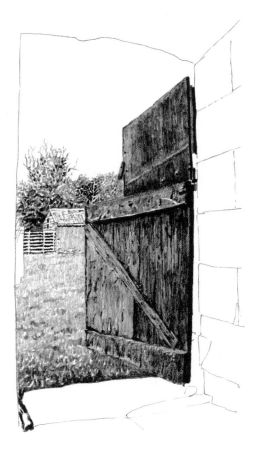

Step 5

Now, add the two wooden stable doors in HB, using strokes that follow the wood grain, then add the areas of shadows along the door rails in darker tones.

Step 6
Complete the flagstone floor in blended tones, using darker shades in the gaps between the stones and any eroded areas. Then fill in the gap between the door and the wall with a grass and vegetation background.

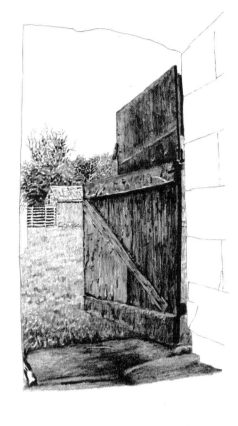

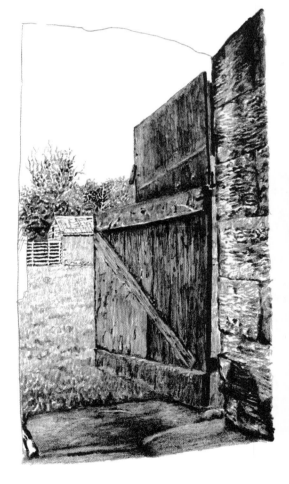

Step 7
Complete the dressed stones of the wall on the right-hand side, using stripes of light and dark blended tones, leaving some areas blank to indicate remnants of old limewash paint.

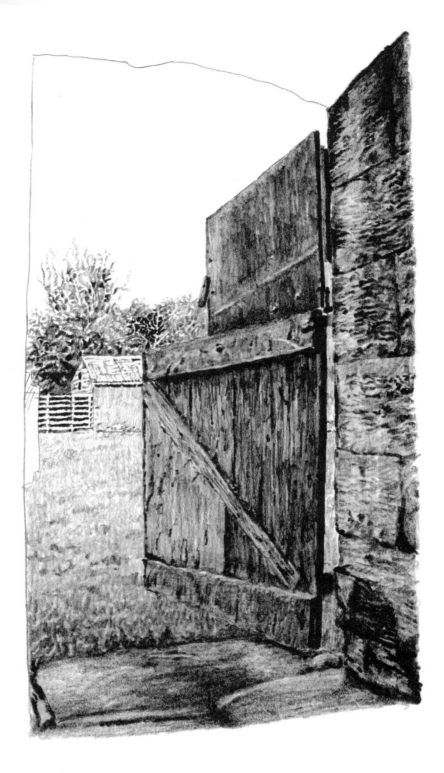

Step 8
Overshade the grass, the wooden door, the stone floor and wall using a
3H pencil so that most of the blank areas are covered. This softens the
tones and adds a greater air of realism.

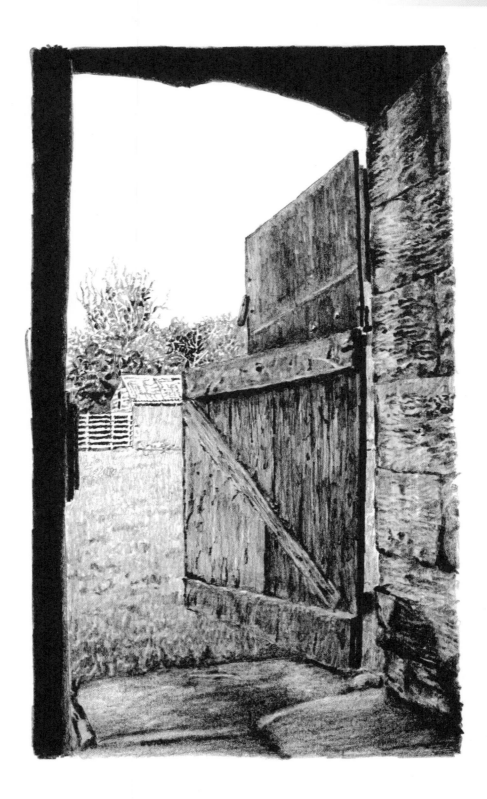

Step 9
Finally, shade the left-hand wall and door lintel in very dark, even tones. If needed, refer to the guidance on shading large areas on page 43.

Garden terrace

The final exercise in this chapter is a garden terrace in the late afternoon sun, with atmospheric sunbeams giving rise to very strong elements of light and shade. It may look more difficult than it is to draw, particularly the areas of negative space between the chair spindles and legs, but as soon as you break a subject down into steps, it quickly becomes apparent how easy it is to complete. Most of the tones are either very light or very dark and you'll work from top to bottom and from one side to the other. The size of the completed original drawing is 15 x 16 cm (6 x 6¼ in).

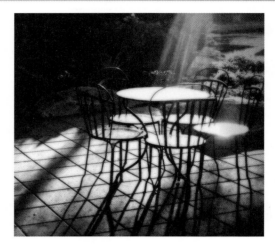

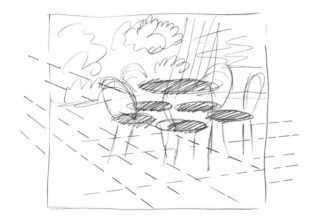

Use the photograph and finished piece as a guide to produce a rough sketch of the main elements and gauge their relative positions and sizes. Then find the vanishing points by drawing perspective lines from the paving slabs off to the left and right of the picture, shown here as dotted lines.

Step 1
Carefully outline the picture elements, particularly the chair frames, using the grid pattern of the paving slabs to help you lay out your drawing. Remember that it will be easier to complete the chair frames last, and that you'll be drawing the vegetation areas in the negative space between the outlines of the chair spindles and furniture legs.

The number of elements in the furniture may appear confusing but just remember that each piece of furniture has four legs, and each chair has a leg at each corner. On some chairs, the legs divide into two near the feet.

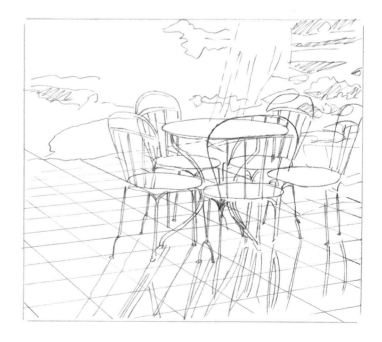

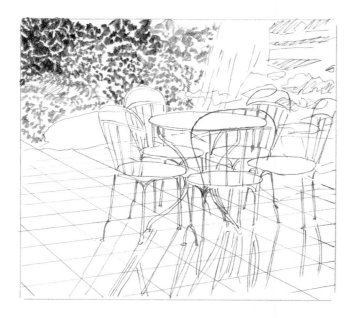

Step 2
Draw the vegetation in the top left-hand corner using an HB pencil and discrete patches of light and dark tones, leaving the surrounding areas blank.

Step 3
Use an H pencil and light tones to add the areas of vegetation and water on the right-hand side, and a few rays of sunlight.

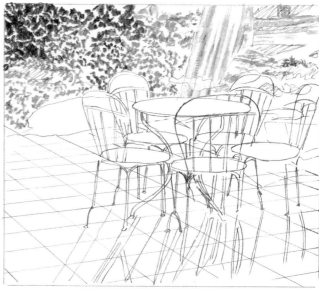

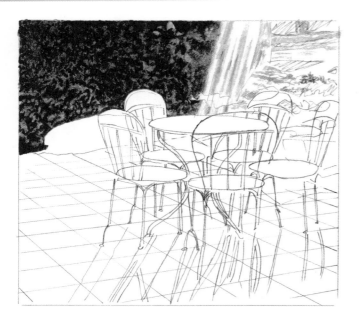

Step 4
First, overshade the vegetation on the left-hand side with a 3H (top detail) then overshade again with an HB pencil in blended tones (bottom detail). Take care to avoid drawing over the furniture outlines.

Step 5
Use an HB pencil and blended tones to overshade and darken the strips of vegetation on the right-hand side, then use horizontal strokes for the areas of water. Use paler tones for blending the darker tones of the shafts of sunlight.

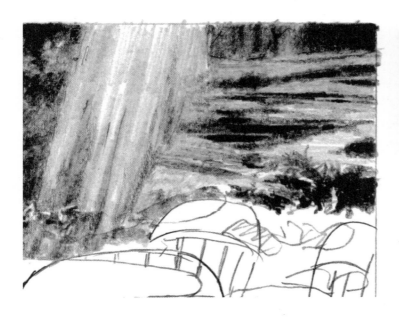

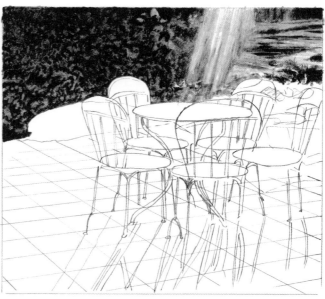

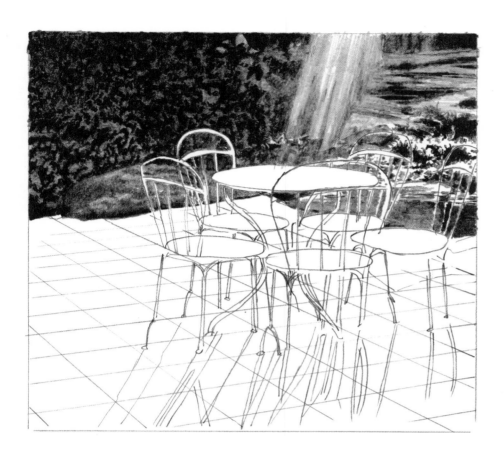

Step 6

In HB blended tones, add the boulder on the left-hand side at the edge of the terrace and the strip of vegetation bordering the far edges of the terrace, carefully filling in the paler tones between the chair spindles.

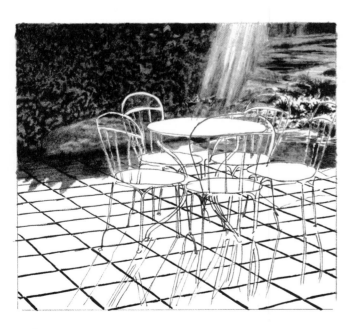

Step 7

Extend the shadows along the far left side of the terrace and add dark outlines to the patio paving stones, using discontinuous lines so that you don't draw over the chair legs or slab intersections.

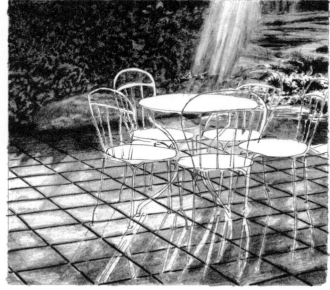

Step 8

Carefully avoiding the furniture outlines, shade along all the edges of the paving stones in 3H to create the effect of a raised, highlighted edge, then shade different stones in blended dark, medium and light tones. Use paler tones on the left-hand side where the sunlight is brightest and darker tones for the shadowed foreground areas and stone edges. Complete the remaining areas of vegetation in the areas underneath the table.

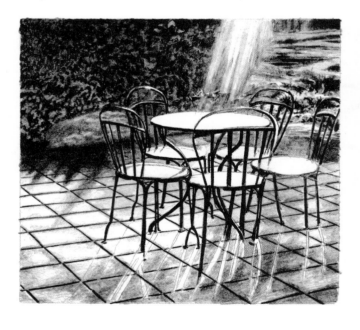

Step 9

Use dark, bold strokes of a blunt HB pencil for the furniture frames, leaving the sun-dazzled areas blank and using much paler tones for the slightly less bright areas and falling sunbeams. If needed, use an eraser sliver to create the highlights.

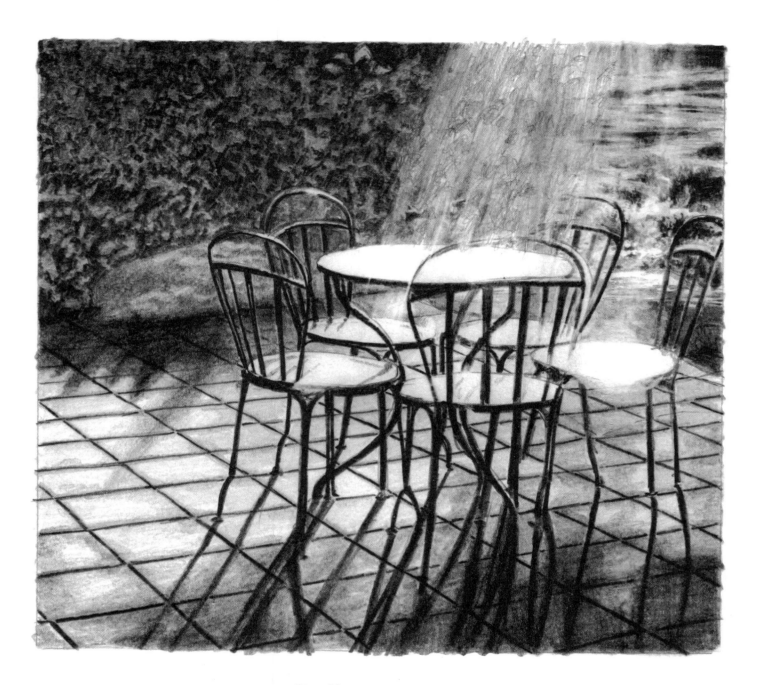

Step 10
Add the furniture leg shadows on the paving stones in bold HB strokes and then darken the other areas of moss and shadows on the paving stones. Finally, make any necessary adjustments. I refined the sunbeams by darkening them slightly and creating parallel shafts of light in blended H pencil tones, then lightened the chair seats.

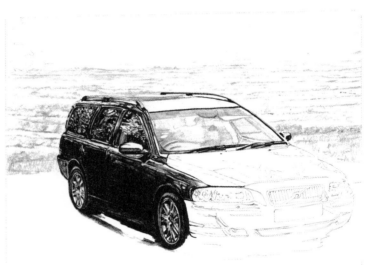

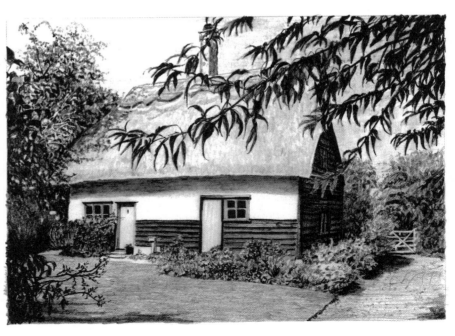

Buildings and Transport

Up to now we've looked at subjects you would normally find indoors or see from indoors, so let's build on your skills and step outside to draw some different scenes. In this chapter, you'll also practise the key technique of using perspective to bring realism to your drawings. Refer to Chapter 1 if you need to refresh your memory about any aspects of one-, two- and three-point perspective.

As before, we'll use the same techniques of looking for shapes, tones and shadows but, this time, the scenes are more complex. However, the only difference between drawing more complex scenes and the earlier exercises is that the number of elements is multiplied, and you need to ensure that each element is placed correctly.

Outdoor shed

To get you started, the first exercise in this chapter is shaded roughly in dark, medium and light tones. It may look complicated, but once you break it down into different elements you will see how easy it is to accomplish.

The shed is built of brick and wood with a slate and tin roof and sits in the corner of an established garden. The shed shapes are mostly simple rectangles, but obviously slightly distorted because of the effects of linear perspective. The scene is lit by natural daylight and also includes a bird table and a variety of irregularly shaped plants.

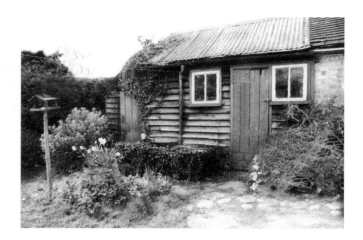

It is always a good idea to begin with a quick sketch of the scene to identify the perspectives and become familiar with all the elements and their relative size and location. Refer to the photograph and my finished drawing to make your quick sketch and use a ruler to draw any lines, if needed.

When you look at the photograph and the lines of the roof, windows, and wooden shiplap cladding, you might think this scene is in one-point perspective with the vanishing point off to the left. However, when you study it more closely, you can see that the bird table is viewed corner-on and thus presents a second vanishing point off to the top right. There is a third vanishing point, too – if you look at the roof, you will see that the lines of the corrugated iron sheets are not parallel but appear to get closer together as they recede into the background, thus revealing a third, vertical vanishing point.

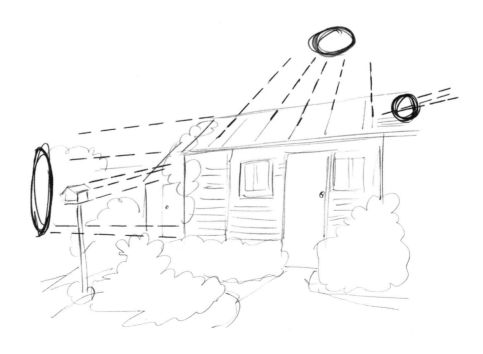

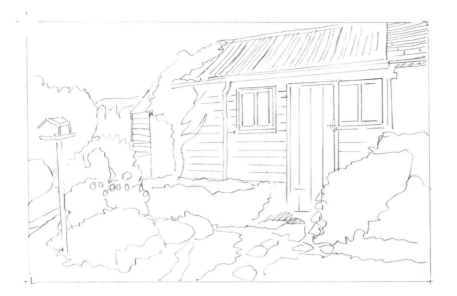

Step 1
Carefully draw faint outlines of the main elements in the correct perspective and with sufficient detail to guide you when adding the tones later on.

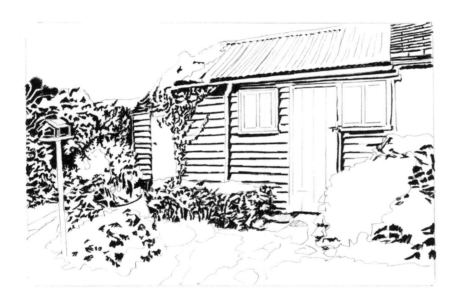

Step 2
Add the darkest tones of the shadows on the shed, vegetation, and barrel rim in HB and see how you can use different shapes to create the various features – for example, small triangular shapes on the shiplap planks and a row of half circles for the underside of the corrugated roof panels (top detail). Create the bird table and clumps of vegetation by drawing the negative spaces (bottom detail). Drawing all the small vegetation shapes may test your patience, but do persevere because as soon as you add the other tones your drawing will be transformed.

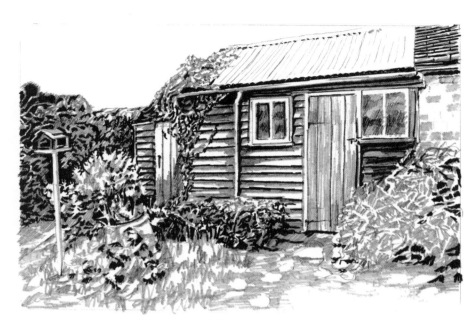

Step 3

Use medium tones in H pencil to draw the roof ivy and lines on the corrugated iron roof sheets, and shade the wooden shiplap and door planks, bricks in the wall, window reflections, and blades of grass. Leave the paler-toned areas of the shed roof and walls blank. Overshade the areas of dark-toned vegetation, leaving some of the twigs, leaves and flowers blank. Shade in the negative spaces of the clump of vegetation on the right-hand side and around the paving stones in the foreground.

Step 4

Use a 3H pencil to add light tones to most of the remaining areas, leaving the window frames, strips of the corrugated roof iron and tops of the vegetation blank. Add a few small twigs to the top of the vegetation on the far left-hand side. Make any further adjustments as you go – for example, I added slightly darker tones to the window reflections.

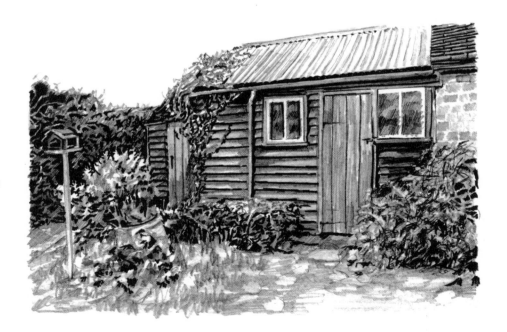

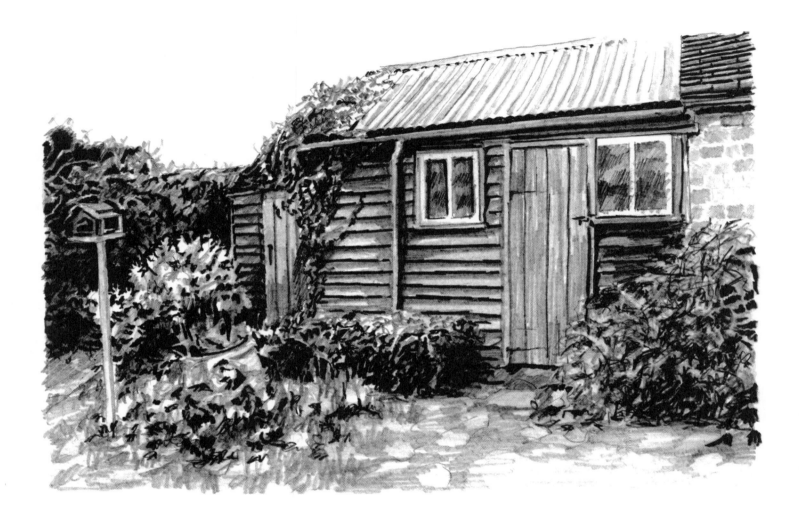

Step 5

Finally, review your drawing and make any necessary edits. I held up the drawing to a mirror and then added dark tones to the various patches of vegetation, including the bottom of the hedge behind the bird table, deeper shadows along the strands of ivy on the shed wall and roof and darker patches of grass. To finish, I enhanced the shadows on the other plants.

Country cottage

In this exercise of a thatched and sunlit country cottage in a pretty garden, you will use blended strokes to complete it section by section across the picture, and from background to foreground.

The drawing appears to be more complex because there are so many elements, but when you zoom in to the details, you will see just a collection of simple shaded shapes that have been placed correctly. When you break it down into sections, it also becomes very manageable to draw – you just need to ensure you use the various tones consistently across the drawing. For example, aerial perspective is more pronounced in this exercise so you will need to use consistently paler tones in the background and darker tones in the foreground.

For practical reasons, most of the dark-toned tree branches and leaves in the foreground are added at the end to avoid smudging and spoiling other areas as you work.

Use the photograph as a guide to roughly outline the main shapes and use the lines of the roof, windows and wall cladding to identify the linear perspective vanishing points. The first VP (circled) is just off to the right of the scene and is derived from the windows and wooden cladding of the end wall, as well as the line of the driveway verge. The direction of the second VP is identified from the roof ridge line, the bottom edge of the thatch, and the tops of the windows and doors, but the actual VP is too far to the left to be marked on the page.

Step 1

Decide how big you would like to draw your cottage and mark this size as a faint rectangle divided into quarters on your page, then mark the positions of the VPs. Use the VPs to carefully outline the main features in their correct perspective, employing the rule of thumb to determine relative positions and proportions. Outline the main clumps of vegetation and prominent branches and leaves in the foreground.

Step 2

The next three steps focus on adding the background vegetation on the left-hand side of your drawing. You'll see that the individual shapes you draw may not look right at first, but as soon as you zoom out, the overall effect is much more lifelike. Lightly erase any guidelines so they won't show in the final work then, in light, medium and dark HB tones, and blunt pencil point, draw strings of small leaf shapes with a few sections of dark lines to denote twigs and branches. Notice how you can use the narrow, curved areas of tone to create the effect of layers of vegetation, both as blank shapes for the uppermost highlights, and dark patches for areas in shadow. You can see the shapes in more detail in the extract on the right.

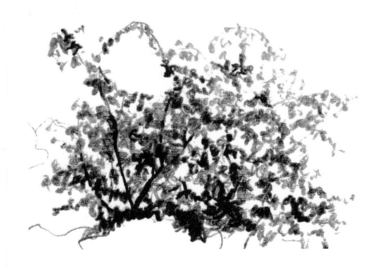

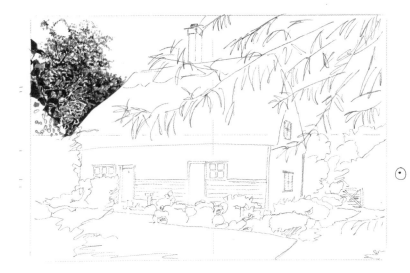

Step 3

Continue to use light, medium and dark HB tones to draw the middle section of the foliage adjacent to the sloping roof edge, leaving plenty of 'white bits' to describe highlighted branches and leaves amid the dark curved shapes of the shadows. Remember that some of the dark triangle and diamond shapes on the far left are foreground leaves.

Step 4

Complete the lower section of vegetation by first outlining a few strings of several leaf shapes and then shading around them in very dark tones. Leave some leaves blank and fill in the remainder with a mix of light and medium tones.

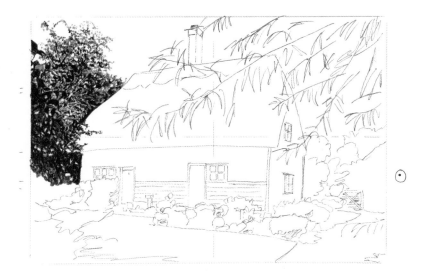

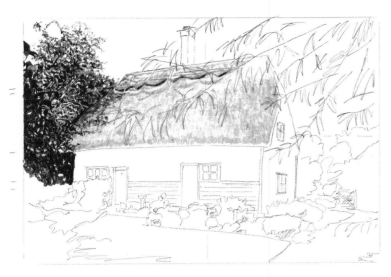

Step 5

Now, complete the thatched roof in light-toned 3H and 5H pencils. First, use a 3H pencil with a blunt point, and make rows of short diagonal strokes in the direction of the thatch to shade the patterns along the roof ridge. Then, twist your pencil and use the edge of the point to add the darker tones of the raised scalloped edge. Use your HB pencil to add the tree branches and shadows that overhang the roof down the far side of the roof edge.

For the remainder of the roof thatch, use a 3H and blunt point to draw overlapping rows of diagonal short strokes which align with the slope of the roof, using firmer pressure to create the slightly darker patterned areas. Then, overshade with a 5H to lightly blend the tones (refer to the technique for shading in rows on page 43).

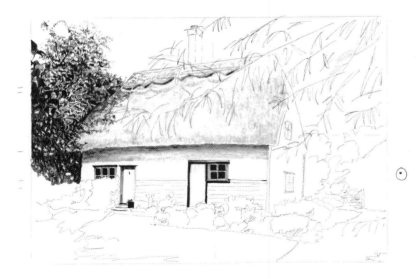

Step 6

Use 3H to first add a strip of shadow underneath the thatch overhang, then overshade in HB in a dark-to-light gradient that extends partway down the wall. Add the window and door details in dark and medium HB toned horizontal and vertical rectangles. Next, use a 5H pencil and vertical strokes to shade the wooden door planks. As you build up your picture, remember to rest on a piece of scrap paper to avoid smudging your work.

Step 7

Add the horizontal boarding on the lower part of the wall in dark and medium HB tones, employing the same shading technique you used for the shed walls in the previous exercise. Review your work to see if you need to make any adjustments.

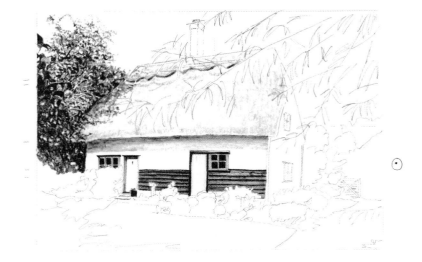

Step 8

Complete the flower border at the front and side of the house, using a variety of irregular and negative shapes, in light, medium and dark tones. The detail on the right above shows you how easy it is to create this border with a selection of shaded shapes. Then draw the vegetation at the right rear of the cottage in blunt HB and medium and dark tones, using the same techniques as you did for the other side. Use negative shapes to create the white five-bar gate (detail above).

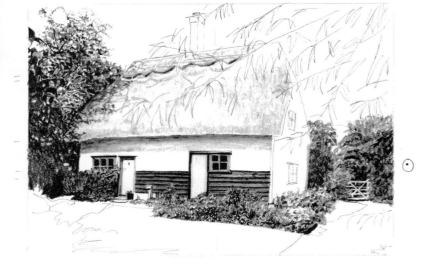

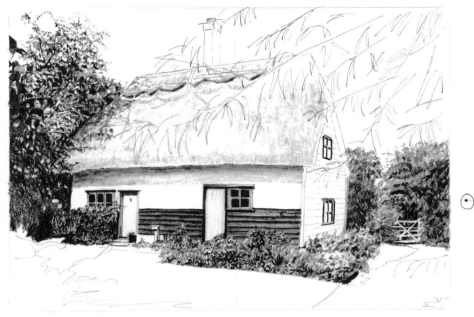

Step 9

Use the right-hand VP to faintly draw the lines of boards on the end wall of the cottage, then add the window outlines and shadow details in HB.

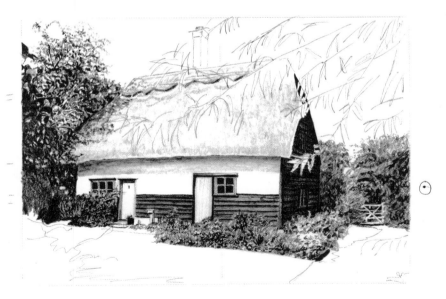

Step 10

Use HB dark tones and a blunt point to add the tonal gradients of the boards, taking care to leave the foliage blank. Next, overshade the planks and both windows to darken the wall and create the overall shadowed effects on this side of the cottage.

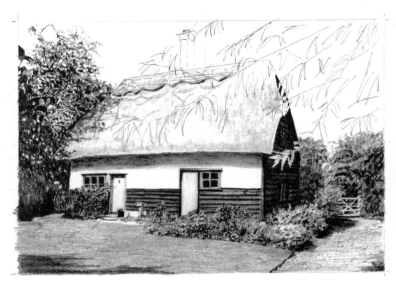

Step 11

Shade the lawn in soft, medium-toned HB, first using horizontal strokes that flick from the lawn edge inwards, then overshade in H. Draw the drive in rough horizontal HB strokes and blunt point, adding random dots of tone to denote small stones.

Next, use 3B to add the narrow dark strip along the lawn edge to create the illusion of the shadow and the little step up onto the lawn itself. Then, add dark shadows to the flower border on the driveway side of the cottage, and parts of the foreground areas of the lawn and driveway.

Now review your drawing and make any adjustments. I added darker tones in HB to deepen the shadows on the wall underneath the overhanging thatch.

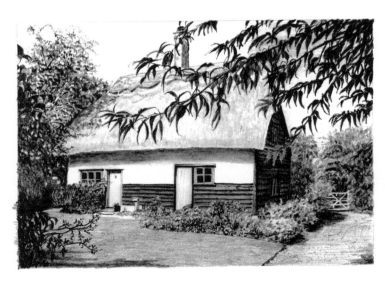

Step 12

Add the chimney in light and medium tones, then the foreground branches and leaves. Notice how the addition of the very dark leaves in the foreground instantly gives greater depth to the drawing (aerial perspective) and enhances the illusion of three dimensions.

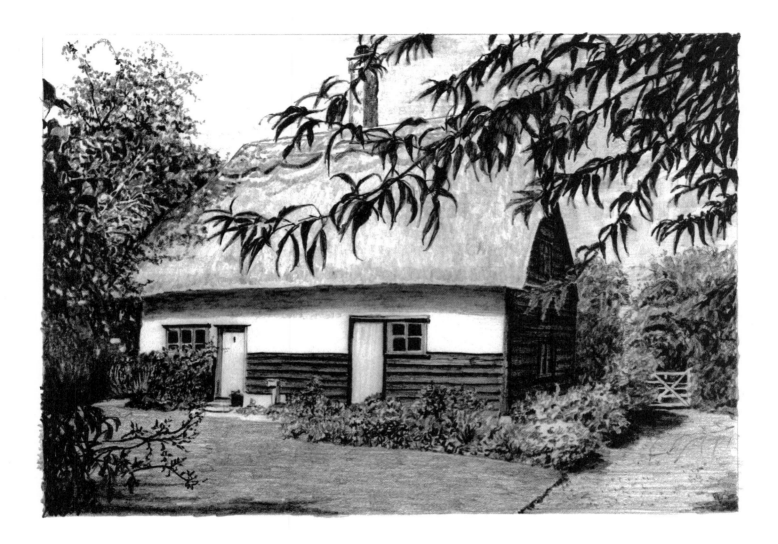

Step 13

Finally, use a 3H flat pencil lead to very lightly shade areas of sky between the tree branches on the right, and a few small areas above the cottage. You can see how the combined use of aerial perspective, the view of the cottage corner-on, the angle of the gate at the rear and the simple use of tones to create light and darkness helps to create a realistic and intimate view of this cottage in the landscape.

Review your work to make any final adjustments and congratulate yourself when you have completed this drawing!

Family car

Now, let's draw something very different – the sleek contours and more rounded shapes of a family car which you will complete in sections across the picture. Don't worry if you have not attempted this subject before or have no knowledge of vehicles, just draw what you see – the shapes and tones. Have a quick practice by sketching a few vehicles to become familiar with their shapes and sizes. To help you gauge proportions, use the rule of thumb or compare features – for example, one feature may be twice the length or half the width of another.

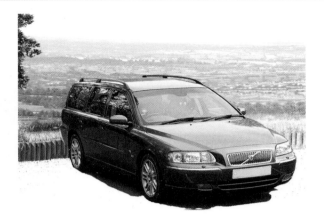

When you are deciding whether to draw a vehicle from the front or side, consider the overall lines and perspectives and how the car appears when viewed from different angles, including from above or below eye level. Don't worry if you think your first attempts are not quite right – you will definitely improve with practice!

For this exercise, use the photograph and/or my finished drawing as a guide to roughly draft the outlines and become familiar with the car, using the two vanishing points to help you achieve the correct shapes. If you find it difficult to identify the VPs, use features that are normally horizontally aligned such as the bottoms of front and rear wheels, the sill, and bottom edges of the side windows for the left-hand VP, and the front wheels, number plate, and windscreen (for the right-hand VP).

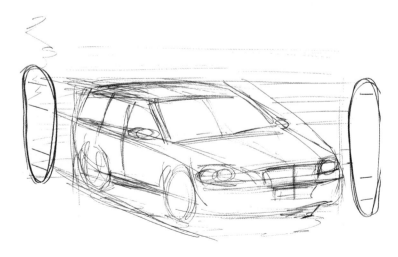

Step 1

Take your time to outline the main shapes in sufficient detail to allow you to fill in all the different tones later. Start by gauging the overall dimensions of the car and the angles of the windscreen, windows, bodywork panels, and bonnet. Once these are placed correctly and you are satisfied with the overall proportions, add the outline shapes of the windows, wheels, bonnet, and headlights. Then, in as much detail as you require, add the smaller shapes of the window reflections, wheel spokes, and any areas of highlight and shadow. For the background landscape, draw successive faint lines of hedgerows and trees.

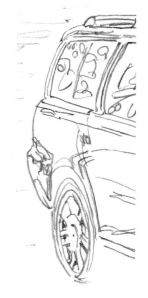
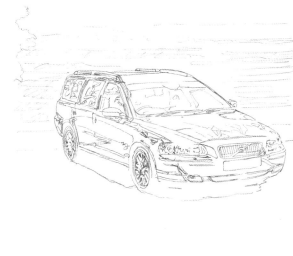

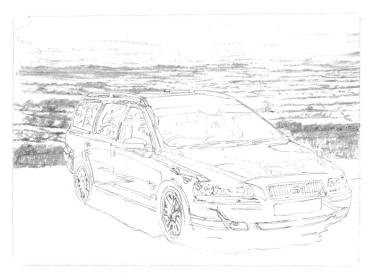

Step 2

Use a blunt pencil point and rough strokes to add the background hedge and tree details, working with a 3H pencil for the distant pale tones and then H for the increasingly dark tones towards the foreground. For now, leave the foreground blank in the area where the tree branches are shown in the drawing.

Step 3

Use an HB pencil and dark tones to outline the car's rear window, wheel, and the rear section of the roof rail, leaving blank strips to denote the palest highlights.

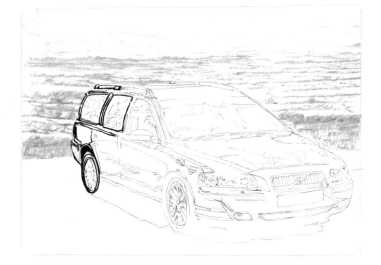

Step 4
Draw the rear bodywork panels, wheel and window reflections in dark HB tones, leaving white bits for the reflective areas. Don't worry about how to do this – just start with one small area and simply draw the shapes that you see within that area, then move to the next area, and so on.

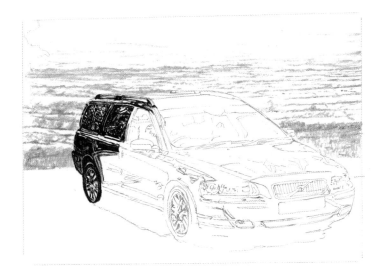

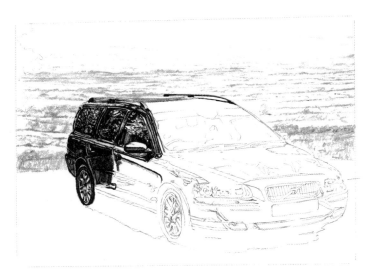

Step 5
Continue using HB to draw the roof and remaining side windows.

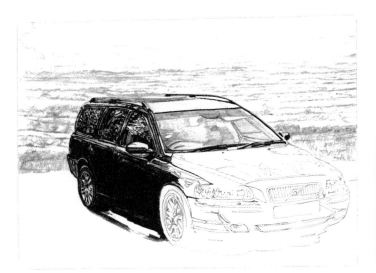

Step 6
Complete the front door panel in HB and add the windscreen shapes and tones in 3H.

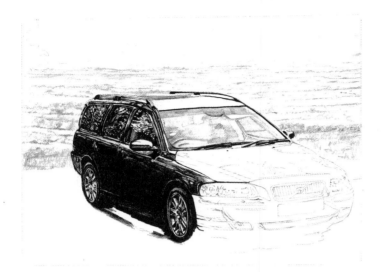

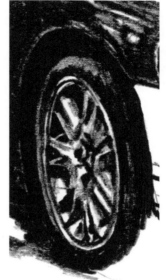

Step 7
Continue to draw the bodywork quarter panel, then add the front wheel details in HB – you'll notice they contain numerous little triangle shapes.

Step 8
Add the bonnet details in H pencil and then use HB blunt and fine pencil points to draw the remainder of the front of the car: the grille, valance, number plate and headlight assemblies.

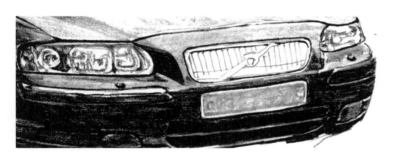

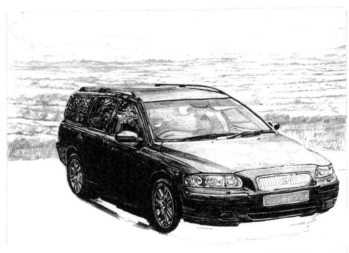

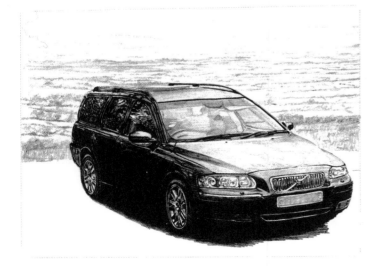

Step 9
Add the dark tones of the shadows using an HB blunt pencil point, allowing the bottom edge of the car and shadow areas to merge. Notice how you enhance the effect of aerial perspective and create more depth to your scene when you add these dark foreground shadows, which contrast with the pale background landscape.

Step 10

Use dark HB tones to add the tree branches to the left. Next, use paler, rough horizontal strokes to shade the foreground surface, adding a few darker dots to signify stones – this is exactly the same technique you used for the cottage driveway.

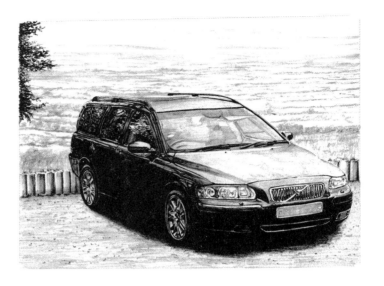

Step 11

Finally, use an HB pencil to add the tonal gradients to the short wooden fence behind the car. Remove any unwanted lines and review your work; I added slightly darker tones to the windscreen shapes and some of the distant hedgerows.

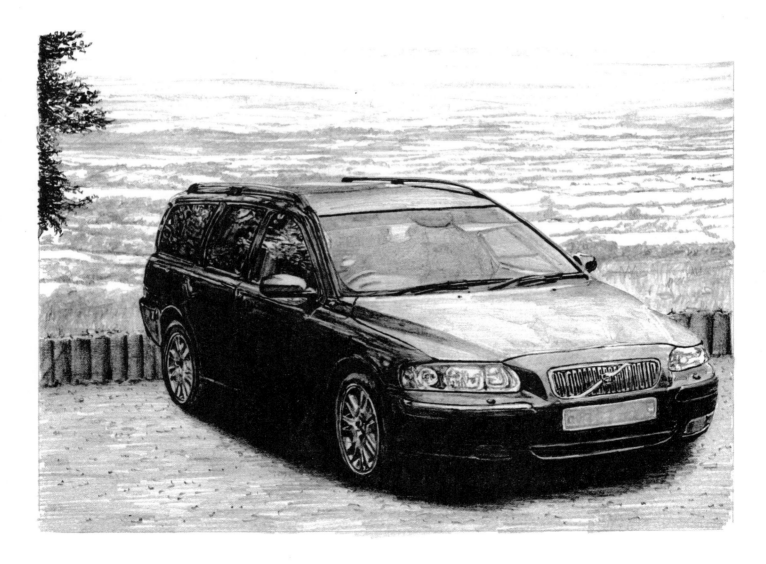

Urban dwelling

In this exercise, you'll draw these Scottish apartment blocks in a less detailed style, where the focus is on using perspective and limited tones to describe the features. The key is to draw the initial outlines in their correct proportions and perspective. Then, you will add the various building features such as windows and balconies which are mostly created from simple blocks of tone.

Use the photograph as a guide to draw a rough sketch so you become familiar with the scene. Use the lines of perspective derived from the rows of windows and doors and roof lines to locate the two vanishing points (VPs) at each side.

Step 1
Outline the shapes of the main buildings and the window and door frames in their correct position and perspective, adding as much detail as you require. You may prefer to do this by eye, or else use a ruler to achieve the lines of perspective.

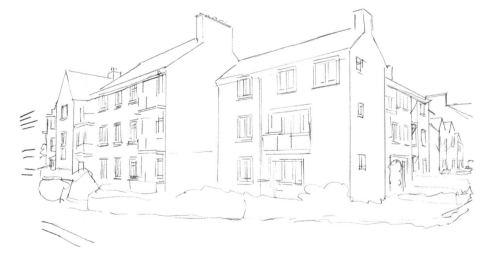

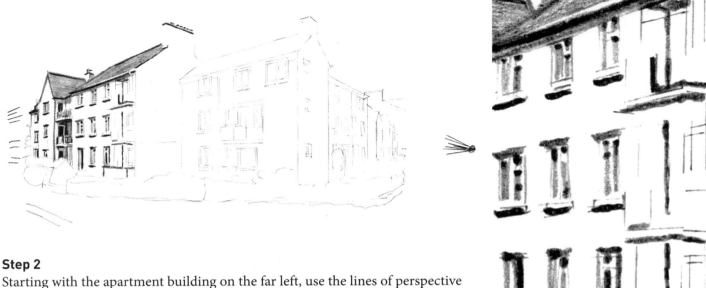

Step 2

Starting with the apartment building on the far left, use the lines of perspective as a guide to draw the roof and chimney shapes, then shade these in medium- and dark-toned blunt HB. Use simple strips of darker tones to draw the tops and bottoms of the windows and balconies. Add narrow vertical strips of medium tones for the window glass, noticing how few marks are needed to create the impression of these features. Use little triangles of tone at the ends of the window lintels, and darker tones at the tops of the rectangles to indicate the recesses and shadows. You can tell from the relatively short shadows and their direction that the sun is high in the sky and to the left of the scene.

Step 3

Use simple lines and blocks of HB tones to complete the shading of the balconies and diagonal lines and triangles of tone for the dark shadows in the recesses. In close-up, the shapes may not resemble any features but when you step back, the scene becomes more apparent.

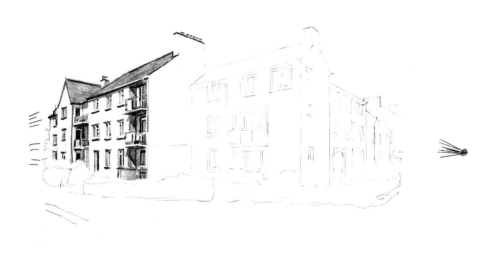

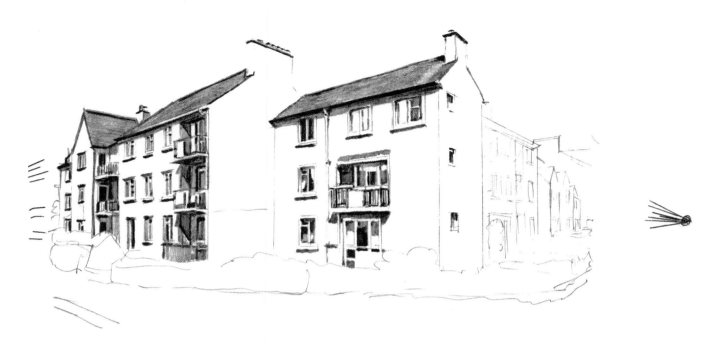

Step 4
Continue and complete the next apartment block, adding the roof, window and balcony details.

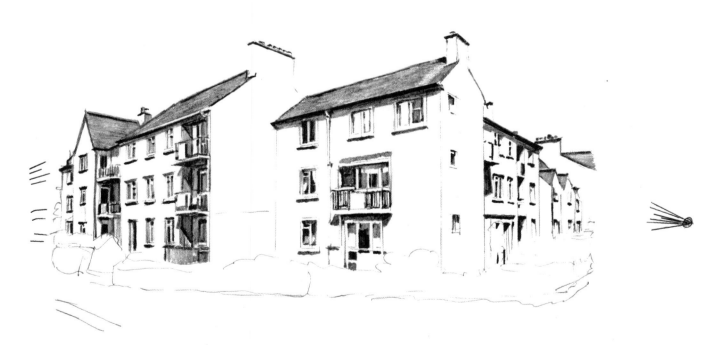

Step 5
Complete the remaining apartments and houses in the same way.

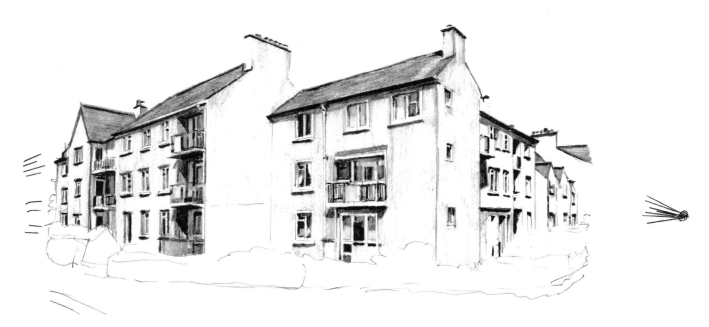

Step 6
Use a 5H pencil to add light tones to the walls of the buildings, creating slightly darker shades where the shadows fall under the roof eaves and tiles.

Step 7
Add all the vegetation in front of the buildings, using HB and the same techniques you employed for the previous shed and cottage exercises; you now know that when you add very dark tones at the base of plants and shrubs, it creates the illusion of shadow and enhances the three-dimensional effect. Add two diagonal strips of tone in the bottom left corner to denote a kerb.

Step 8

Review your work, remove unwanted marks, and make any final adjustments; I lightened the tones of the main apartment block walls.

Steam train

This steam train pulling into a station makes an exciting composition, and although it may look very complicated to draw, when you simplify it and break it down into steps, you'll see how easy it is to render a good likeness. The original photograph is included so you can choose to produce a detailed drawing or simply capture the essence of the scene in looser strokes. Both approaches will require you to first assess the scene, look for lines of perspective, and accurately outline the features in their correct place and proportion. Notice how the carriages look smaller in size as they recede into the distance, and the way the contrast between the lesser background detail and greater foreground detail adds to the sense of perspective and realism.

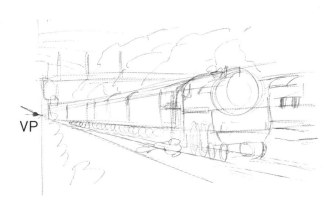

Produce a quick outline sketch to become familiar with the scene and try to simplify it rather than get bogged down in all the details. To do this, close one eye to help you identify the dominant bright and dark shapes.

There are no new techniques in this drawing – it's basically a row of box shapes receding into the distance with a collection of more intricate shapes under each carriage and at the front (the train engine), a few straight lines (rails, platform edge), and a generous helping of vegetation – all of which you have drawn already.

The first vanishing point (VP), on the left-hand edge of the scene, is identified by following the lines of the platform edge, the railway tracks and the carriage roof and floor lines. There are too few clues, apart from the obvious front buffer plate, to accurately identify the second VP off to the right, so this has been omitted.

If you're not sure how to approach a drawing like this, start with a quick tonal sketch of the main dark, medium and light-toned shapes. Sketching like this will help you to interpret and focus on those elements that characterize the scene, as well as identify superfluous items. When I produced this sketch, I discovered that the train on the other platform, the bridge and vegetation detracted from the train, so I decided to omit them from this exercise.

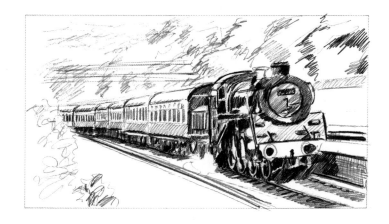

Step 1

Define the size of your drawing with a rectangle and decide the level of detail you would like to include. Then, as accurately as you can, outline the main shapes of the carriages and engine before adding other smaller shapes such as windows and engine parts. I used a ruler to draw the window and carriage lines in perspective. Of course, it will take you more time to draw all the shapes, but care taken at this stage will pay dividends in the final drawing.

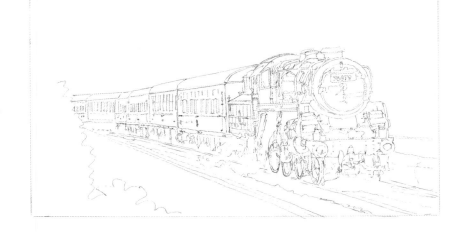

In this exercise, I have numbered the train passenger carriages 1 to 6 from front to rear. Notice that carriages 3 and 4 appear joined because the bend in the track and viewing angle render them almost indistinguishable from each other – a clue to the number of carriages is in the number of carriage windows.

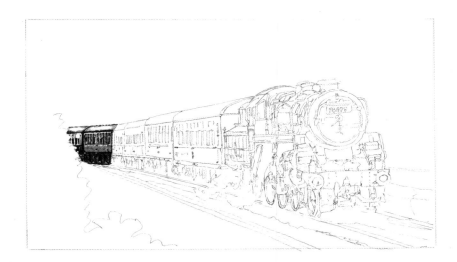

Step 2

With H and HB pencils, use a mix of sharp and blunt points and dark and medium tones to carefully shade the shapes of carriages five and six (the last two carriages). To avoid smudging your work, rest on a piece of scrap paper and draw from one side to the other.

Start with the darkest tones and draw the carriage window top sections as 'T' shapes (the window recesses and shadows), then the bottom window sections as simple vertical rectangles. Draw the line of the carriage roof as a string of small blobs, then use long, thin, horizontal rectangles to define the top and bottom of the carriages, leaving highlighted areas blank. Fill the space between the carriages with a strip of dark tone and, for the undercarriages, draw a row of dark-toned rectangles, filled in-between with medium tones in H. Add a strip of dark HB shadow underneath the carriages. Use the H pencil to shade in the outer edges of the roof and between the window shapes, leaving the highlighted areas blank.

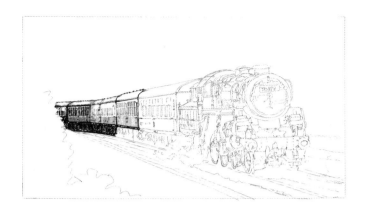

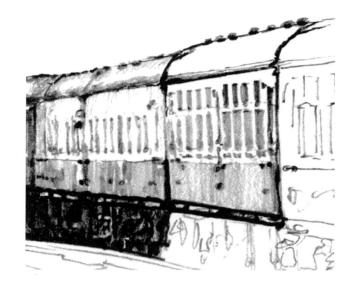

Step 3

Draw carriages two, three and four in 3H, H and HB. Use H
to draw the windows as a series of vertical rectangles, ten per
carriage, noting that the windows in the second carriage have separate upper and lower sections. Draw
a string of blobs to define the roof lines and add the carriage door hinges as small, dark circles. Roughly
shade parts of the carriage roofs and the sides of the carriages under the windows, in 3H.

Then, for carriages three and four, use HB, your best judgement, and initial guidelines to add the dark-
and medium-toned shapes of the undercarriage – you will see there are no distinct wheel shapes, just the
paraphernalia of all the heating and brake services. Leave highlighted areas blank.

Step 4

Complete the second carriage roof in 3H, and the underside in HB as
for the previous carriages. Continue with the 3H, H and HB pencils
and the same techniques to complete the roof and side of the first
carriage. Use HB to add the arched roof and rectangular end panel
shapes, carefully drawing around the horizontal and vertical white
pipes and three short, dark-toned vertical pipes with paler caps.

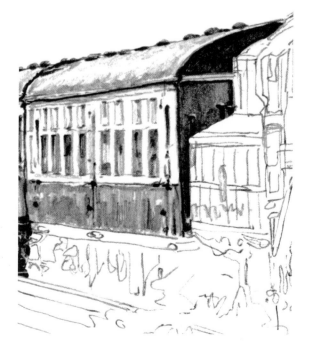

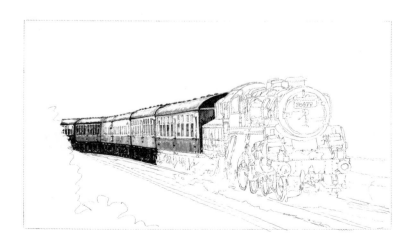

Step 5

Draw the underside of the first carriage, shown here in two detailed images to help you understand how to accomplish the detail. Admittedly, it is very fiddly to draw and when viewed in close-up these two extracts look unrecognizable, but once you see them within the context of the overall scene, you can immediately make sense of the picture.

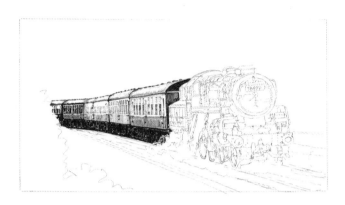

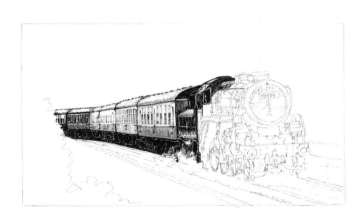

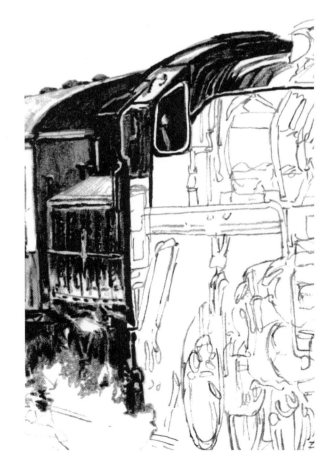

Step 6

Use HB tones to add the panels and negative shapes of the water/coal tender (which sits between the first carriage and the driver's cab), then add the more curved shapes of the driver's cab window and roof and some of the pipework on top of the boiler. Use negative shapes to complete the pipework below the tender, then draw tonal gradients to create the soft edges of the steam cloud, using an eraser if required.

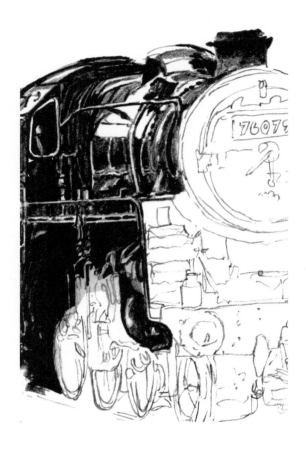

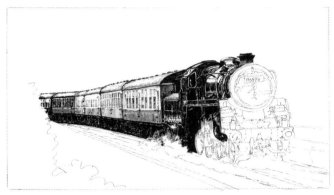

Step 7

With your HB, add the uppermost engine details including the curved sections of the barrel-shaped boiler and the domes and funnel on top of the engine, using the techniques for shading up to edges described on page 43. Leave highlighted areas blank and use negative shapes to define the pipework. Shade the solid dark areas of the lower part of the engine, drawing carefully around the various components. Finally, review your work and make any amendments you think necessary. Here, I made the funnel slightly taller.

Step 8

Complete the visible parts of the elliptical-shaped drive wheels and outline the circular smoke box door components on the front of the engine in HB.

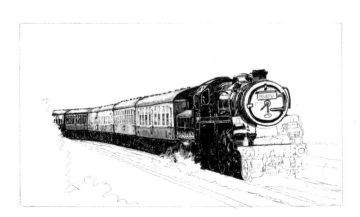

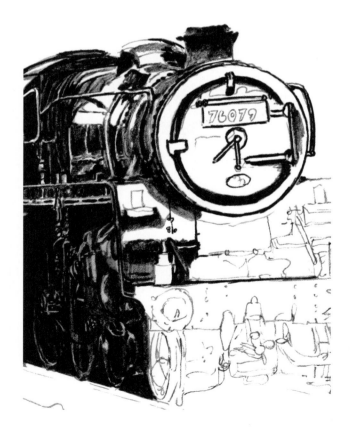

Step 9

Use HB dark tones and tonal gradients to complete the smokebox's circular door details then add the various bolts and seam edges on the plates at the front of the engine in 3B. Use 5H to shade the remaining areas of the front plates and add several semi-circles in HB to denote rivet heads. Carefully shade around the two items standing on the buffer plate – the lantern and oil can. Leave these two items blank, except for the label on the oil can and the negative space of the lantern handle.

Complete the two front wheels, leaving the reflective shiny metals parts blank, then add the front coupling details and the shadows underneath the engine in HB.

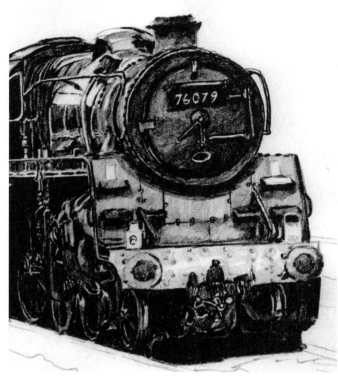

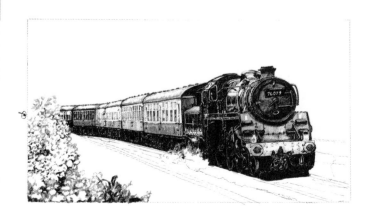

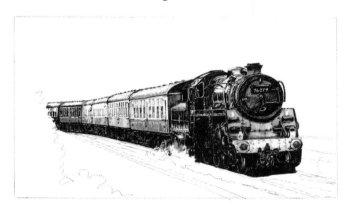

Step 10

Now, add the foreground vegetation shapes in H and 3H, but first use your eraser to lighten any guidelines so they won't show in the final work. Draw the vegetation by applying the same techniques you used in the shed and country cottage examples (see page 102 and page 106).

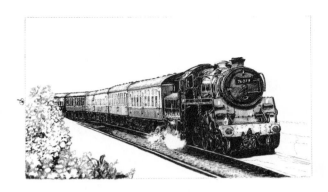

Step 11

Use HB to add the platform and rail edges as straight lines of dark tone, and then create the pattern of the nearest railway sleepers and fasteners in two stages.

For the sleepers, first draw a strip of equally spaced, near horizontal, short dark marks in HB, leaving a small gap between these marks and the rail (top detail). For the fasteners, draw the negative shapes as a strip of small circle outlines next to the sleeper marks and then a short row of small circles touching the rail itself. Next, fill in the gaps around the circles with HB, then overshade them all with 3H. For the ballast, draw numerous small random marks in H, then overshade with 3H (bottom detail).

Step 12

Draw the remaining set of railway tracks and sleepers in the same way as before, then add the ballast stones in mixed tones, leaving some white. For the brick wall next to the track, use the vanishing point on the left-hand side to draw the rows of bricks in perspective, then use an HB and very dark tone to draw the lines of mortar. Use horizontal strokes to overshade the brick rows in H, then use HB to roughly draw a few vertical lines with a blunt point. Next, draw the platform edge above the wall as a dark line in HB, then add the diagonal lines of the supporting stonework in HB, overshaded as before. Use a very blunt point and paler tones to draw a few lines along the platform itself.

Step 13

Finally, add the foreground platform surface paving in 5H, then use your imagination to create the background details on the right-hand side of the scene. I added another railway line and platform edge, then a fence with some vegetation behind it.

Review your work, make any final adjustments you think necessary, and congratulate yourself on completing this vintage steam train!

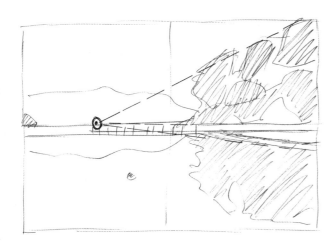

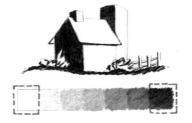

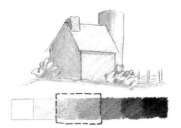

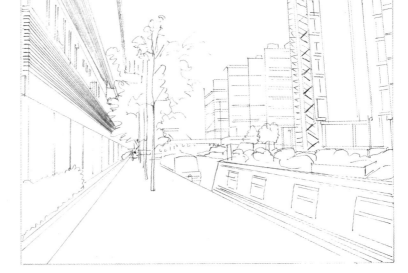

Chapter 5

Landscapes

In this chapter, you'll be drawing a variety of landscapes with a particular emphasis on aerial perspective. As you work your way through the examples, you'll discover your own favourite scenes to draw, whether that's from visiting places or looking at photographs. You'll also begin to develop your own style, so feel free to experiment with different drawing techniques.

If you intend to draw outside, known as *en plein air* (in the open air), your drawing time will probably be limited by the lighting and weather conditions, so it's a good idea to take photographs to enable you to complete your work later. It's also sensible to take a folding stool to sit on, an easel or stiff board to rest on, and a backpack to carry essentials such as your drawing materials.

Rural scene

This exercise is based on a photograph of a country road in winter where there is a short distance between the foreground and background objects (shallow depth of field). The combination of the low sun illuminating the scene from the left and the clear winter sky gives rise to well-defined, long shadows and thus the striking contrast between the pale and dark tones.

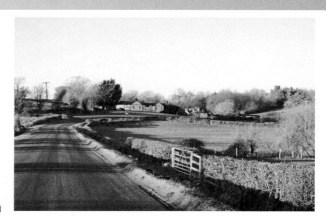

HB is used for most of this drawing, with H just for the paler fields. The aim is to draw the scene as simple blocks of blended tones, so you will need good hand-eye co-ordination and the ability to simplify details – the idea is to create an impression rather than total accuracy. Use darker tones for the foreground trees and shadows, fading to paler trees in the background. Note that coniferous trees will always appear dark wherever they are located in the landscape.

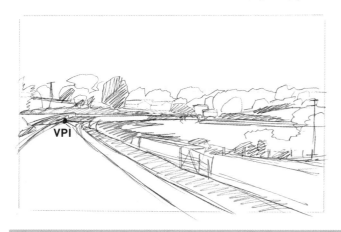

Start with a rough sketch to identify the vanishing point(s) and main shapes. In this example, a single vanishing point (VP1) is identified by following the lines of the roadside edges and hedges. You may find it easier to identify the blocks of tone if you close one eye.

VIEW-FINDING: SELECTING A SCENE TO DRAW

If you're wondering where to start with a landscape composition, the first step is to decide how much of the view you want to include. A viewfinder in the form of a piece of card with a hole cut in the middle can help you to frame a pleasing composition, or you can simply use your hands to frame part of the scene (see page 69).

Just as with arranging a still life composition, selecting the best view comes with practice and following your instinct for what looks 'balanced' and 'right'. Begin by looking at the elements in the scene such as the sky, ground, vegetation and any structures, and consider the theme of your drawing; will the focus be on the sky, land, or other feature? Will it be an impression or a detailed record? At home, take time to look at the work of other artists and see if you can identify what makes it special.

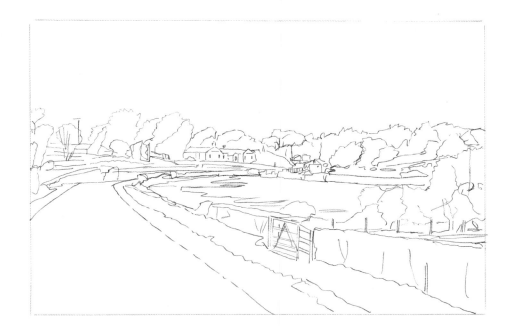

Step 1

Use the photograph as a guide to outline the main blocks of tone in as much detail as you need.

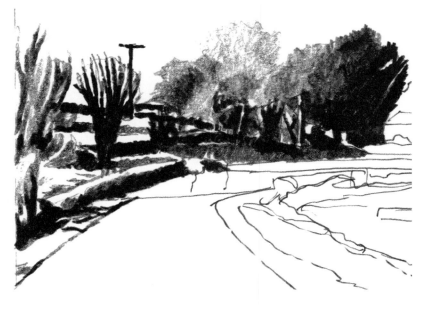

Step 2

First, lighten any guidelines so they don't show in the final drawing. Then, work from left to right (or right to left if you are left-handed) and background to foreground, using HB to shade the main shapes you have identified.

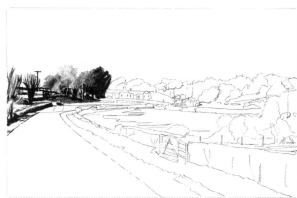

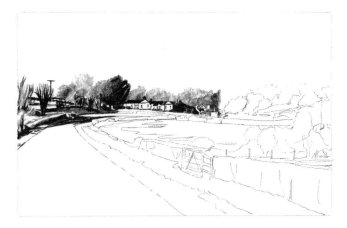

Step 3

Use blocks of very dark HB tone and minimal details to define the buildings, then use H and pale tones for the trees behind the buildings.

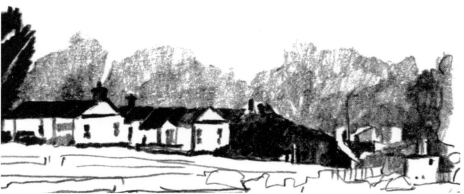

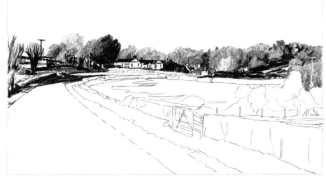

Step 4

Complete the background trees, then use thin strips of HB tones to define the adjacent field boundaries. The detail below shows the trees and field boundary on the right-hand side of the image.

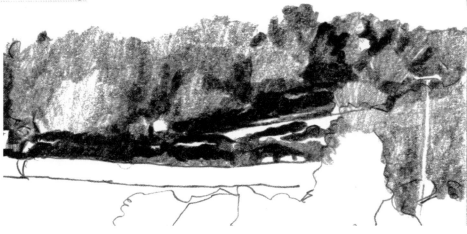

Step 5

Add the land in front of the left-hand-side buildings as two strips of tone in H and HB. Then add the field boundaries and roadside details on the right of the scene, using very dark HB tones for areas in shadow. Create the fence posts with rows of short, dark, vertical strokes, leaving white spaces in between (see detail below). Leave a white strip for the telegraph pole on the right.

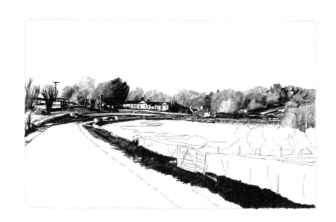

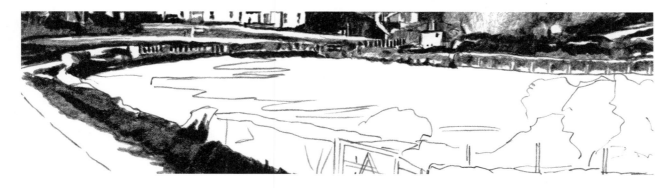

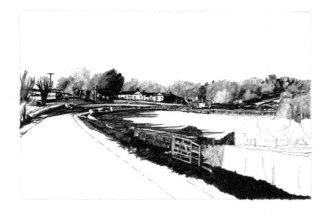

Step 6

Use HB to add the roadside hedge in the foreground and shadow details elsewhere, leaving areas where the sun catches the verge and hedge blank as highlights. Draw the gate and wooden plank details on the right-hand side as a series of negative spaces.

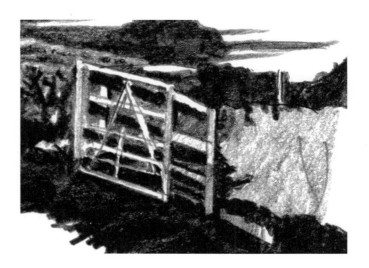

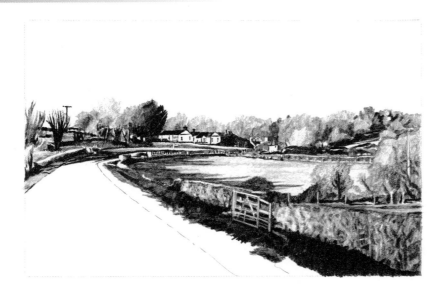

Step 7
Fill in the remaining field details with H, and the hedge details in HB, using progressively darker tones in the foreground.

KEY TECHNIQUE: DIFFERENT WAYS TO USE TONES

You can use tones to change the mood of your drawing, for example to create a sense of either calm or drama. A few examples of this are given below.

Tonal contrast is the difference between the darkest and lightest tones in a scene. The greater the difference, the more striking the effect will be and the more your eyes will be drawn to these areas. Lighter tones also appear more pronounced when they appear next to very dark tones.

High tonal contrast: *Tones from extreme ends of the scale create drama, for example, in brilliant sunshine where very dark shadows are cast.*

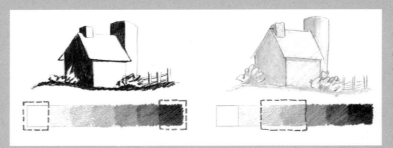

Low tonal contrast: *A narrow range of tones from anywhere on the scale creates a muted effect, such as on an overcast or misty day when everything appears duller and softer.*

Tonal key describes the overall 'tone' or mood of a drawing.

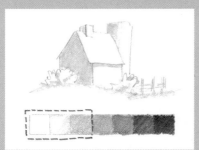

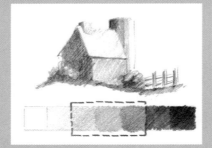

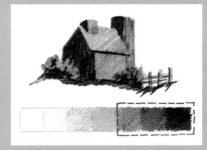

High tonal key: *Lighter values produce delicate, ethereal effects.*

Middle key: *A mid- or full range of tones conveys tranquillity.*

Low tonal key: *The darkest tones convey drama.*

Step 8

Use HB to add blocks of bold
horizontal strips of shadows
across the road, drawing a kink
at the right-hand end to indicate
the rise of the verge. Then
review your work; I refined
some of the long shadows in the
large right-hand field.

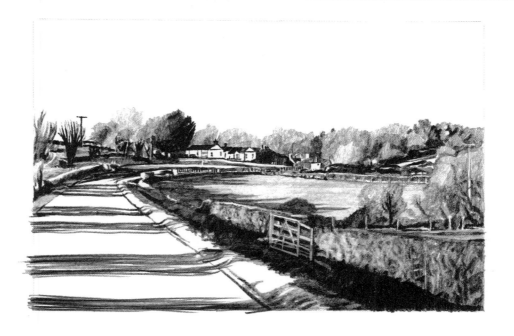

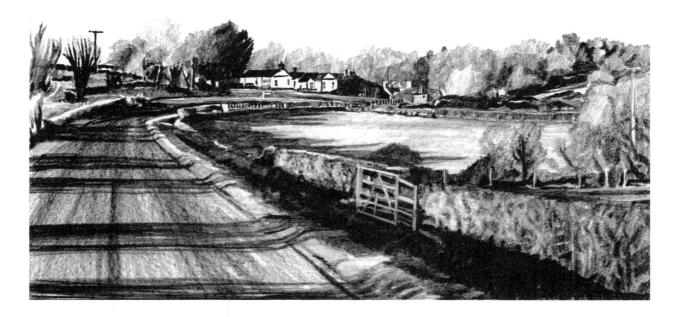

Step 9

Complete the roadside verge in H and HB, then use the flat side of the pencil lead to shade the
tarmac in long strokes that follow the lines of the tyre tracks on the frosted road surface. Finally,
review your work again and make any changes you need. I used the H pencil to overshade and
slightly darken the paler areas of the fields and hedges.

View of a hill

The view of Catbells in the English Lake District is not just of the mountain itself, tempting you to climb it, but also includes the tranquil lake and tangled wooded slope in the foreground, all inviting you to explore further. You can see that the aerial perspective is much more apparent because of the contrast between the very dark and more detailed foreground, and the less detailed, hazy background, creating a dramatic effect and giving the impression of great depth in the scene. Complete the exercise section by section, using a mixture of blended and rough strokes in HB, 5H, 3H and H pencils.

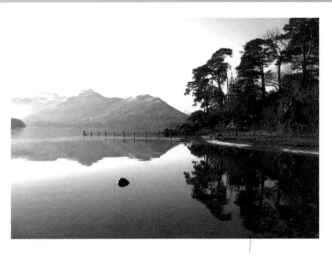

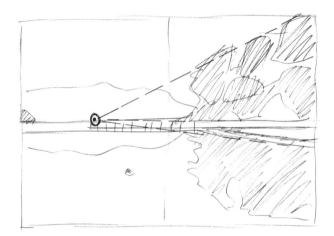

Roughly sketch the main areas of dark and pale tone, then locate the vanishing point. It's a little more difficult to find it in this scene than in previous drawings, but if you follow the rough line of the treetops and lake edge, it's located on the opposite shore just above the water line, shown here as a circled dot.

Step 1
Outline the main shapes of dark and light tone, including the very dark areas and conifers in the foreground on the right, and the distinctly pale tones of the hill in the distance. Take time to place these shapes accurately.

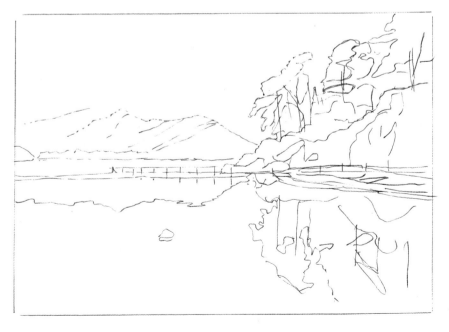

Step 2

Lighten any outlines then use 5H and 3H to complete the background mountain and the trees down to the waterline, in strokes that follow the inclines. Add the rock in the lake on the left in HB.

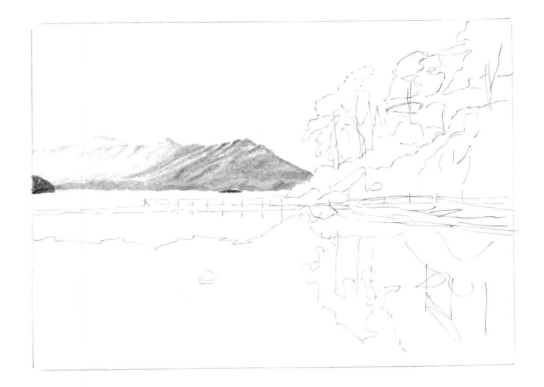

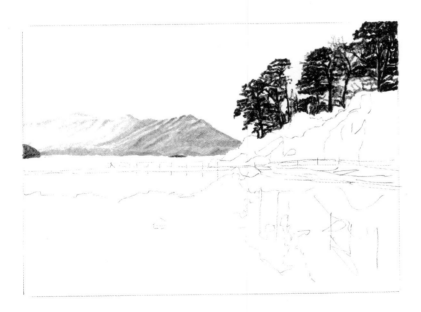

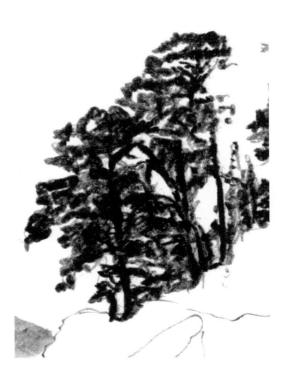

Step 3

Add the conifer tree shapes on the right along the skyline in bold HB, drawing dark, vertical strokes for the trunks and short rows of dark and medium tones to define the branches.

Step 4

Draw the foreground slope in dark and medium HB tones, then add the row of fence posts along the bottom edge. It's not always easy to identify the details at this scale, so focus on recognizing any shapes and patterns such as the contrast between the dark and light shapes of the fallen trunks and the blobs of very dark tones merging into surrounding blurry medium-dark tones (see detail below).

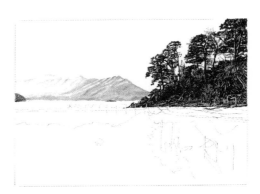

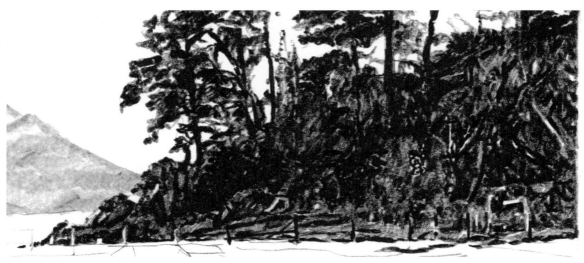

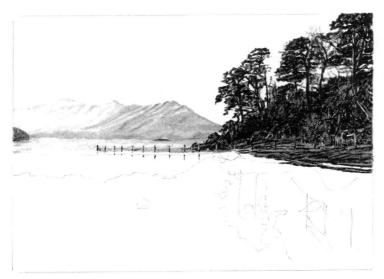

Step 5

Now, use HB to add the shoreline details and the fencing that extends into the lake. Add the fence post reflections in short, stacked, horizontal strokes that are paler at the edges to create the blurred effect of the reflections.

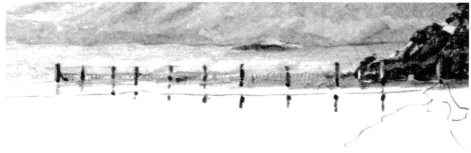

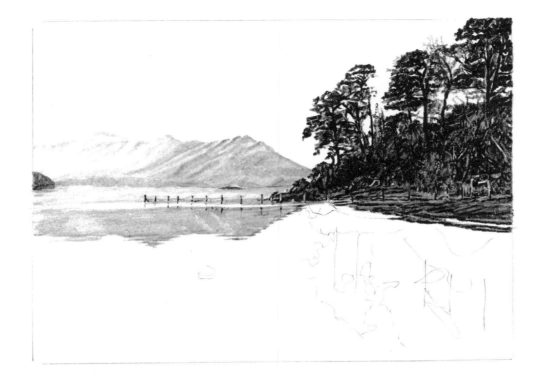

Step 6
Use 3H and 5H to add the reflections of the mountain in the lake.

Step 7
Use HB and rough horizontal strokes to draw the dark- and medium-toned reflections of the trees in the lake, leaving some areas blank. Try to keep the strokes horizontal (mine were not and I amended them later, drawing faint horizontal guidelines with a ruler to help me).

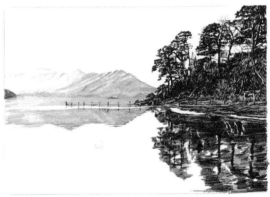

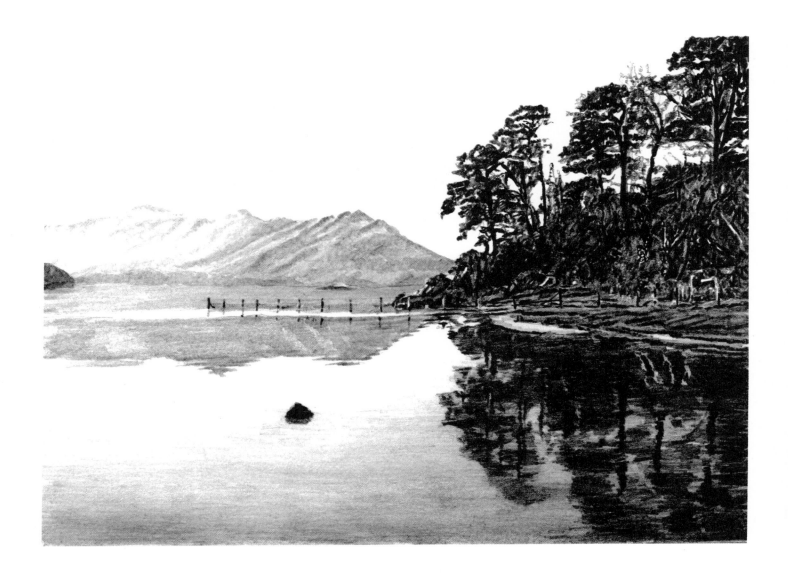

Step 8
Finally, draw the rock in the lake in HB, then add the water tones as smooth tonal gradients from 5H to H followed by a blending tool. Finish by using the H pencil to overshade the area of tree reflections in the water.

Mountain scene

The lower slopes of Scafell and Scafell Pike on the right and Kirk Fell and Great Gable on the left create this mountain scene in the north-west of England. The observer's low viewpoint of the foreground public footpath sign and gate is interesting as it helps to emphasize the majestic mountains behind and creates the feeling of the start of a journey into the landscape. It also adds a man-made structure to this natural scene.

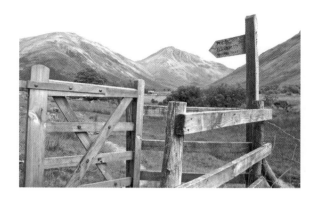

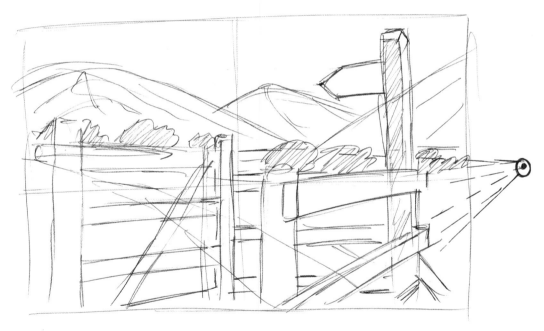

Make a rough sketch and locate the vanishing point on the right-hand side, shown here as a circled dot, by following the lines of the two fence rails. The shadows tell you that the scene is illuminated from the right-hand side.

VIEWPOINT: THE EFFECT ON YOUR SCENE

Once you have identified a scene to draw, you can affect the nature of the drawing by the viewpoint you choose. If your viewpoint is low down, so that your subject towers above you, the scene may appear to the viewer to be more majestic and powerful than it is in real life. Alternatively, if you have a high and commanding viewpoint looking down onto a scene, it will appear to be less significant and the observer more dominant. An eye-level, neutral viewpoint allows the observer to feel more a part of the scene. Experiment with drawing from different viewpoints, thinking about how the viewer will experience your drawing.

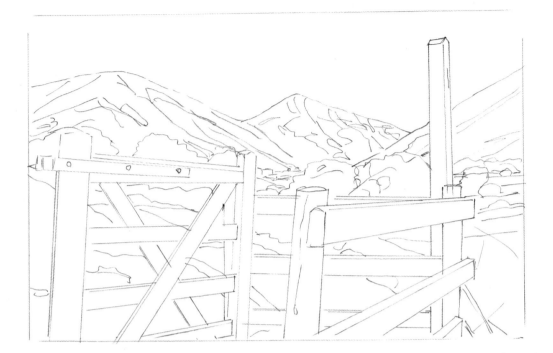

Step 1
Carefully draw the main shapes as faint outlines. You can use a ruler if you wish for the straight edges of the gateway.

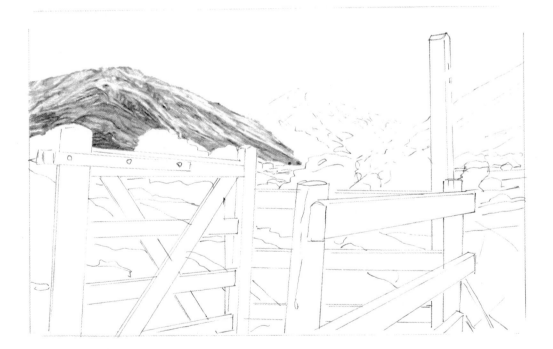

Step 2
Use an H pencil to shade the left-hand mountain in blended pale tones, following the lines of the slopes. Erase any guidelines that might show through the work.

Step 3
Complete the central mountain in the same way, except in paler 5H tones.

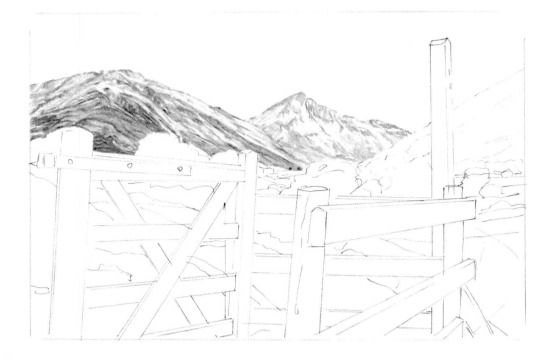

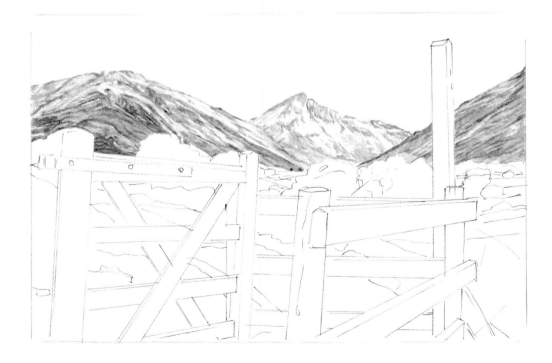

Step 4
Now, use an H pencil to shade the slightly darker-toned slopes of the right-hand mountain.

Step 5

Working from the background to the foreground, start to fill in the various details of the valley. Use the techniques you have already practised to add the trees, field boundaries and distant farmhouse in H and HB, and use 5H for the fields.

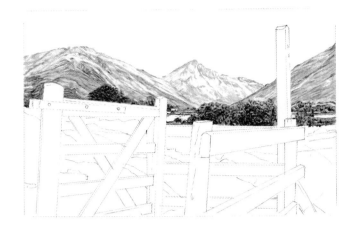

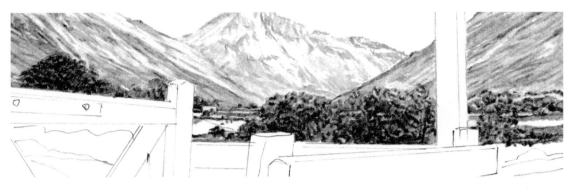

Step 6

Now, begin to add the foreground details in HB, carefully shading between the bars of the gate and fence, leaving the footpath blank. See the tip on page 43 about shading up to edges if you need to refresh your memory about this technique. Shade the grass as rows of short, upright, parallel strokes in slightly different ones, then use individual darker strokes for the spiky leaves.

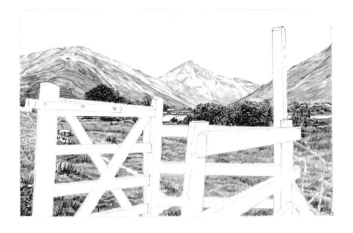

Step 7

Continue in the same way to complete the rest of the foreground vegetation, leaving the wooden planks and fence wires blank so that they become negative shapes.

Step 8

Start to add the gate details. Draw the two upright post faces with blunt H and the remaining wooden plank features with HB. Use rough strokes and paler tones for the wood, following the line of the woodgrain, then very dark tones for the knot details. Add thin, dark lines to emphasize the woodgrain. Use even, medium, blended tones for the gate hinge, then very dark tones for the shadows, the end of the hinge, and the circles for the bolt heads.

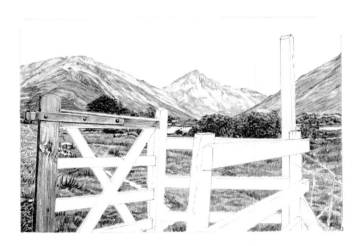

Step 9

Complete the rest of the gate in HB, using tonal gradients to shade the bolt heads and areas of shadow.

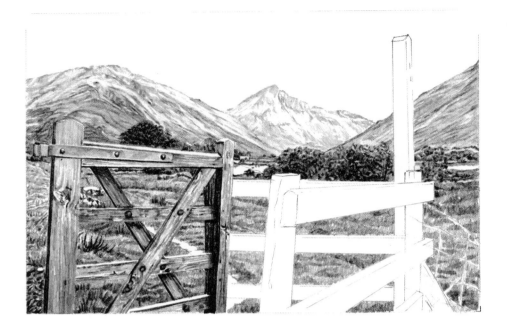

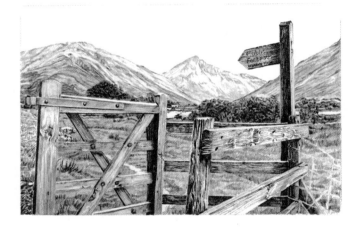

Step 10

As before, use HB tones to shade the wooden planks of the fence but, this time, draw separated strokes so that you exaggerate a few areas of the woodgrain. Use tonal gradients when shading the vertical circular posts and darker tones for areas of shadow. Draw the strands of wire around the post as strips of dark tone, leaving the other pieces of wire white. Add the signpost details in HB.

Step 11

Finally, add the remaining strands of wire fencing as discontinuous strips of dark HB tone, leaving the rest of the wire blank. Review your work, check the consistency of tones across your drawing and make any adjustments. I used 3H to overshade the wooden rails and posts, then darkened the middle round post with HB. I also used 3H to overshade the ground vegetation, followed by HB to emphasize some of the strips of grass and clumps of plants. The completed drawing is below.

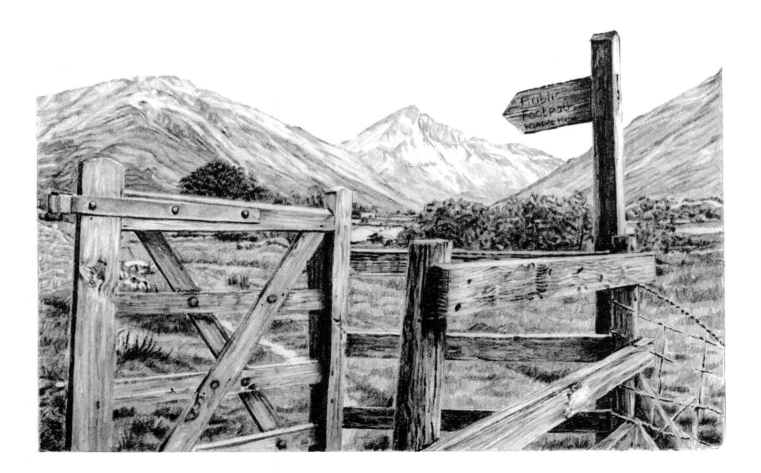

City scene

Compared to the previous tranquil, outdoor scenes, this glass and concrete city scene is full of blocky shapes and contrasting tones which convey a real sense of intensity and drama, especially with the darker tones in the foreground. It may appear to be just a collection of office blocks, but the lower-than-eye-level viewpoint which highlights the converging lines of all the elements adds extra interest and draws you into the scene. It obviously contains a lot of detail and structural elements, so the aim is to draw a simplified picture in roughly shaded tones. You can choose how much detail you would like to include.

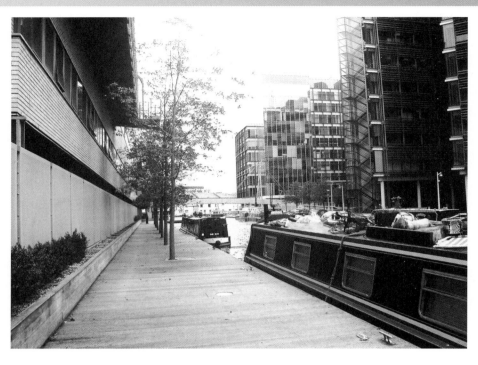

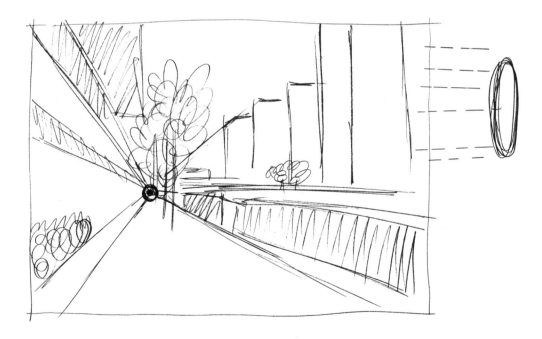

Begin by identifying the vanishing points so that you can roughly sketch the main shapes in the correct perspective. The first vanishing point (a circled dot) is on the horizon, or eye level, and is easy to find by following the converging lines of the footpath, the rows of windows on the left, and the slope of the office roofs on the right. The lines of all the building storeys on the right point to the second vanishing point, as shown by the dotted lines, but this point is too far away to be identified on the page. There is also insufficient detail to identify a third, vertical, vanishing point, although you can see that the taller buildings appear to lean to the left.

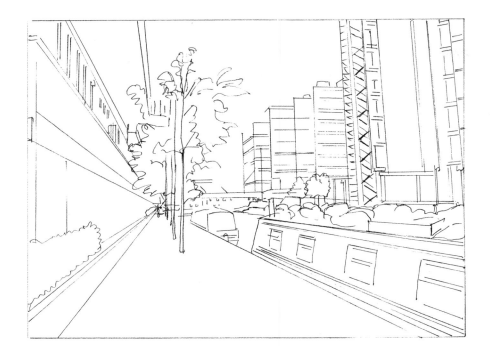

Step 1

Use the first vanishing point as the basis for carefully outlining the main shapes in the scene in the correct perspective: the buildings, canal banks, barges and office blocks. At this stage, I used a ruler to draw the straight lines because it was much quicker than drawing freehand. Put in the trees and as much detail as you need to complete your outline drawing. I added horizontal lines to mark various storeys in the buildings, as well as the canal boat side, windows, and assortment of items on its roof, and the main vertical and diagonal lines of the glass-encased building stairwell. Also consider adding a few vertical guidelines to the office blocks to help you align the windows when you shade them in later.

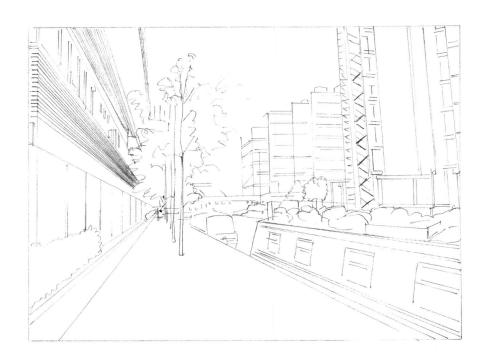

Step 2

Start with the building on the left and use HB to draw numerous closely spaced lines for the upper-storey white brick wall under the overhang, and the 15 rows of white bricks on the first floor. Then use H to draw the pale vertical lines that separate the wall panels on the ground floor. Add a few thin marks at the edge of the upper overhang to describe the storeys above, using an eraser to lighten any guidelines if necessary.

Step 3

Use 5H to shade the rows of white bricks and wall panels, using 3H for the darker patches and shadows. Use HB to add a few dots of shadows between the foreground wall panels. Shade simple blocks of HB tones for the row of windows on the first floor, leaving the window frames and the most reflective windows blank. Use 3B to add the very dark tones beneath the building overhang, fading to paler tones down the brick wall. You may find it easier to shade the lines under the overhang and along the diagonal rows of bricks if you rotate your page. For now, roughly shade around the tree foliage, with the leaves remaining blank. Continue to use 3B to add the long, thin gap between the ground and first floor and the shrubs and stones in the planter. Use long strokes to shade the planter box frame in medium-toned HB. When you have finished the building, review your work and make any adjustments. I darkened the gaps between the ground floor panels in the foreground.

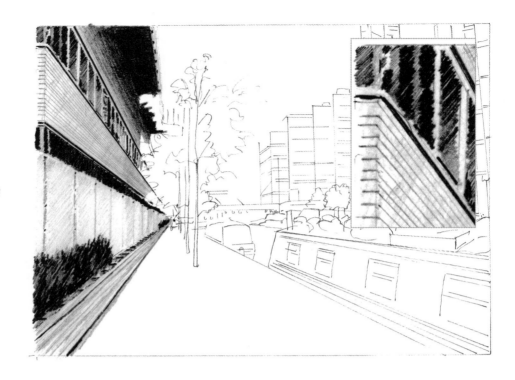

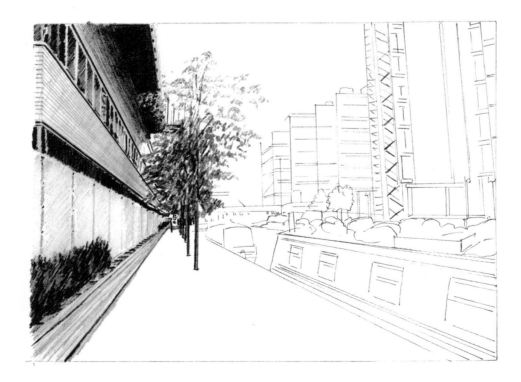

Step 4

Add the line of trees in H and HB by roughly sketching small clumps and lines in diagonal strokes.

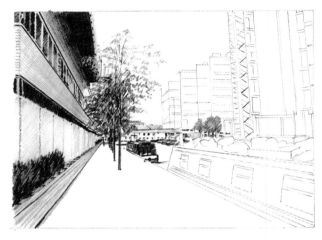

Step 5

Add the buildings and background details in H and HB, using small blocks of tones to define the windows and diagonal strokes to draw the trees on the right. Then, use HB to add the barge moored next to the row of trees on the left.

Step 6

Add rows of windows to the office blocks on the right-hand side in HB as rectangles of tone, leaving vertical gaps between each window and horizontal gaps to define the various storeys. Draw extra guidelines if needed to help you align any windows – my vertical alignment is a bit wonky! Then overshade the office block windows in 3H. The glass-encased stairwell is more complex, but is just a repeating pattern of diagonal lines which appear paler on the upper few floors.

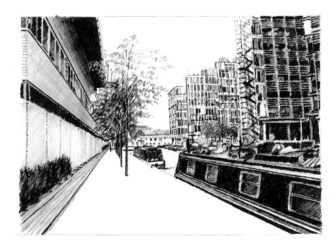

Step 7
Now, using dark and medium HB tones, work on the canal barge in the foreground with its assorted items along the roof.

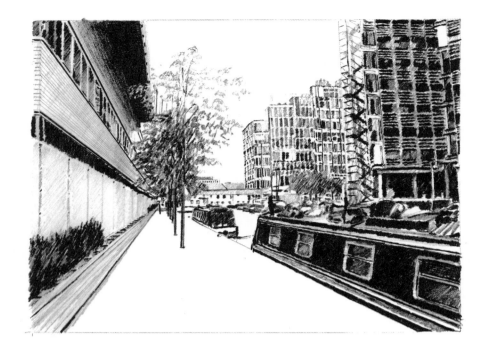

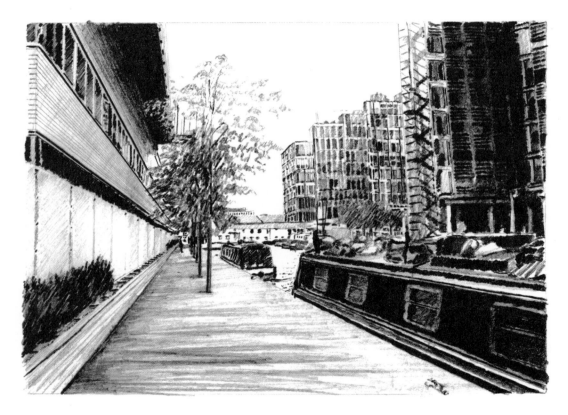

Step 8
Finally, use HB to add a few ripples to the water surface and draw long horizontal strokes to shade in the path. Add dark shadows along the bottom edge of the planter and at the base of each tree. Review your work again and make any adjustments. I darkened the nearest office block using the flat side of an HB pencil point, and then overshaded the barge side paintwork in HB and the windows in 3H. I slightly enlarged the tiny figure in the background and then used a blender to smooth the tones of the path.

Seascape

The final exercise in this chapter, which you'll complete in blended tones, is a sandy bay encircled by dunes with a view to hills across the water. The viewpoint from the top of a dune allows you to see a large expanse of beach and bay below. The deep depth of field is created by the few dark-toned rocks in the foreground which contrast with the very pale hills in the far distance and this, combined with the lighter tones of the sea and sand, helps to create a very relaxing scene.

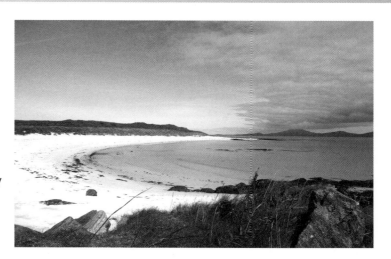

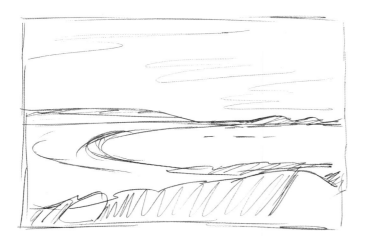

Quickly draw a rough sketch of the scene to become familiar with the elements – strips of land, sea and sky.

Step 1

Outline the main shapes of the narrow ribbons of land and elliptical shoreline, noting that it's very difficult to identify any lines of perspective and vanishing points except for the overall aerial perspective.

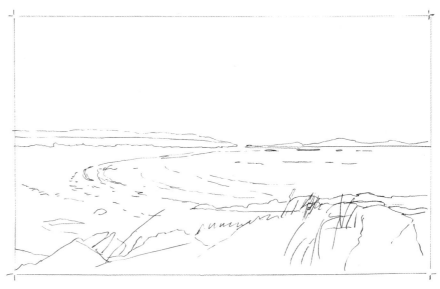

Step 2

Lighten your guidelines with an eraser so they won't show in the finished work, then use an H pencil to draw the three-layered dune section on the left – the darker vegetation on top, middle layer of pale tone, and bottom layer of medium-toned grass and small rocks.

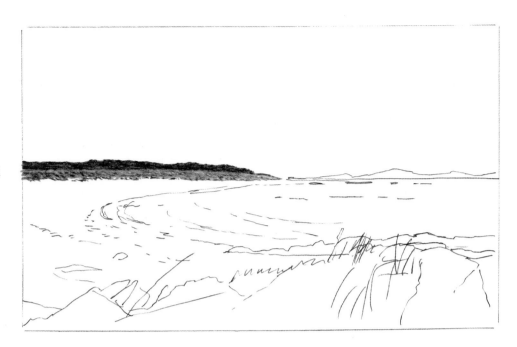

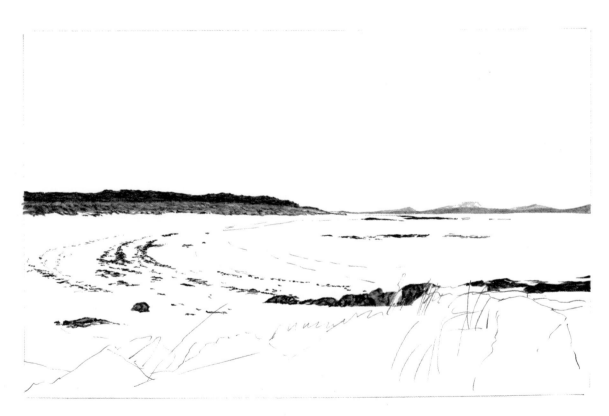

Step 3

Use 3H and H to draw the distant hills, then HB and a very fine pencil point to add the dark rocks along the curved shoreline.

Step 4

Darken the shoreline of the distant hills with HB, then use 5H, 3H and H to shade the blended tones of the water. Add very subtle darker patches to indicate submerged rocks and the different wave reflections.

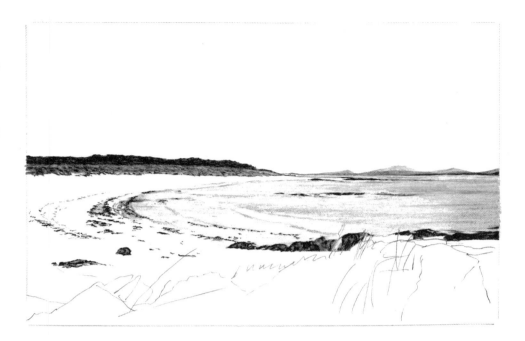

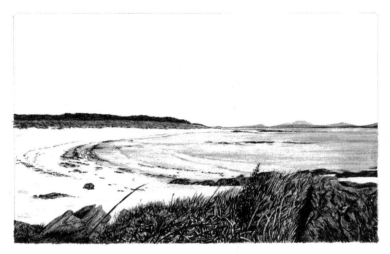

Step 5

Draw the foreground vegetation and rocks as an assorted mix of triangular and linear shapes in darker HB tones, leaving white bits to denote reflective leaves and blades of grass.

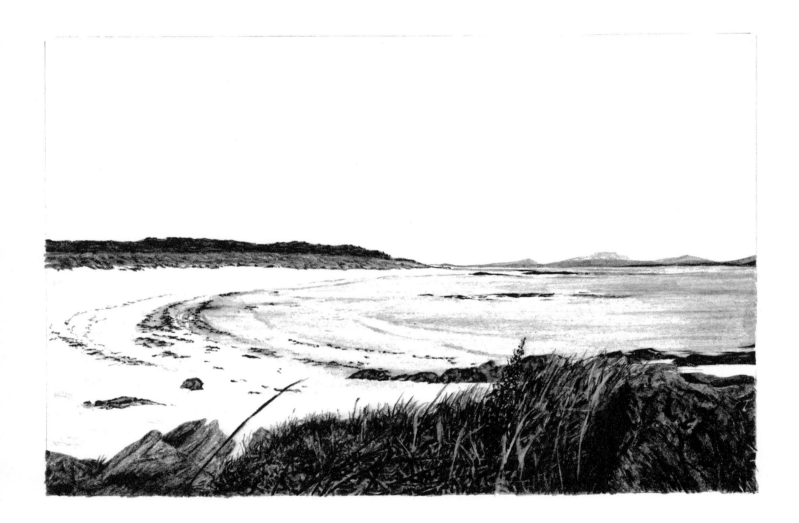

Step 6
Overshade the foreground vegetation with 3H and darken some areas with the flat lead of an HB. Use a sliver of eraser to create a few blades of grass.

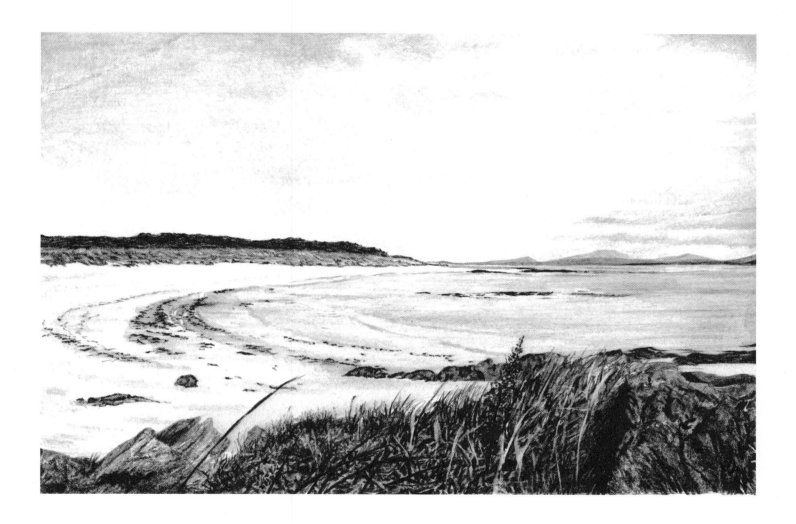

Step 7

Draw the sky in very pale, blended tones of 5H, 3H and H, using the techniques you learned on page 43 to shade in large areas of even tone. Finally, use a blender to smooth the sky tones, then review your work and make any adjustments.

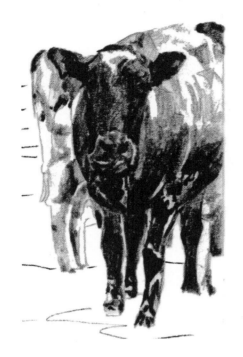

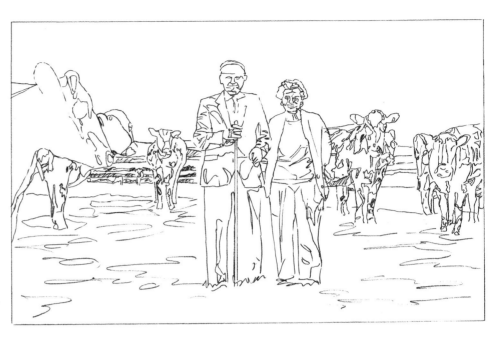

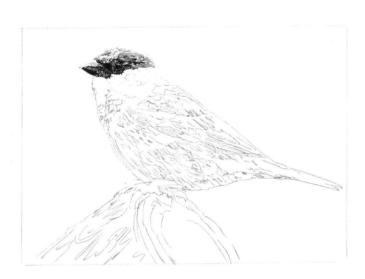

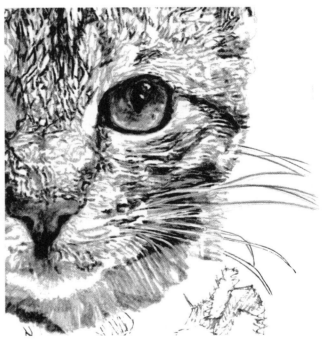

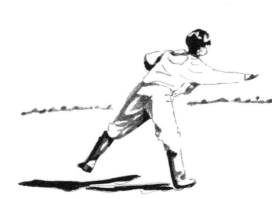

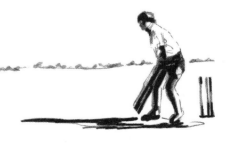

People and Animals

Let us look now at drawing people, often considered to be one of the most difficult subjects. However, people are no more difficult to draw than any other subject because you will still use the same techniques you've already practised. The difference is that you must ensure you position all the shapes and features correctly to achieve a good likeness. The skill lies in your powers of observation, your hand-eye co-ordination, and your ability to draw what you see. In this chapter we'll look at some key techniques to employ as you work your way through the exercises.

Finally, we'll move on to some detailed step-by-step images of animals. The focus is on fur and feather textures and although these pictures are larger and more detailed, you'll continue to use the same methods as in previous exercises. The final exercise showing a dog will introduce another way of working with a photograph to produce a very detailed and realistic drawing.

KEY TECHNIQUE: BODY PROPORTIONS

The first step when drawing people is to develop an understanding of body proportions, and the following diagrams will help to explain this. Although people come in many different shapes and sizes, the relative proportions of head to body size remains fairly constant for adults, young people, and babies.

A baby's body is between three and four times the length of its head, a child's body five to six times, and an adult's body roughly eight times the length of the head.

CHOOSING A POSE

If you're not sure where to start when drawing people, begin by sketching the following examples of stick and 'blobby' adults and children in various poses. You'll be surprised at how easy it is to create lifelike figures using this method and how quickly you'll become proficient at drawing them.

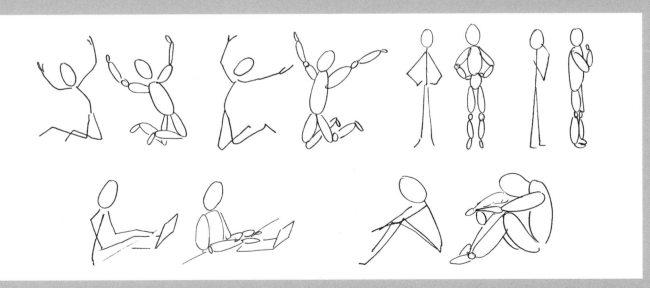

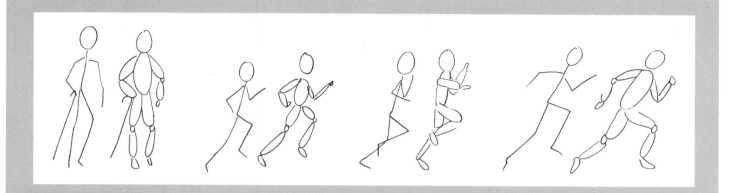

When observing people, identify the overall shapes made by the head, torso and limbs then represent these shapes with lines for the stick people, and jointed oval shapes for the 'blobby' people.

Once you've mastered some basic poses, the next step is to add clothing and a little more detail. To do this, we'll use some of the examples shown above and at the foot of the facing page, and simply add a few shapes in roughly shaded different tones. Notice the instant transformation into more lifelike figures.

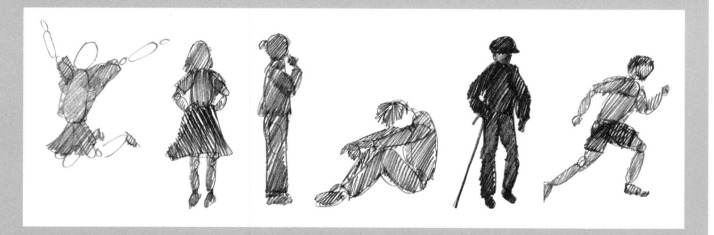

Add a few roughly shaded tones to stick people to create clothed figures.

If you'd like to practise drawing other people with different poses and gestures, you'll find plenty of examples to copy in magazines and online to inspire you. To try drawing from life, you can sketch yourself in front of a mirror or people out and about in public places. You don't need to ask permission to draw people from a respectful distance in a public place and they'll continue to act naturally, unaware of what you're doing. Remember to simply draw what you see.

Children playing

We'll start with a sketch of two children playing cricket on the beach – the type of sketch you can easily accomplish to capture live action or reproduce later from a photograph. You will find that not all photographs are very detailed, and this photograph is deliberately blurry to show you that you can use your skills to create an impression of a scene using simple shapes and tones.

Draw a rough outline of the two children in oval shapes to familiarize yourself with the poses and proportions.

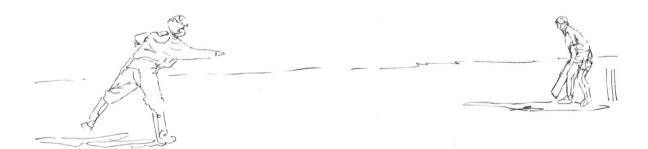

Step 1
Use your observation skills to carefully outline the main features in faint lines and achieve the required likeness and proportions. Draw in sufficient detail to guide you when you add the tones.

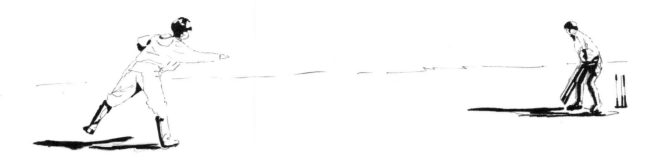

Step 2
Use HB to add the darkest tones on the heads, the areas of shadows
on the clothing and beach, and the cricket stumps.

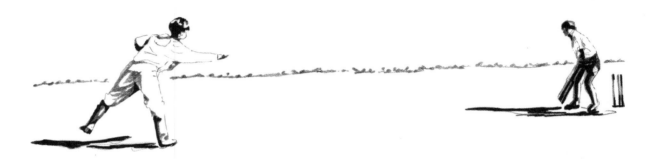

Step 3
Add medium tones in HB to describe the clothing folds, cricket stumps and the
tidemark line of pebbles on the beach.

Step 4
Finally, use 3H to add the paler tones for the remaining features on
the heads and bodies. The detail on the left shows the shapes and
tones on both heads.

KEY TECHNIQUE: HEAD PROPORTIONS AND EXPRESSIONS

So far, we've looked at overall body shapes and the next step is to look at techniques to help you draw lifelike faces.

The human head obviously grows in size from birth to adulthood and a comparison of the relative sizes and proportions is illustrated here.

 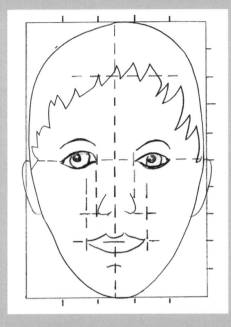

Left to right: (a) baby's face, (b) child's face, (c) adult face. A common mistake is to place the features too high on the head; you'll notice here that the eyes are always on or below the halfway point. Compared to an adult, a baby's features occupy less space and are positioned lower on the head, and the eyes are below the halfway point. A young person's eyes are closer to the halfway mark than a baby's and their features occupy a little more space on the head. An adult's eyes, however, are on the halfway mark. This adult's face is divided into sections to show you how to draw it when you follow the instructions below.

DRAWING AN ADULT FACE IN PROPORTION

Step 1
Draw a rectangle divided into quarters and then draw an egg shape for the head. Divide the rectangle into five columns and ten rows and mark these divisions faintly around the edge.

Step 2
Draw the eyes halfway down (on the fifth row), one eye between the first and second column marks, and the other between the third and fourth column marks. Add a curved eyebrow above each eye.

Step 3
Add the nostrils on the seventh row from the top, between the second and third columns. The nostril width is the same as the distance between the eyes.

Step 4
Go down to the eighth row and add the mouth. The width is the same as the distance between the pupils. On the ninth row, add a small, curved line for the chin.

Step 5
Draw the ears on each side of the face between the fifth and seventh rows.

Step 6
Finally, add the hairline, starting at the second row on the forehead.

FACE IN PROFILE

Now, have a go at drawing this face in profile.

First, draw a square divided into quarters and then marked into eighths around the edges. Add a diagonal line which indicates the limit of the hairline and then use the marks around the edges as a guide to add the remaining features.

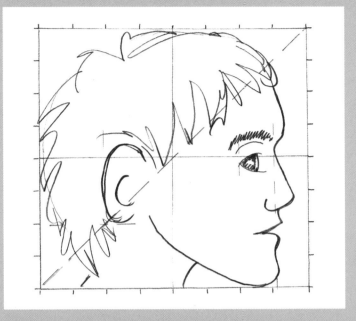

EXPRESSIONS

You'll now apply the techniques about proportions you've just learned, such as placing the eyes halfway on the adult head, to have a go at sketching these comic strip expressions. Notice the importance of the eyebrow and mouth shapes when you define expressions.

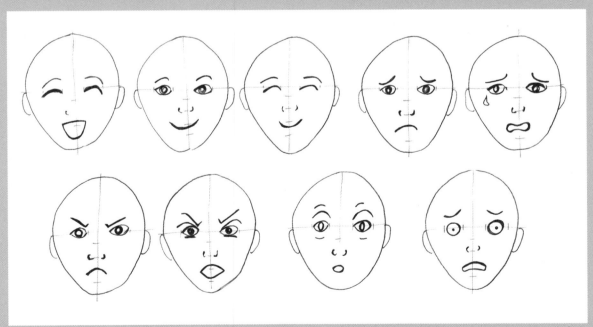

Top row, left to right: Very happy, smiling, blissful, sad, very upset.

Bottom row, left to right: Annoyed, very angry, surprised, frightened.

Mastering these techniques will enable you to place features correctly when you are producing quick sketches and rough drafts for more detailed works. When you work on more detailed portraits, however, the emphasis is on creating shapes and areas of tone rather than drawing lines, and this is the subject of the next exercise.

Expressive face

You'll produce this moderately detailed portrait in a mixture of rough and blended shading, using a grid to help you draw the features in the correct place. Follow the steps to see how this photo was interpreted. The photograph is not very clear, to help you focus on using a grid to place the features and areas of tone, rather than looking at the finer detail.

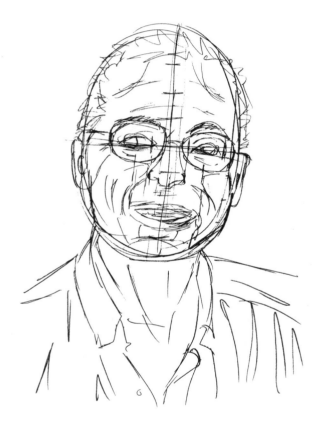

To familiarize yourself with the subject, first produce a rough sketch in the correct proportions.

KEY TECHNIQUE: USING A GRID

Use a grid to help you draw your subject in the correct proportions on the page. A grid is placed over the reference image to divide it into smaller sections and then the details are carefully replicated onto the drawing page, square by square. If both the grids and details are replicated accurately, then the drawing will automatically be correctly proportioned. Using a grid speeds up the process of outlining a drawing and can also be used to scale a drawing up or down. To help you navigate your way around the drawing, you can number the squares along the vertical and horizontal axes, starting from the origin at the top left corner.

Step 1

To prepare for your moderately detailed portrait, draw a grid over your photograph, either onto a transparent overlay if you do not wish to spoil your photo, or directly onto the photo itself. Use a permanent marker so the ink does not smudge. The size of the grid depends upon personal preference and the size and resolution of your image and drawing. This photo is 155 x 217 mm (6 x 8½ in), and I drew 2 cm (¾ in) squares, numbered, with the origin in the top left-hand corner. In this exercise, because the drawing is the same size as the reference image, draw the same size grid onto your page.

Step 2

Refer to the photo and, square by square, replicate the details onto your page, including the numbers if you wish. Look for the main areas of tone and faintly outline these in as much detail as you need. Once you have copied the main shapes from all the grid squares, your drawing should look like this, and you can begin to shade in the tones.

The extract shows how the shapes in one square of the photo grid (the ear on the left) are replicated into the corresponding grid square on the page.

Step 3

Lighten any guidelines with an eraser so they won't show in the final work and then, starting at the top of the picture, refer to your photo as a guide to softly shade the hair shapes in blended 5H and 3H tones. Some of the hair is white so will naturally blend into a white background. If you like, you can emphasize the hair outline later by adding a darker edge or a darker background (so the hair becomes a negative space). The particular effect you choose will depend on the time you have. I chose to leave the background blank and the hair as a faint outline.

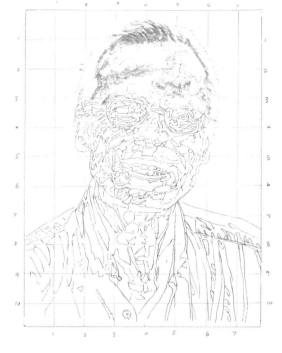

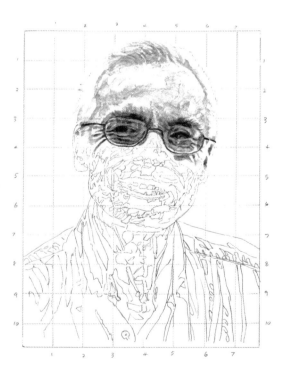

Step 4

Add the shapes of the forehead, eyes and spectacles in H and HB, carefully blending the tones. Don't forget to rest your drawing hand on a piece of scrap paper to avoid smudging your pencil marks.

Step 5

Continue down the face, shading the shapes of the nose, cheeks and ears in various HB tones, leaving the highlighted areas blank.

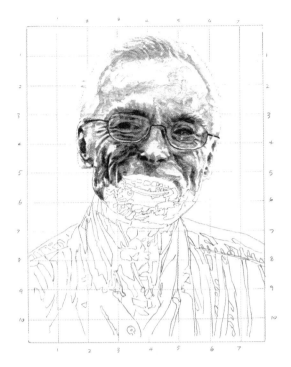

Step 6

Still using HB, add the mouth and chin details, leaving the upper teeth and part of the lower lip blank for now.

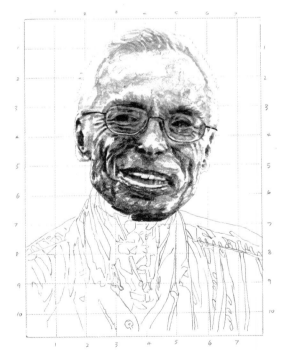

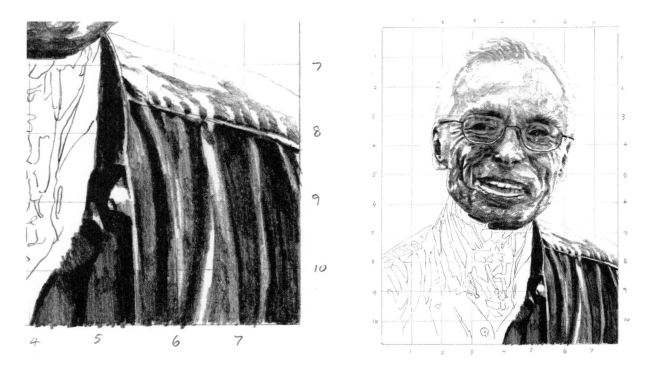

Step 7

Draw the shirt fabric in darker HB tones, remembering how to emphasize the folds using adjacent strips of contrasting dark and light tones in the same way you drew the kitchen curtains on page 84. Leave the highlighted areas blank.

Step 8

Add the neck details, again in HB tones, and then review your work. I used an eraser to lighten some of the fabric folds on the shoulder.

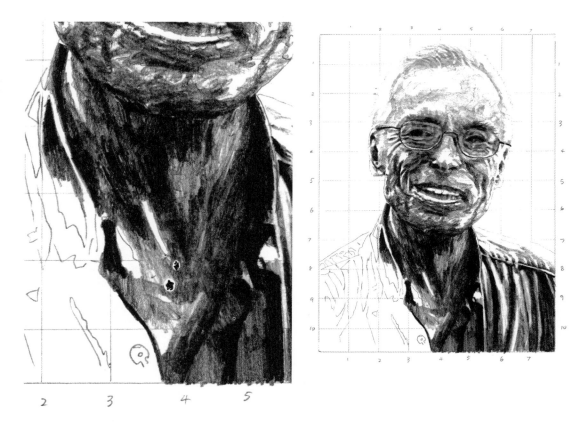

Step 9
Complete the rest of the shirt on the left-hand shoulder in HB dark tones.

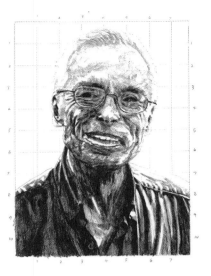

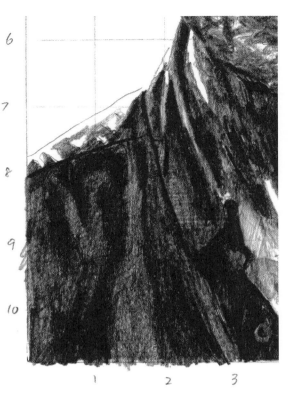

Step 10
Hold your picture up to a mirror to see if you need to make any final adjustments. I overshaded the skin and shirt in 5H to even out the tones, then used HB to draw lots of parallel, slightly sloping lines on the right shoulder to create a checked shirt pattern effect. I then overshaded and darkened the teeth and lower lip slightly in H and created a more curved shape to the dark mouth crease on the right. Finally, I lightened the skin tones on the left side of the face a little, then used a blender to soften all the skin tones.

KEY TECHNIQUE: WORKING WITH PEOPLE

For a portrait you will require a model, either to pose for you in person or in the form of a photograph – very few of us can draw completely from memory. Family members and friends may be happy to pose for you, and if you're likely to see people while you're out and about, take your camera or a sketch pad so that you can practise on the spot. Good places to sketch are cafés and restaurants where people are likely to be sitting still for a while, as well as parks, libraries and on public transport.

If you're lucky enough to have a willing model, prepare beforehand. Explain to your model how long you would like them to pose for and the sort of poses you would like to draw. Ensure the space is welcoming and comfortable, with suitable seating and lighting and perhaps some background music.

Married couple

This exercise requires you to draw several subjects as it comprises a married couple surrounded by Ayrshire cows on a family farm. A herd of cows gives you the opportunity to draw multiple animals viewed at different angles and attitudes and, because parts of these animals are white, you'll draw these as negative shapes. Your observational skills will be tested as you work out which legs belong to which cow.

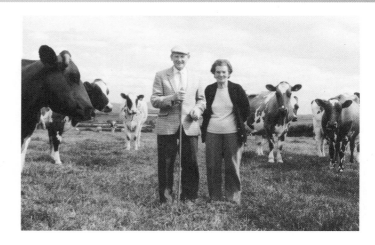

It is difficult to identify any lines of perspective from this photo, but you can surmise that the vanishing point is straight ahead in the direction of view, at eye level, on the horizon. The effects of aerial perspective are very evident in this scene as there are darker tones in the foreground and paler ones in the distance and the animals appear smaller as they recede from the observer.

Begin by drafting the various elements to ensure you have correctly gauged proportions and perspective.

Step 1

Take care to draw the main areas of tone as faint outline shapes. For the purpose of this exercise, the larger cows are numbered one to seven from left to right.

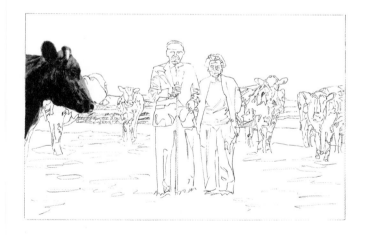

Step 2

Focus on drawing the shapes and use a blunt HB point and mostly dark tones to shade the head and shoulders of Cow One on the far left-hand side. The eye is created as a black circle with a small white dot in the upper part of the circle, which is then surrounded by a thin outer ring of medium-dark tone. Leave most of the cow horn blank as a negative shape apart from a strip of medium tone down the left edge.

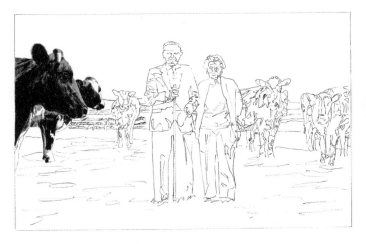

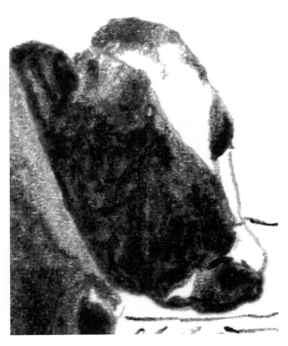

Step 3
Still using HB, complete Cow Two, which is partially concealed behind Cow One. Shade the darkest shapes first and use tonal gradients to fade to the medium-toned areas, shading carefully around the white areas. The right-hand eye is defined by a very dark elliptical shape and protruding eyelashes using a sharp-point HB.

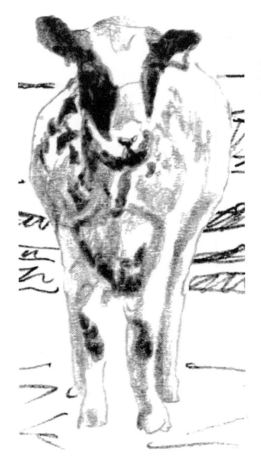

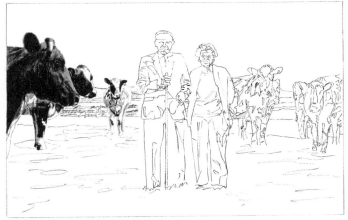

Step 4
Use H to shade the pale tones of Cow Three and HB for the dark-toned ears and face patches, creating small pale shapes to denote the eyes and ear tips.

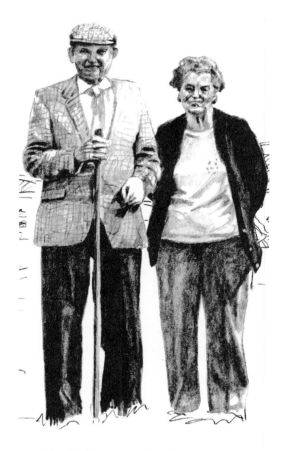

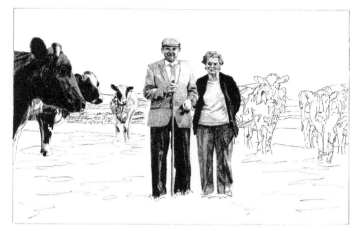

Step 5
Add the two figures using H and HB. You will need a very sharp HB pencil point to draw the intricate facial features in darker tones as shown in the detail.

Joe: Shade the cap and jacket in soft tones with a blunt H point, then add the creased fabric shadows in dark HB. Draw the lines of the check pattern in H, using wavy lines to create the illusion of volume and form. Shade the trousers in dark HB with strips of medium tone to denote the highlighted creases. Use gradient shading to define the stick.

Kathleen: Shade the jacket in dark HB tones, the trousers in medium and pale HB, and the pale top and fabric folds in blunt-point H.

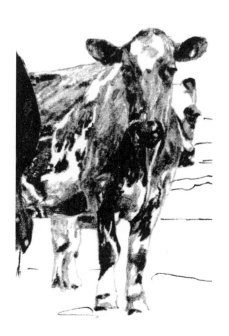

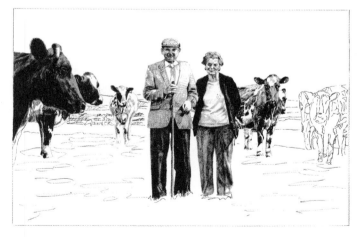

Step 6
Shade Cows Four and Five with a blunt-point HB leaving some areas white, and use a very sharp point to complete the eye and nose features.

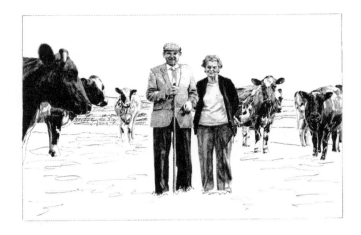

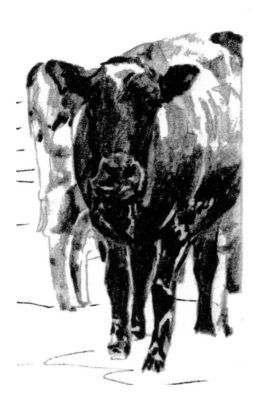

Step 7

Complete the rear end of Cow Six in blunt-point H tones and Cow Seven in darker-toned HB. As before, carefully add the facial features with a sharp-point HB.

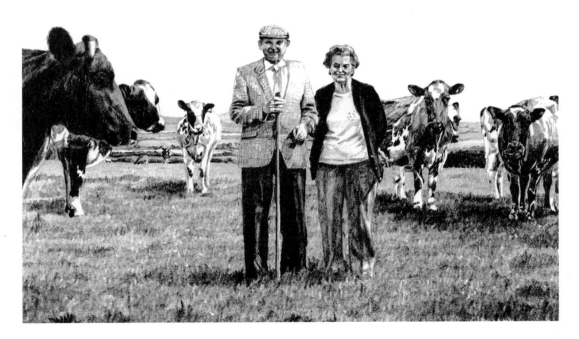

Step 8

Add all the background details, using horizontal strips of soft H tones for the distant fields and darker-toned HB strips for the hedgerows. Add the grass in the middle distance with blunt-point H and the foreground grass as rows of short vertical strokes in 3B, in the same way you added the grass for the mountain scene exercise. Finally, review your work and make any adjustments.

Garden bird

The familiar house sparrow (*Passer domesticus*), found in most parts of the world, is seen here perched on the end of a sawn log. This detailed drawing requires fine hand-eye co-ordination and keen observation skills. You'll complete this picture working from head to tail and will need to switch between a fine and blunt pencil point as you progress.

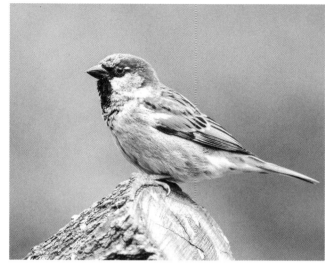

Begin with a rough sketch to identify the various oval shapes and overall dimensions.

KEY TECHNIQUE: USING PHOTOGRAPHS OF ANIMALS

Unless you have an exceptional memory to recall every feature of your intended subject, you'll need a reference photograph as most animals are unlikely to stay still for long. This is particularly the case for detailed works, when a photograph is invaluable to clarify subtle tonal variations or those few whiskers that constitute a particular feature.

Obviously, it's preferable to have a photograph with your subject in clear focus and with high-resolution detail. For copyright reasons, you should always obtain permission to use someone else's photograph. You can also use a grid or ruler in conjunction with a photograph to help lay out your drawing proportions, and then take your time to accurately outline the various shapes to achieve a good likeness.

Step 1

Refer to the photograph to lightly outline the main shapes and tonal areas of the sparrow, correctly positioned on your page. Remember you can use the rule of thumb or a grid to help you draft this framework.

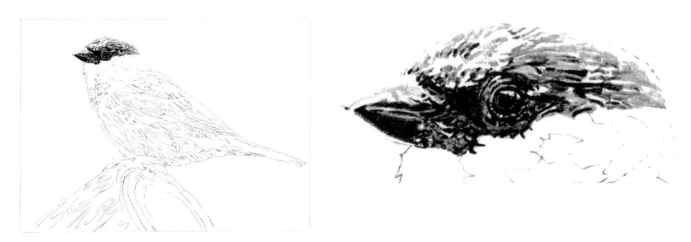

Step 2

Lighten any guidelines as necessary then add the beak details in 3B and the head in HB tones, using a very fine pencil point to draw the eye shapes. Use paler tones to blend and soften the edges of any areas of dark tone. The eye and beak consist of many circular shapes, while the feathers on the head are indicated by a series of short lines. If needed, use a tonal strip to help you identify the correct values.

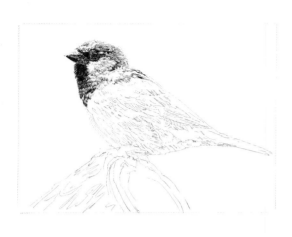

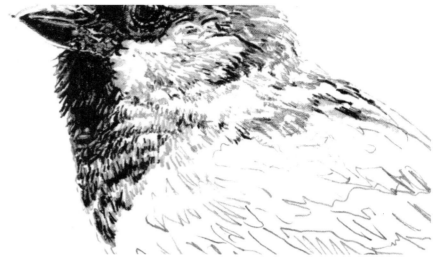

Step 3

Add the soft feather details to the throat and neck as rows of short lines with white spaces in between, like lots of little worm shapes. First, draw these lines in HB then overshade with 3H. This is similar to the way you created the areas of grass in the mountain scene (see page 148) and herd of cows (see page 180).

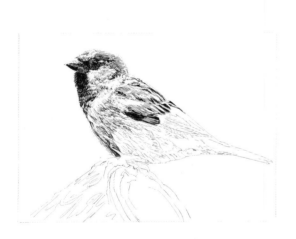

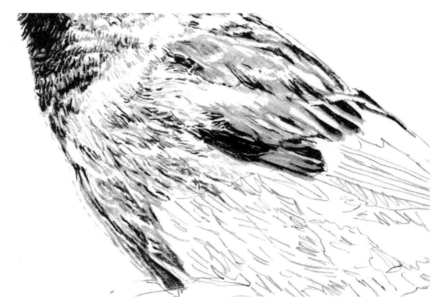

Step 4

Continue to add the soft feather details of the chest as collections of lines and white spaces, then draw blocks of medium and dark tones to define the large feathers of the wing, leaving white spaces in between some of them.

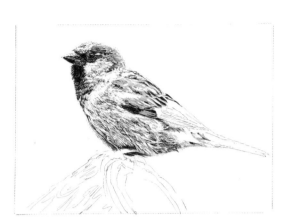

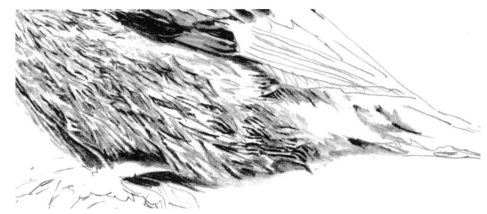

Step 5

Complete the soft feather details of the chest down to the claw in HB and 3H, following the orientation of the feathers and using slightly darker lines towards the tail. When working at this level of detail in an area containing so many similar features and a maze of lines it can be easy to lose your place, so use the more distinctive dark-toned shapes to help you find your location in the drawing.

Review your work and make any adjustments.

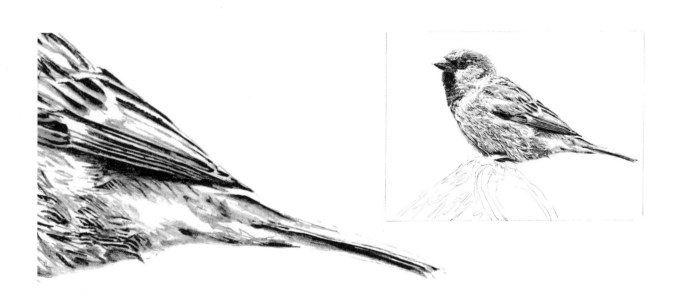

Step 6

Complete the wing and tail details as stripes of dark, medium-light and white tones.

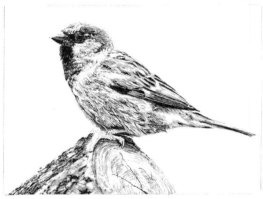

Step 7

Draw the bird's foot and the log shapes in 5H, H and 2B. Note that the claw is a negative space defined by the surrounding log tones and cast shadows from the bird. Draw the top half of the bark as parallel strips of wiggly dark-toned 2B lines separated by white spaces, then use H and 2B blended tonal gradients for the section of bark nearest the observer. Draw the concentric circles of the growth rings on the log's sawn surface in H, overshade in 5H, then add the inner bark edge and dark splits in the wood in 2B.

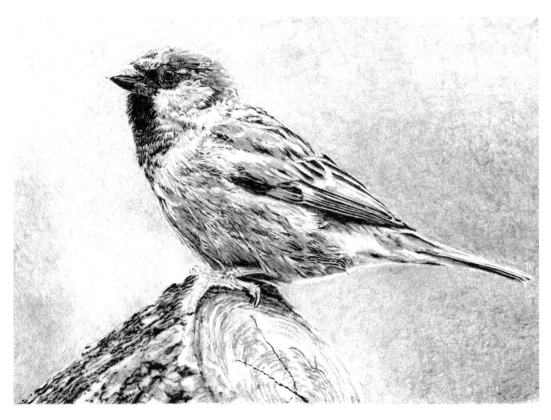

Step 8

Shade the background in blended, soft, even tones using a very blunt point. Start with 5H for the palest areas around the bird and log, fading to H along the left-hand edge and top, and then fade to 2B around the tail and along the right-hand edges. Finally, overshade and blend the bird feathers in 5H, leaving just a few areas white.

When you're working on the drawing detail, you tend to focus on the individual strokes and shapes, but as soon as you step back and review the whole picture, it can suddenly come to life. Sometimes, you may need to take a break or sleep on it and return to look with fresh eyes to review your work.

Wild animal

This magnificent European brown bear (*Ursus arctos arctos*) is the subject of our next detailed drawing, which you will render in blended tones of mostly HB and 3H to capture the dense furry textures. Once you have completed the bear you can choose to add a background or leave it blank.

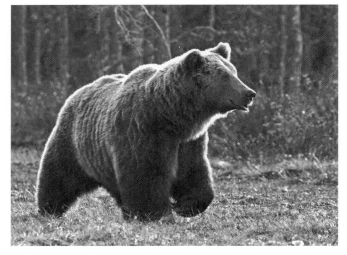

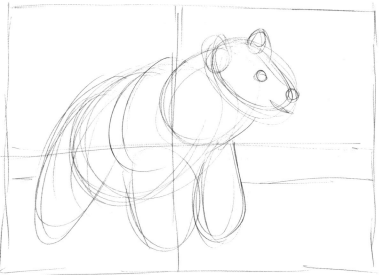

It's always a good idea to make a preliminary sketch to work out the subject shapes and proportions. A rough tonal sketch will also help you identify the main areas of light and shade in the picture so you can incorporate this information about form and volume in your drawing.

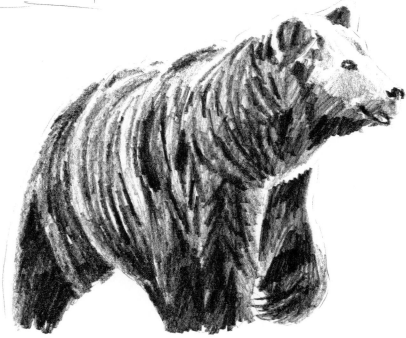

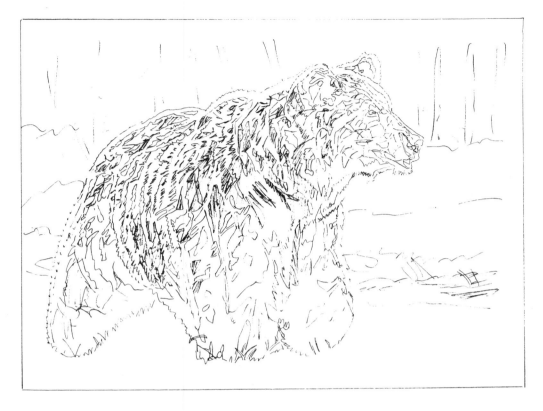

Step 1

In faint tones, outline the main shapes on the bear in the same way you approached the tweed button exercise (see page 40) – you can choose to outline either the dark or light tones, or a mix of both, whichever you find easier. The more time you spend at this stage the better, as this will speed up the process of filling in the tones later.

Step 2

First lighten any guidelines, especially those around the upper outer edges of the bear, then use a blunt-point HB to add the alternating strips of light and dark tones to the rear leg, following your initial outlines. Rotate the page if this makes it easier to draw and use rough strokes in the same direction as the fur. You'll notice the technique is very similar to drawing areas of grass. Leave some areas of fur blank – these will be overshaded later. Draw the blades of grass around the paw as negative shapes.

Step 3

Add the fur details to the flank in strips of dark and light tone as before, varying the pressure of the pencil on the page to achieve the different values. If needed, refer to your tonal strip to help identify which tone to use. Use flick strokes for the fur where it meets the grass.

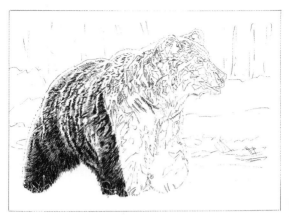

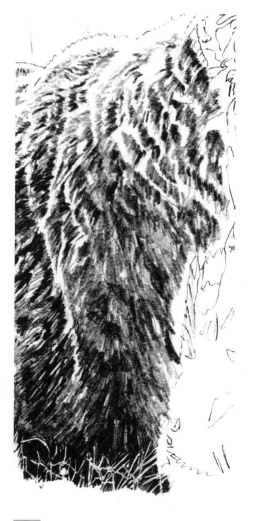

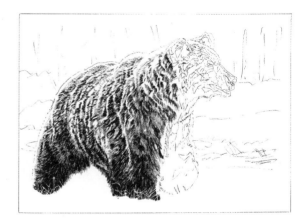

Step 4

Review your work so far to ensure you are achieving the correct tonal balance across the picture and make any adjustments if necessary – I lightened some of the fur on the top of the bear. Still using the same techniques, add the fur shapes to the right leg and up to the base of the neck, leaving some white spaces.

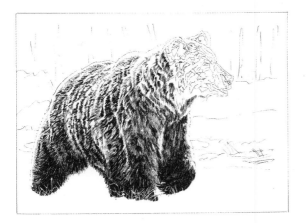

Step 5
Use darker tones in rough downward strokes to complete the other front leg, using negative shapes to define a few blades of grass along the bottom of the paw.

Step 6
Still using HB, but this time with a very fine point, add the eyes, nose and mouth shapes. Next, use a blunt point to add the fur on the rest of the head. This is where you'll appreciate the precision of your initial outlines. These details are tricky to draw, so do not hurry.

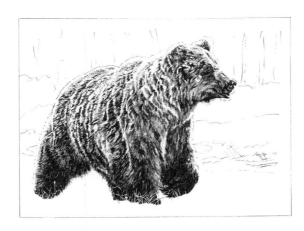

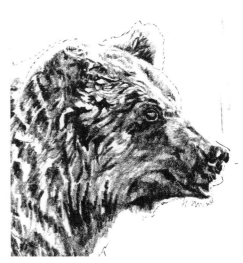

KEY TECHNIQUE: DETAILED FUR TEXTURES

This sequence of three images illustrates how to create soft fur effects.

First, follow your initial outlines to shade the areas of fur in rough HB tones in the same direction as the fur.

Second, overshade and blend the tones with a blunt-point 5H. This adds a layer of graphite that 'seals' over the initial HB strokes.

Third, review your work by holding it up to a mirror and/or closing one eye to identify areas of darker shadow which require darker tones. Then, use the flat edge of an HB pencil point to shade in broad tones. You'll discover that the underlying 5H layer results in the HB creating more soft and subtle effects. Finally, with a blunt point, add short flick strokes of medium and dark tones to draw individual hairs and use an eraser sliver to create individual strands of paler fur.

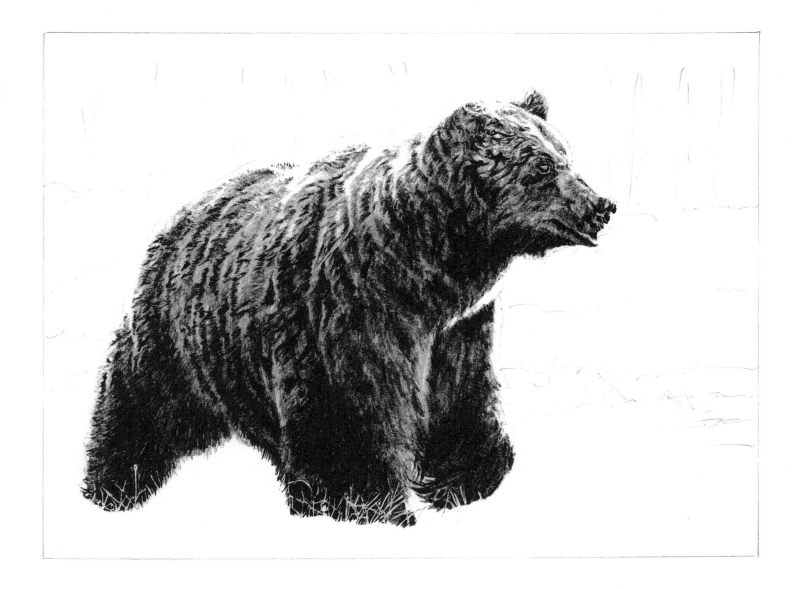

Step 7

Now, use a 5H to overshade most of the fur, leaving the highlighted areas blank, and blend the edges of the existing strips of fur to create tonal gradients and a softer effect. Remember that your first marks will show through, so use this effect to further overshade with the side of an HB pencil lead to create deeper shadows in some areas. Use the photograph as a reference and close one eye to help you identify those areas of light and shade to enhance. Note that the background outlines in this image have been minimized in order to highlight the bear itself.

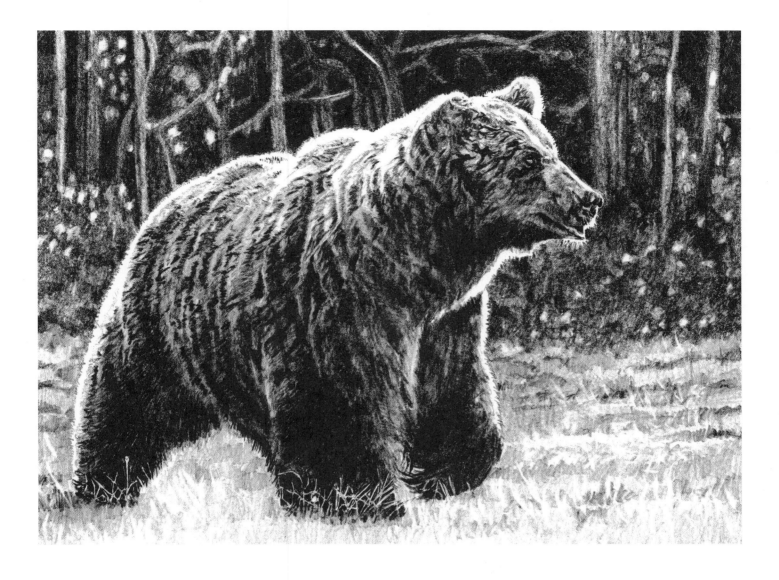

Step 8

Use a blunt-point HB to add most of the background details, changing to a fine point to carefully shade around the wisps of fur along the highlighted edges of the bear (see page 43 for filling in large areas of even tones). With a blunt point, add the foreground grass as strips of short strokes in different tones. Outline the background trees as negative shapes, then fill these shapes with tones fading from dark to medium. Finally, use an eraser to create the small circular highlights of the flowers and leaves in the background.

Domestic cat

Pets are popular subjects to draw, and the portrait of this gorgeous Bengal cat called Rocket Dog uses similar techniques to those of the bear drawing. We may not always have our ideal photograph to work from and it's fine to change the background details or omit them altogether. The main criteria for detailed works are that the subject is in clear focus and there is sufficient detail.

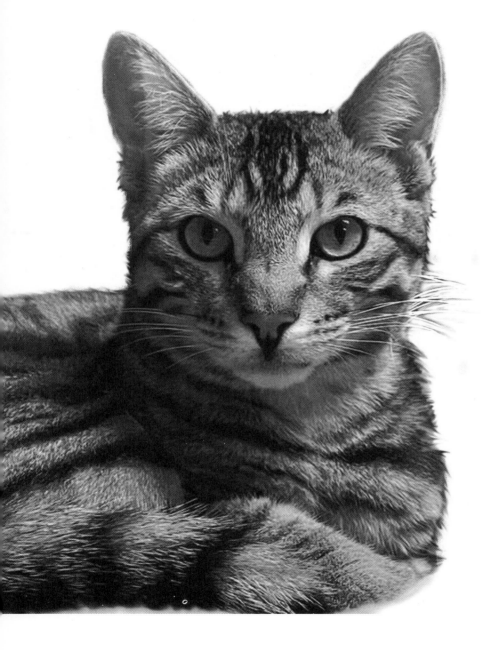

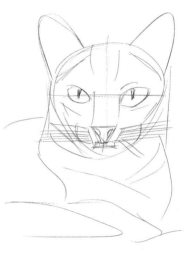

Familiarize yourself with the subject by drawing a rough sketch of the main shapes. If you find it helpful, also produce a tonal sketch to identify the main areas of dark, medium and light tones.

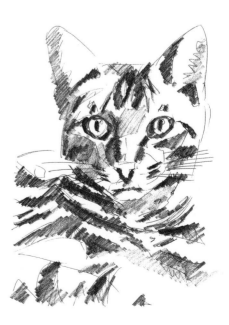

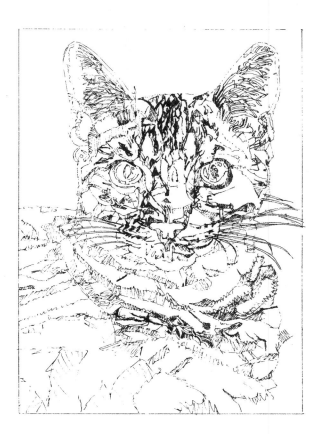

Step 1
Outline the main shapes in faint tones in as much detail as you require. On a detailed drawing such as this, which contains many similar features, use placemarks such as pre-filling some shapes with darker tones so you can easily find your place later when shading. During this stage, you'll discover you'll become very familiar with your subject. For illustrative purposes, this image has been darkened to show you the details.

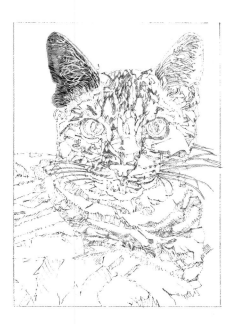

Step 2
Use a blunt-point HB to add the various soft tones to the cat's right-hand ear, altering the pressure of the pencil to create the differing shades and leaving the negative shapes of the hairs white. Try not to draw the tones too dark – you can always adjust them later when you review the finished drawing. You'll notice that most of the features consist of lines or 'worm' shapes rather than smooth areas of tone.

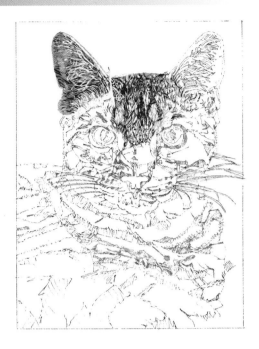

Step 3

Still using a blunt-point HB and guided by your outline and placemarks, add the various tones to the forehead section. You'll see that some of the strokes appear to be quite rough at this stage, but these can be edited later. You may be thinking this will never look like a cat, which is quite normal at this stage, but do persevere and you'll be surprised how quickly your drawing will take shape.

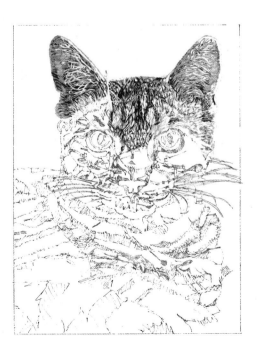

Step 4

Continue in the same way with a blunt-point HB to add the tones to the cat's left-hand ear, using gradient shading at the outer edges to create a soft fur effect.

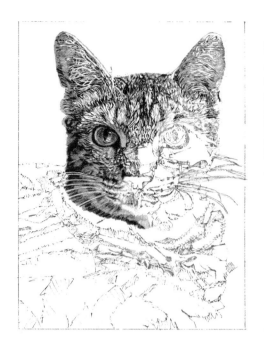

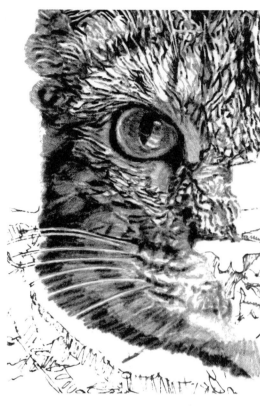

Step 5

Next, complete the cat's right eye and cheek where you will need to alternate between different pencil points, using a blunt point for the fur shapes and a very sharp point for the eyes. Use negative shapes for the eye highlights and long, white whiskers.

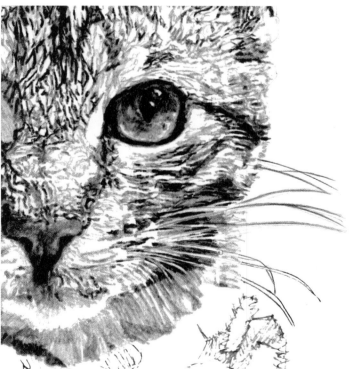

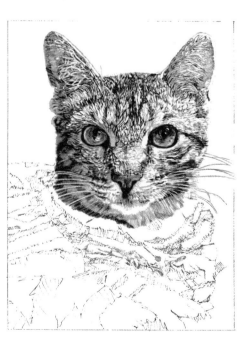

Step 6

Draw the cat's left-hand eye in the same way as before but use slightly paler tones around the eye, nose and cheek to show that the cat is illuminated from this side.

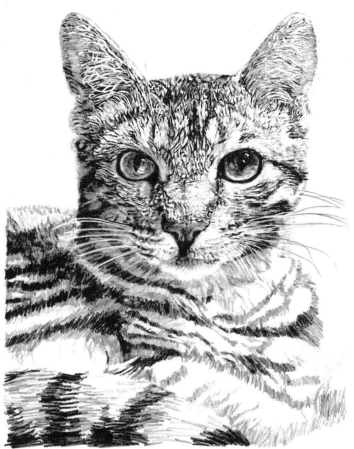

Step 7
Use rough strokes in HB to complete the rest of the fur in dark and medium-toned stripes. As your first marks will show through, you will use this technique to refine these fur details later. Review your work and make any adjustments. I slightly narrowed the line of the left-hand eye's lower lid.

Step 8
Use a blunt-point 5H pencil to blend and overshade all the existing marks to create softer edges, taking care not to fill in the white bits.

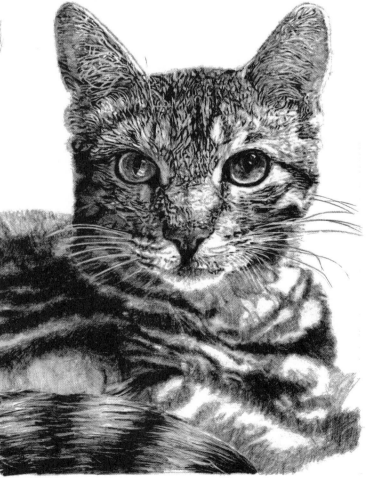

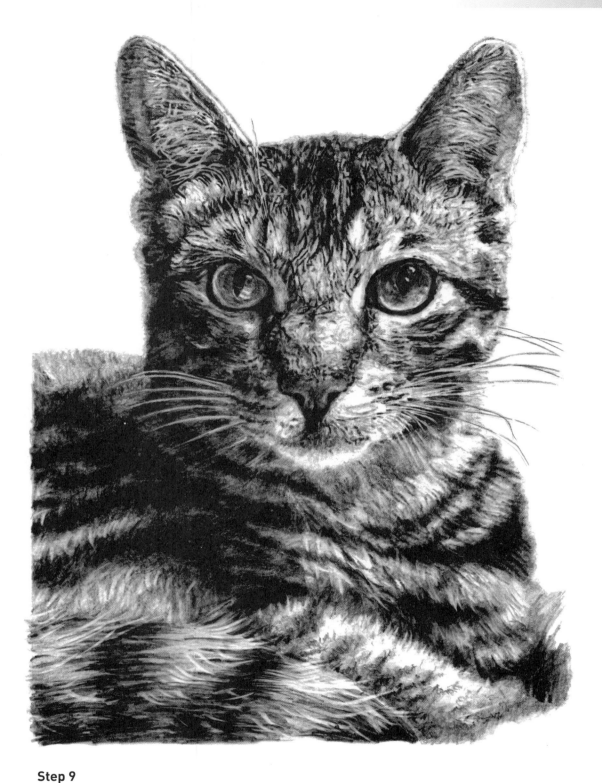

Step 9

Use a blunt-point HB to add the medium- and dark-toned marks to create a more realistic fur effect, using much darker tones in the shadowed folds of fur. Create the individual white hairs with an eraser sliver. Finally, review your work again, check you have used tones consistently across the drawing, and make any adjustments.

Labrador

If you would like to create a pet portrait for yourself or as a gift for someone else, then here is your opportunity to produce a beautifully detailed drawing in just 14 steps. This exercise is more challenging than previous ones because the detail and range of pale tones in the patterns of fur require a consistently light and delicate touch of your pencil. It will also take you longer to draw, but if you follow each step, you will be guaranteed to produce a beautiful work of art.

In this exercise, you will be shown how to use a photograph to produce a detailed, realistic drawing by measuring key points on the photo and copying these measurements onto your page.

KEY TECHNIQUE: PREPARING TO USE A PHOTOGRAPH FOR A DRAWING

First, check your photograph contains good detail and lighting and consider converting a colour image to black and white so that it's easier to identify the tones to draw in graphite. Many phones and computers have built-in apps to convert colour images to black and white, or you could scan at high resolution and then print in monochrome.

Next, think about the size of your photo and drawing and if you would like to draw the same size or larger/smaller than the photograph. Draw a rectangle around the edge of the photograph in permanent ink (or trim the photograph and use the edge as your reference 'rectangle'). Then, draw a rectangle of the required size on your page in faint tones so that you can erase it later and leave no trace on the paper (use a softer B pencil which will not indent the paper surface as much as a harder 3H or 5H pencil). Obviously, the same size drawing and photograph will have the same size rectangle, but if your drawing is twice the size of the photograph, the rectangle on your page will need to be double the length and height of the photograph. These rectangles are key to laying out your drawing in the correct proportion.

Step 1

We'll use a full-size photo, roughly 18 cm wide x 20 cm tall (7 x 8 in) and produce a drawing of the same size. Draw your rectangle as outlined in the box above.

Notice the contrast between the pale tones of the fur and the deep dark tones of the eyes and nose, and the way the light shines from the dog's right side to create soft shadows on the opposite side of the head. These effects help to create a three-dimensional appearance, bringing real depth and life to the portrait. There is no need to produce a rough sketch for this exercise because the proportions and tonal areas are measured directly from the photograph.

For illustrative purposes, most of the images in this exercise have been slightly darkened so you can see them more clearly, as shown by the enhanced rectangle corner in the inset circle compared to the faint outer lines of the original rectangle.

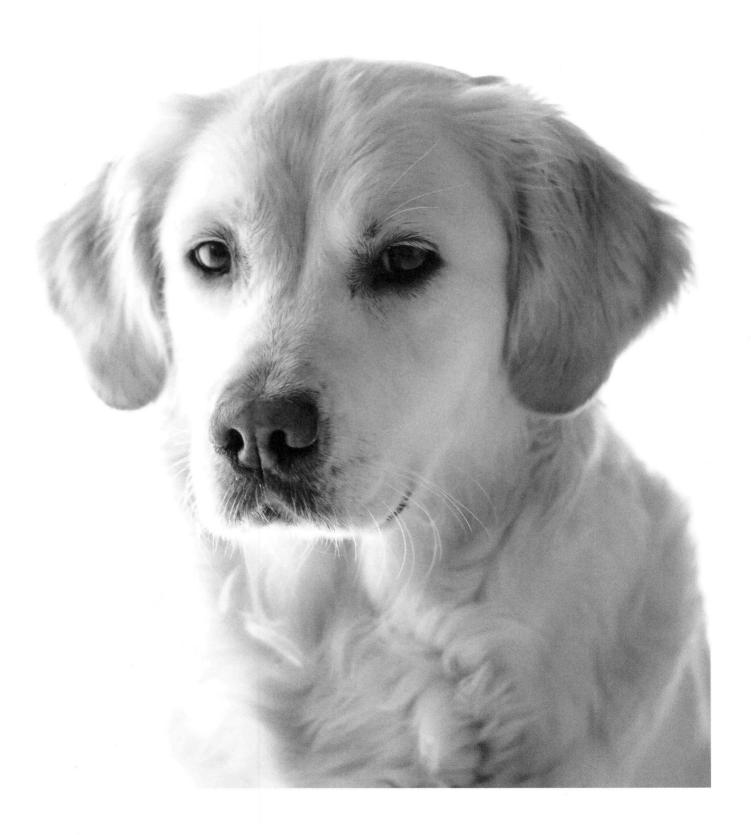

Step 2

The aim is to identify the accurate location of each significant point and shape on the photo and accurately map these onto your page.

To do this, first identify a key point on the photo, such as the top of the right ear, by measuring the distance to this point from the top and side of the photo. In this example, the point on the top of the ear is 4 cm (1½ in) in from the left and 1.5 cm (½ in) down from the top edge of the photo. Use these measurements to locate and mark this point with a tiny dot in H pencil on your drawing page (shown larger here for illustration only). The diagram also shows how four more dots at the bottom of the ear are joined together by a faint line to create a shape. Often, as you draw your outlines, you will discover regular shapes like triangles.

Step 3

Continue to accurately create outlines of the main areas of dark, medium and light tones and overall dog outline. It does not matter where you start, but I tend to work from top left to bottom right purely because I am right-handed, and it stops me smudging my work. The pencil lines are deliberately pale and made with very light pressure so that they don't indent the paper surface or show through in the final work, which would affect your later drawing strokes.

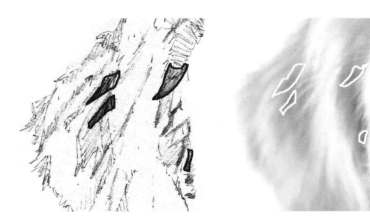

The details of the dog's right ear show (left) the shapes drawn on the page and (right) the corresponding area on the photo where the shapes are located.

DRAW WHAT YOU SEE

All you have to do is simply draw what you see, not what you think you see. If you cannot distinguish a particular feature because it is too blurry or indistinct, then draw a blurry, indistinct shape. It is a good idea to use a dotted line to identify these blurry areas and this also acts as a reminder when you come to fill in the details with blocks of tone later.

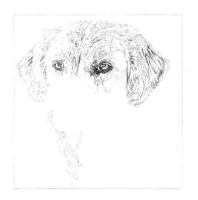

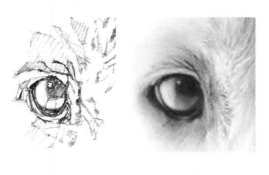

Step 4
Continue to work across the photograph with your H pencil, adding the shapes of the forehead and eyes including the whisker outlines. You don't have to draw every shape – just enough detail so you can fill in the tones easily later. The more care you take at this stage, the better your final picture will be.

This shows how the shapes of the eyes drawn on the page (left) are derived from the photograph (right). It's not necessary to draw every detail, such as eyelashes, especially if there's not enough room to fit everything in. It's sufficient to draw the main shape such as the eye, or eyelid, in the correct position on the page then use a dotted outline to show the boundary of other nearby features such as eyelashes.

Step 5
Add the outline shapes of the nose, chin, and neck tones.

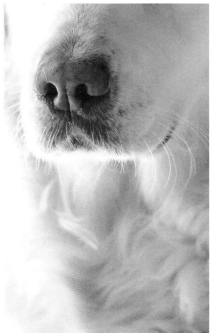

TIP Spend more time on important features such as the eyes, ears, and nose rather than areas of general fur below the chin and shoulder, where accuracy and precise proportions are less crucial. As you progress, you will develop your own style and will know how much detail is needed to complete the drawing to your satisfaction.

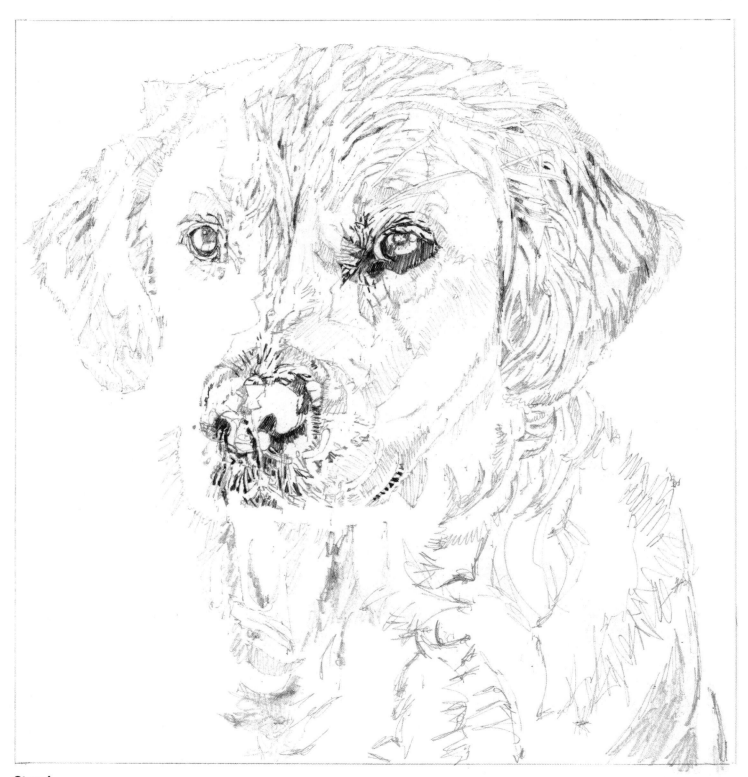

Step 6

Draw the remaining outline shapes of the neck and shoulder to complete the layout of your perfectly proportioned dog. Carry out any final checks to ensure you have all the detail you need, then look forward to the fun stage of shading in the detail next.

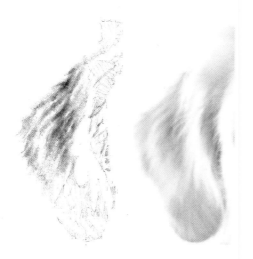

Step 7

Before you start to shade the paler-toned details, partially erase any outlines so they do not show in the finished work. Gently lighten the lines by either dabbing with the eraser or using the flat side of it and sweep away any crumbs with the soft paintbrush. Use 3H and 5H to blend the pale-toned areas on the ear, then use H and HB for the darker areas. Refer to the photograph to judge how light or dark each shape needs to be and how much to blend adjoining areas of different tones. Also use your tonal strip as a guide to assess tones. The aim is to create areas of even and blended tones where you cannot see the individual pencil strokes.

TIP If you need to take a break, try to complete a section first, such as a whole ear, before you stop. This way, any differences such as a change in pencil pressure or tone will not show.

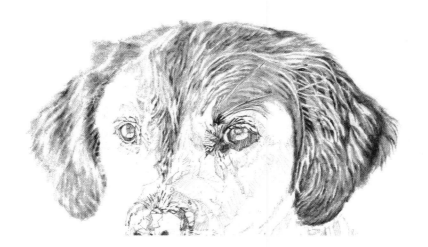

Step 8

Continue with the same blending techniques and pencils to gradually fill in the dark, medium and light tones of the dog. Aim to be consistent with your use of tones across your drawing and be mindful of how light falling on the subject creates different tonal effects. The right side of the dog's face is much brighter with greater tonal contrast and some areas of the face are completely blank, whereas the dog's left side is in shadow with less tonal contrast.

TIP Sometimes, you may find drawing angles awkward, so it's a good idea to rotate your page (and the photograph) to find a comfortable position. In fact, this is a very good technique for switching off the autopilot in your head because you will now draw what is actually there and not what you just think you see.

Step 9

Review your work. At this stage in the exercise, I compared the last two work-in-progress images with the photograph and thought the dog's left ear had areas of too much tonal contrast and over-defined edges. To rectify this, you need to create softly blended tones between adjacent areas by using 5H and 3H pencils to draw over the area, then blended shading along edges of the tonal areas to remove the sharp contrasts. If needed, use an eraser to lighten tones.

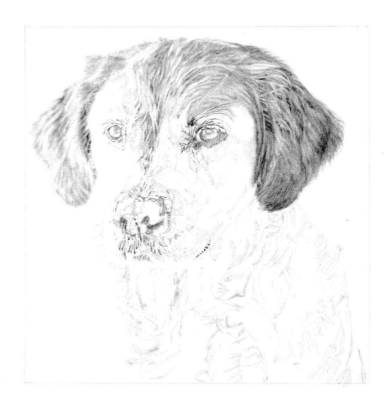

Step 10

Use an HB pencil, a fine point, and firm pressure to achieve the dark, bold lines around the eyes, and then softer, more blended strokes to fill in the eyeballs so that you cannot see individual pencil strokes. Notice how your drawing becomes transformed when you add the eyes and see how the area around them creates the dog's expression. Use a combination of H, 3H and HB pencils to define the negative spaces of the white eyelashes, whiskers, and fur around the eyes, then overshade with a 5H pencil to soften and blend the features, creating the different areas of light and shade.

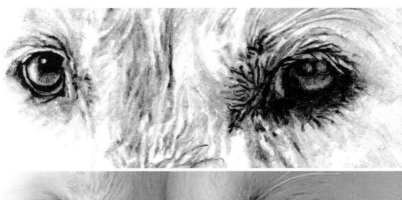

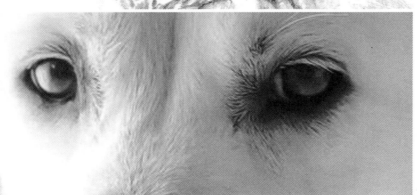

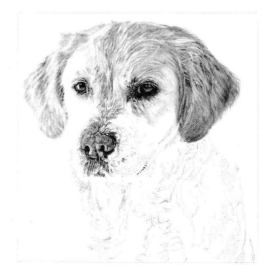

Step 11
Examined closely, a dog's nose is an intriguing feature full of odd shapes! To reproduce this feature, you will need to create a mixture of smooth/shiny and matte/ uneven textures in HB, H and 3H with a blunt pencil point. Then overshade and blend with 5H.

Sometimes you may not capture the exact details, as in this nose example, but if the overall effect is pleasing you can choose to leave the drawing as it is.

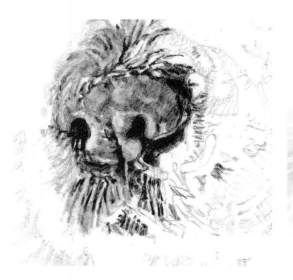

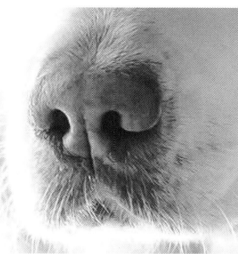

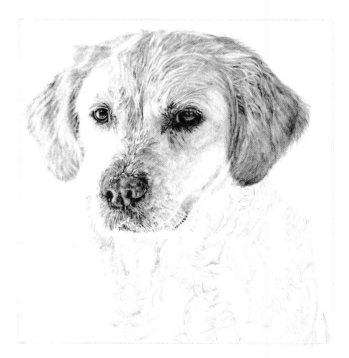

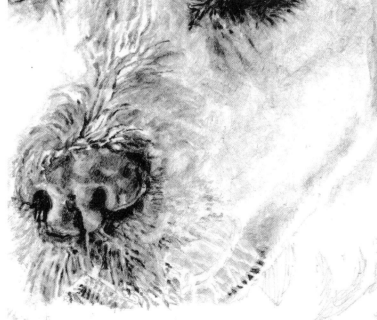

Step 12
Shade the features of the cheek and nose in blunt-point 3H, leaving a few white areas, then use a flat HB pencil lead to slightly darken the fur under the dog's left eye. Add the intricate white whiskers and muzzle fur details (negative shapes) in blunt-point 3H and HB. The mouth area requires you to draw just a few hairs and darker tones so literally just draw what you see – lots of little bits of tone.

Review your progress again. I used a blunt-point 5H to delicately overshade and blend the fur around the nostrils and cheek and removed any pure white areas on the side of the face in shadow.

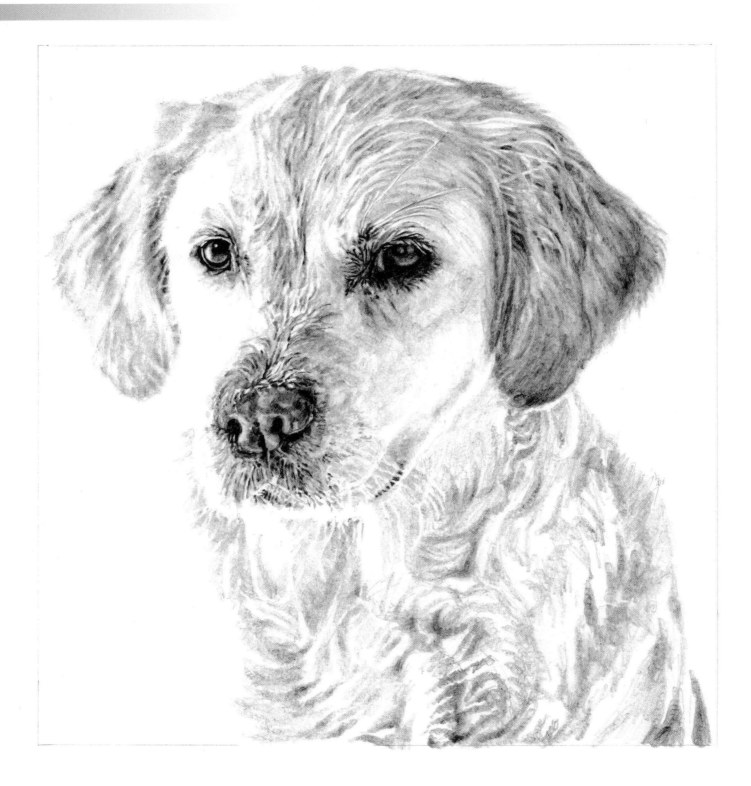

Step 13
Have fun completing the remaining areas of fur on the chest and shoulder
in soft, loose, blended strokes of H and HB tones.

Step 14
Finally, review your work, make any final edits, and congratulate yourself on creating a work of art! I used 3H and 5H pencils to gently blend, soften and darken the fur around the neck and shoulder and created highlights in a few areas with an eraser.

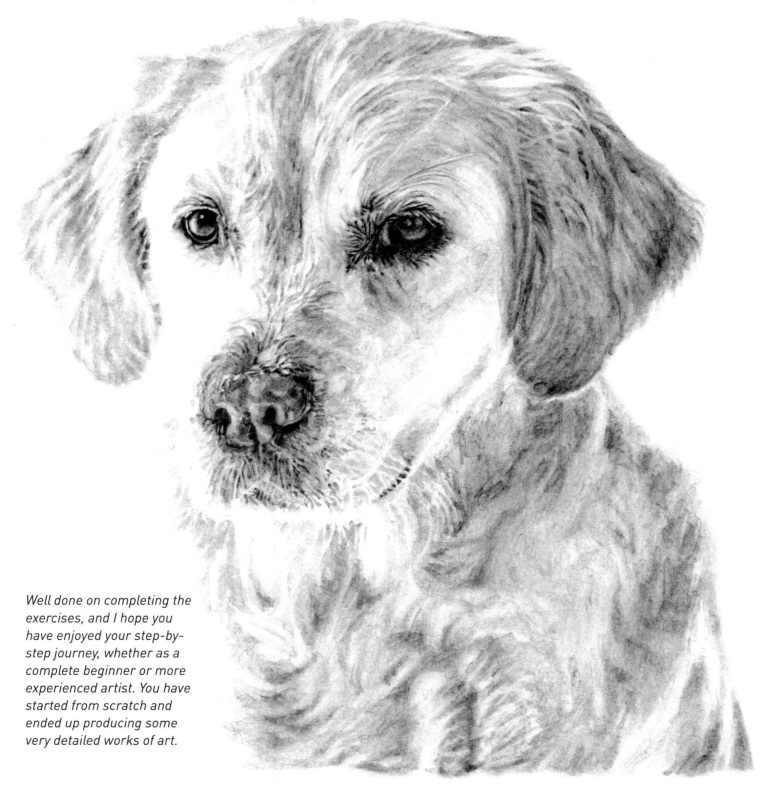

Well done on completing the exercises, and I hope you have enjoyed your step-by-step journey, whether as a complete beginner or more experienced artist. You have started from scratch and ended up producing some very detailed works of art.

Index